DIGITAL WEDDING PHOTOGRAPHY
PHOTO WORKSHOP

D1534181

Kenny Kim

WILEY

Wiley Publishing, Inc.

CALGARY PUBLIC LIBRAR

SEP 2011

Digital Wedding Photography Photo Workshop

Published by
Wiley Publishing, Inc.
10475 Crosspoint Boulevard
Indianapolis, IN 46256
www.wiley.com

Copyright © 2011 by Wiley Publishing, Inc., Indianapolis, Indiana

Published simultaneously in Canada

ISBN: 978-1-118-01411-0

Manufactured in the United States of America

10 9 8 7 6 5 4 3 2 1

No part of this publication may be reproduced, stored in a retrieval system or transmitted in any form or by any means, electronic, mechanical, photocopying, recording, scanning or otherwise, except as permitted under Sections 107 or 108 of the 1976 United States Copyright Act, without either the prior written permission of the Publisher, or authorization through payment of the appropriate per-copy fee to the Copyright Clearance Center, 222 Rosewood Drive, Danvers, MA 01923, (978) 750-8400, fax (978) 646-8600. Requests to the Publisher for permission should be addressed to the Permissions Department, John Wiley & Sons, Inc., 111 River Street, Hoboken, NJ 07030, 201-748-6011, fax 201-748-6008, or online at http://www.wiley.com/go/permissions.

LIMIT OF LIABILITY/DISCLAIMER OF WARRANTY: THE PUBLISHER AND THE AUTHOR MAKE NO REPRESENTATIONS OR WARRANTIES WITH RESPECT TO THE ACCURACY OR COMPLETENESS OF THE CONTENTS OF THIS WORK AND SPECIFI-CALLY DISCLAIM ALL WARRANTIES, INCLUDING WITHOUT LIMITATION WARRANTIES OF FITNESS FOR A PARTICULAR PURPOSE. NO WARRANTY MAY BE CREATED OR EXTENDED BY SALES OR PROMOTIONAL MATERIALS. THE ADVICE AND STRATEGIES CONTAINED HEREIN MAY NOT BE SUITABLE FOR EVERY SITUATION. THIS WORK IS SOLD WITH THE UNDER-STANDING THAT THE PUBLISHER IS NOT ENGAGED IN RENDERING LEGAL, ACCOUNTING, OR OTHER PROFESSIONAL SER-VICES. IF PROFESSIONAL ASSISTANCE IS REQUIRED, THE SERVICES OF A COMPETENT PROFESSIONAL PERSON SHOULD BE SOUGHT. NEITHER THE PUBLISHER NOR THE AUTHOR SHALL BE LIABLE FOR DAMAGES ARISING HEREFROM. THE FACT THAT AN ORGANIZATION OR WEB SITE IS REFERRED TO IN THIS WORK AS A CITATION AND/OR A POTENTIAL SOURCE OF FURTHER INFORMATION DOES NOT MEAN THAT THE AUTHOR OR THE PUBLISHER ENDORSES THE INFORMATION THE ORGANIZATION OR WEB SITE MAY PROVIDE OR RECOMMENDATIONS IT MAY MAKE. FURTHER, READERS SHOULD BE AWARE THAT INTERNET WEB SITES LISTED IN THIS WORK MAY HAVE CHANGED OR DISAPPEARED BETWEEN WHEN THIS WORK WAS WRITTEN AND WHEN IT IS READ.

For general information on our other products and services or to obtain technical support, please contact our Customer Care Department within the U.S. at (877) 762-2974, outside the U.S. at (317) 572-3993 or fax (317) 572-4002.

Wiley also publishes its books in a variety of electronic formats. Some content that appears in print may not be available in electronic books.

Library of Congress Control Number: 2011926315

Trademarks: Wiley and the Wiley Publishing logo are trademarks or registered trademarks of John Wiley and Sons, Inc. and/or its affiliates. All other trademarks are the property of their respective owners. Wiley Publishing, Inc. is not associated with any product or vendor mentioned in this book.

About the Author

Kenny Kim has always been fascinated by the visual arts, especially the connection between art and photography. This passion led him to study graphic design at the University of Illinois where he also became a skilled Web designer. Shortly after, Kenny opened his own design studio, and it was during this time he realized that the greatest outlet for his artistic expression and technical skills would be through his passion for photography.

Incorporating his own vision into the technical elements of photography, Kenny's goal with each photo is to present each moment he captures with a subtle artistry that enhances the feel of the moment. With the launch of Kenny Kim Photography in 2006, his vision instantly resonated with his audience, and Kenny Kim Photography very quickly grew into a nationally recognized studio. Kenny has shot over 120 weddings in locations throughout the United States, Mexico, the Caribbean, and in Italy. His wedding clients include various local and national celebrities such as Yul Kwon (winner of Survivor, a popular CBS TV Series). He has been commissioned as the second lead photographer for the weddings of Salma Hayek and François-Henri Pinault and LaLa Vasquez and Carmelo Anthony by the international celebrity photography team Bob and Dawn Davis. He has also been contracted to photograph various professional and collegiate sporting events and numerous celebrity events featuring David Foster, Andrea Bocelli, John Legend, Three Doors Down, Chris Tomlin, Michael W. Smith, and more.

Kenny is honored to be selected as an Eastman Kodak Company Mentor and Approved Speaker in 2011. His work has been featured in publications including *Destination Weddings & Honeymoon*, *The Knot*, The *KoreAm Journal*, *WIND Magazine*, and more. He is a platinum list member in highly acclaimed Grace Ormonde Wedding Style Magazine since 2009. He is also an active member of WPPI (Wedding & Portrait Photographers International) and has recently received five special honors in the WPPI 2010 Awards of Excellence 16×20 International Print Competition. He was voted by *The Knot* Magazine in 2010 & 2011 as the Best of Weddings in Photography and recognized by Junebug Weddings as one of the best wedding photographers in Chicago.

Kenny currently resides in Chicago but loves to travel and explore new culture. He is thankful every-day for the privilege to call his passion in life his profession as well.

Credits

Acquisitions Editor
Courtney Allen

Project Editor
Cricket Krengel

Editorial Consultant
Alan Hess

Technical Editor
J. Dennis Thomas

Copy Editor
Lauren Kennedy

Editorial Director
Robyn Siesky

Editorial Manager
Rosemarie Graham

Business Manager
Amy Knies

Senior Marketing Manager
Sandy Smith

Vice President and Executive Group Publisher
Richard Swadley

Vice President and Executive Publisher
Barry Pruett

Project Coordinator
Patrick Redmond

Graphics and Production Specialists
Jennifer Henry
Andrea Hornberger
Brent Savage
Julie Trippetti

Quality Control Technician
Lauren Mandelbaum

Proofreading and Indexing
Penny L. Stuart
Palmer Publishing Services

Acknowledgments

Completion of my last book *Digital Wedding Photographer's Planner* and this one that you are holding in your hand would not have been possible without the support and guidance of some important people in my life. First and foremost I would like to thank my family for encouraging me to pursue my dreams. To my dad who is looking down from above, I hope I made you proud and we miss you dearly.

To the amazing staff at Wiley Publishing, thank you again for giving me this amazing opportunity. Barry Pruett, Courtney Allen, and Sandy Smith — it has been a wonderful experience working on this project with you. Alan Hess, thank you for your tremendous help (and patience) in developing the content for this book and making sure I was on track to complete this project!

Joseph Paglia and the staff at Eastman Kodak Company, I am honored that you would include me as one of your Approved Mentor & Speakers for 2011. I look forward to a great year of learning and growing as a photographer under your leadership and guidance.

To Arlene Evans, George Varanakis, and staff at RangeFinder Publishing. Five years ago, I was a fish out of a pond when I first attended WPPI. You guys have supported and cheered me on since then and I'm grateful for the opportunities that you guys have entrusted me with.

My friend and older brother John Hong, for recognizing the potential I had and encouraging me to pursue my dreams. I will always remember your timely words, sound advice, jokes, and friendship throughout the years.

To all my photography friends/mentors — Thank you for investing your time and energy even when I had nothing much to give back. I would especially like to thank (in no particular order) Grace and Hun Kim, Bob and Dawn Davis, Mike Colón, Ray Santana, Roberto Valenzuela, Yervant, Joe Buissink, David Jay, Christopher Becker, and Skip Cohen for their support and inspiration.

Dr. Min Chung, his pastoral staff at Covenant Fellowship Church, and other mentors and friends during my time at University of Illinois, thank you for your prayers and support. I will never forget those days and the training I received. I am still applying the lessons that I learned there.

To Max Brunelli (my brother from another mother) and his family. Thank you for helping me discover the joy of traveling and opening up your home in Italy — one of the most beautiful places on earth. Here's to many more years of friendship and partnership.

To *all* of my wonderful clients, business sponsors and friends in the industry (too many to name — you know who you are), thank you for the opportunities to network, learn, and grow together. In the words of Skip Cohen, "You have all taught me that the best part of this industry has little to do with photography. It's about the friendships that come out of our mutual love for the craft."

And last but not least, I must give all thanks to God — for giving me a purpose to live for something greater than myself.

To God and my family – both of whom exemplify unconditional love

Contents

CHAPTER 5 Outdoor Shooting 85

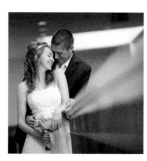

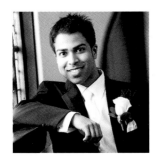

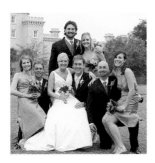

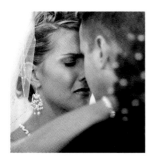

CHAPTER 10 The Reception **195**

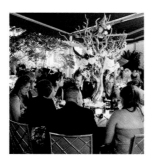

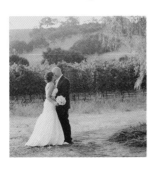

Introduction

Wedding photography has become one of the most popular types of photography today. Perhaps it is the emergence of affordable digital cameras that have made entry in this industry much more accessible. Or perhaps many of us were not happy with our current job and always looked at photography as a weekend hobby until you attended a friend's wedding when it hits you like a lightning bolt — that you want to be a wedding photographer. Whatever the reason is, wedding photography is extremely popular. Many of you are diving into the ocean of photography filled with excitement only to realize right away that you need the right set of skills to swim and survive in this industry.

Five years ago while working as a freelance graphic designer and part-time Starbucks barista, I discovered the joy of photography. I made the decision to drop my designer career and give photography a try. One problem — I had no clue where to start or how to go about this business. Fortunately I have been blessed to be surrounded by a great group of photographers that I got to meet early in my career that have helped me to be where I am today. By attending photo workshops; assisting them as a second shooter; and networking at photo conferences like WPPI, Pictage Partner Conference, PDN, Imaging USA, and others, I began to pick up on the nuggets of wisdom that these other talented photographers shared and immediately applied them to my business.

This book, along with my *Digital Wedding Photographer's Planner*, was written with the idea of creating the kind of resource I wished I had when starting out. This book covers wedding photography as I practice it, from the gear I use to the methods for taking portraits, discussing different styles, shooting indoors and outdoors, and covering the ceremony and the reception.

Welcome to wedding photography. You are surrounded by a community of people who will help and encourage to you become a better photographer. Use this book as a springboard to help you dive into this profession. Then learn to develop your own style and make your photography and business unique! But, don't stop there. Continue to explore and discover new ways of doing things. It is perfectly okay to reinvent the wheel. I hope you find being a wedding photographer as rewarding and fulfilling as I have. And most importantly, don't forget to smile.

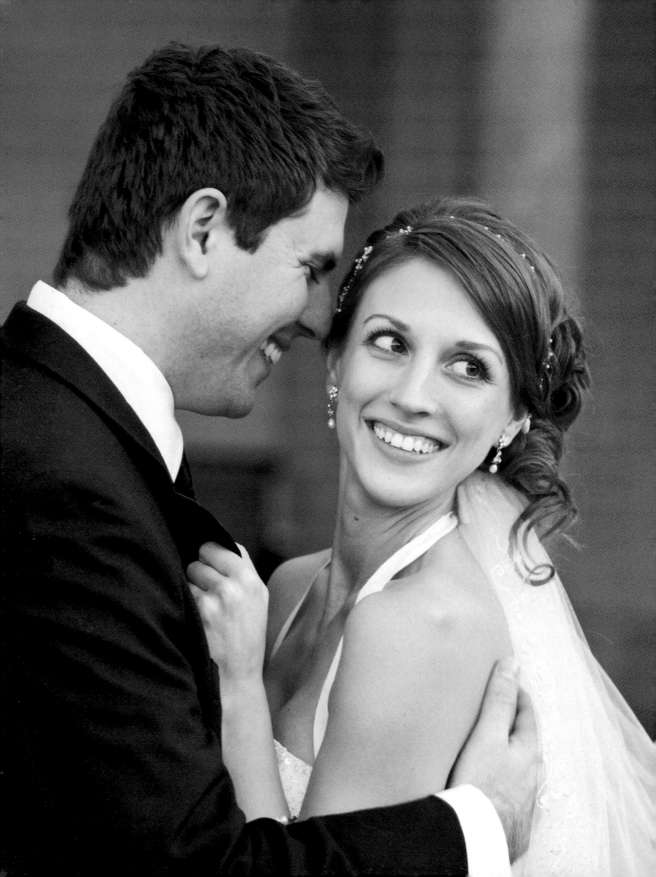

WEDDING PHOTOGRAPHY OVERVIEW

WHAT IT TAKES

Wedding photography is a tough business, and make no mistake, it is a business. Weddings happen every weekend and many weekdays all year long, and the one thing that all the couples need is a good wedding photographer to capture this joyous occasion. Your passion for photography may have led you to this industry, but there is a lot more to being a successful wedding photographer than just taking great photos. You need to be able to find a balance between the creative and the business aspects, and learn how to meet clients and make sure that you understand their expectations. It is also important to be prepared to cover the wedding day itself (see Figures 1-1 and 1-2) and deliver the final products to the clients in a timely manner. So if you are ready, it's time to look at what it takes to be a successful wedding photographer.

Your clients are expecting you to capture the day with the same dedication that they have to their wedding. They don't care that you might be shooting a wedding the weekend before or after, or that you have other clients who need your attention, so finding a balance that keeps everyone happy is important and necessary for you to survive in this industry.

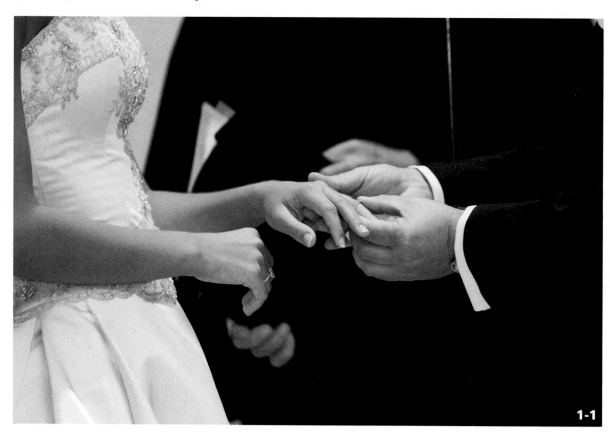

1-1

ABOUT THIS PHOTO *The ring being placed on the bride's finger is a key moment in any wedding, and a good wedding photographer will make sure she is in position to capture it. Taken at ISO 2000, f/3.5, 1/50 second.*

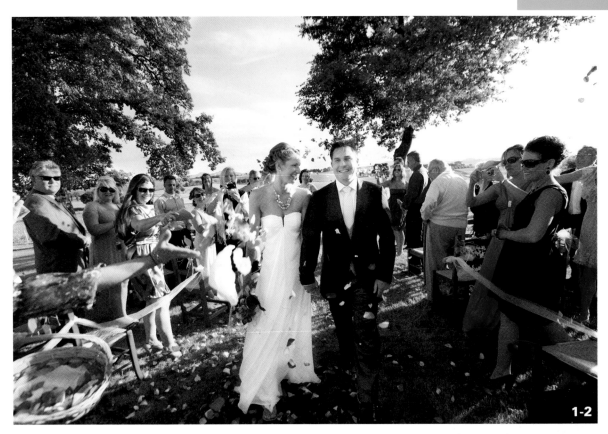

1-2

ABOUT THIS PHOTO *The happy newlyweds walking back down the aisle. Taken at ISO 200, f/6.3, 1/400 second.*

FINDING A BALANCE

Many photographers and artists believe that in order to be successful, you only have to possess talent and creativity. While talent and creativity are crucial (see 1-3), they are only half of the picture. One of the most difficult things to do is to find a good balance between the photographing of a wedding and the business side of being a wedding photographer. But like all things in life, there has to be a balance in your business for it to thrive. Focus on one side of the business at a detriment to the other, and things will fall apart.

As much as you love spending time on your craft of photography, you need to give yourself time to take a break and to get involved in other activities to improve yourself as a photographer. Your time has to be divided so that you can focus on growing your business, doing client consultation, honing your craft, working on your creativity, handling the postproduction of the wedding images, and marketing your business. You also need to find a balance between your work, family, and social life. Because many weddings fall on the weekends, it can really impact the family life of

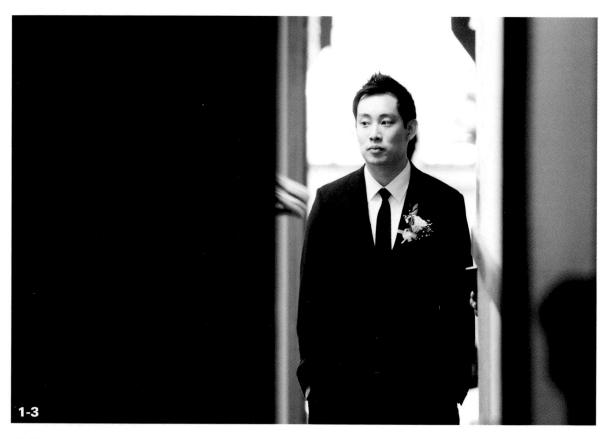

1-3

ABOUT THIS PHOTO *Those candid moments before a ceremony has even started can really capture the emotions of the day. Taken at ISO 1600, f/2.8, 1/100 second.*

the wedding photographer. The key is to plan ahead and make sure that you can juggle these things without making too many sacrifices. It sounds impossible but it can be done with careful planning. Shooting multiple weddings on the same weekend, or generally overloading your schedule, will cause you to burn out and worse, can cause your attention to wander from what you are doing. Not being fully focused on the current job, but instead thinking of the next or last job, will result in a half-hearted performance and a delayed response to your clients and delivery dates — which means that you are not serving your customers to the full extent of your ability.

Plan to take some time off or spread the jobs out as much as you can to make sure you give the clients your best work as in Figure 1-4.

TIME MANAGEMENT

There never seems to be enough time to get everything done. To be a successful wedding photographer, you need to divide your time wisely, because taking the actual photos is just a small part, granted a very important part, of the business. Using a calendar (or a time-management tool or software) is essential so that you keep your commitments in order, not only in general but also for the actual wedding day.

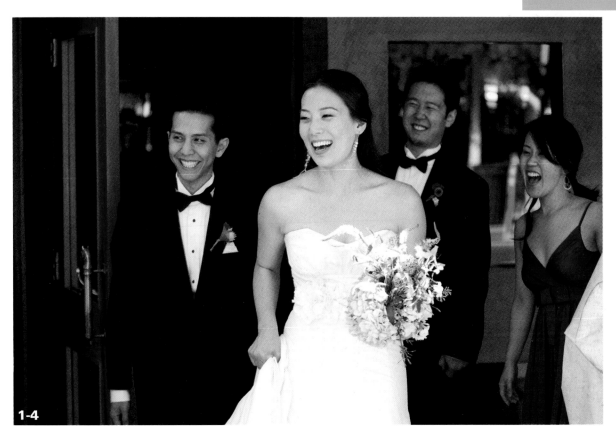

ABOUT THIS PHOTO *Here comes the happy couple. Taken at ISO 400, f/2.8, 1/500 second.*

Some of the things to plan for include:

- **Photographing the wedding.** The most obvious and important thing to plan is the actual time needed on the wedding day for shooting. You need to make sure that you schedule enough time to capture all the shots you need to, including the details (as in Figure 1-5). Make an effort to plan this out with your couple. Most of your clients are more than happy to listen to your suggestions when planning their day.

- **Post-processing.** Post-processing is important and can take more time than you think. Make sure you schedule enough time so that you can do the best job possible. Many

photographers do not take this factor into consideration when coming up with pricing for their photography service. Many clients also do not realize the amount of time you spend making their photos look perfect, like with Figure 1-6, which needed to be slightly cropped. All of this takes time, and it is important to educate them so they understand what the prices for your services cover.

- **Client meetings.** Client meetings are very important and can set the tone for the whole client/photographer relationship. Make sure that you schedule enough time to get to know the clients. This is a good way to determine whether you are a good fit with them. Give

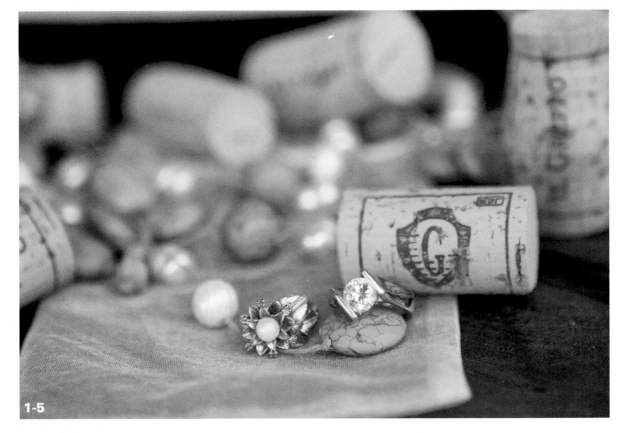

1-5

them your full attention and listen to what their needs are. The better you understand them, the better job you will do on their wedding day.

- **Engagement shoots.** These can be a lot of fun and a lot of work all at the same time. They can also take a lot of time and need to be planned well in advance so that the images are given to the couple well before the wedding.

- **Travel.** I shoot weddings all over the world, and it is key to plan all the travel needed well in advance. You need to factor in your time and travel budget accordingly into your

proposal. Also plan to arrive a day or two earlier. It gives you time to settle in and scout out the location, because arriving late or tired can be disastrous!

- **Rehearsal dinner.** Many times photographing at the rehearsal dinner can result in some great photos but more important, it can create a bond between you and the clients that makes shooting the wedding easier. Keep in mind that your client's dear friends and close family members will be at this event. Getting to know who they are will help you focus on them when photographing the wedding.

- **Continuing education/training.** It is important to set aside time to work on improving your skills by attending workshops or other training. (Even reading a good book on wedding photography once in a while is a good idea.)

- **Free time/family.** Make sure you schedule yourself some time off. Find hobbies that help you take your mind off work. Believe it or not, this is very important for boosting your morale, and it makes you a better photographer.

CREATIVITY VERSUS BUSINESS

A successful wedding photographer has to walk a tightrope when it comes to dealing with the creative and business sides of the job. To be successful, you can't ignore either side and need to balance them out evenly. Many people get into photography in general because they are creative and want to create great images like the use of light and repeating patterns in figure 1-7, and there is nothing wrong with this. But unless

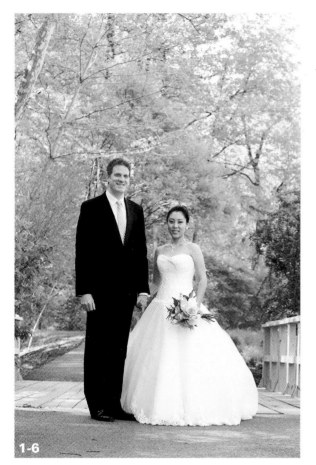

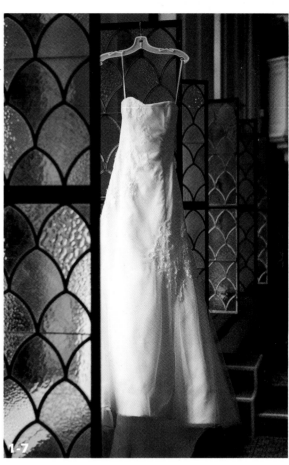

ABOUT THIS PHOTO *Each image needs to be looked at and edited in post-production to get the best possible results. This image needed to be cropped slightly to get the best results. Taken at ISO 800, f/5.6, 1/250 second.*

ABOUT THIS PHOTO *This dress hanging in the window makes a great image by the creative use of the light and patterns. Taken at ISO 400, f/2.8, 1/200 second.*

you have a business manager who takes care of the business side for you, you need to spend time growing and improving your business.

For example, if you take a photography workshop, balance it out by taking a business course. Check out your local community college, where you will find a variety of great business courses. Being the most creative wedding photographer without any clients is not a good business plan, and at the same time, if you put all your efforts toward the business side, the lack of creativity makes the job boring, and chances are you won't have many clients either.

Part of the business side of photography is dealing with other photographers and vendors, not just your clients. Attend social networking events and meet-ups, or even take the photographers or vendors out for lunch or coffee to find out what their needs are. If I work with other photographers at a wedding, I always make sure to provide them with images from the event so that they can use them to promote their business. Spending time to network with other photographers is also important. You can refer couples to them when you are already booked, and hopefully they do the same for you. You can also partner with other photographers as a second shooter, which is especially useful when you are starting out. I photographed the couple in Figure 1-8 when I was a second shooter at a wedding.

Building relationships with vendors, especially those that supply prints or wedding albums, can really help you create complete wedding packages with a wide variety of products. Spend some time talking to the customer reps for products you might want to offer so that you can be knowledgeable when offering services to your clients. Attending big conventions such as WPPI (Wedding and Portrait Photographer International), Imaging USA, or PhotoPlus Expo is a great way to meet and connect with

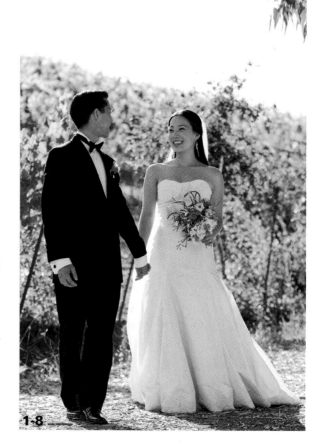
1-8

ABOUT THIS PHOTO *Working as a second shooter at a wedding will allow you to improve your photography and network at the same time. Taken at ISO 200, f/4, 1/250 second.*

numerous vendors that you might want to build relationships with. The basic idea is to continue to improve your photography as well as your business at the same time.

MEETING THE CLIENTS

When starting out, your clients might be friends, friends of friends, or even family members. As you grow your business, clients will come to you from a wide variety of sources: word of mouth, Internet searches, referrals from clients, responses to

advertising, and networking. Regardless of where the leads come from, you have to market yourself to be attractive to them.

FIRST IMPRESSIONS

Everyone knows that making a good first impression is important. What might not be so obvious is that you are making this first impression often times unknowingly. The following are all examples of when you might be making a first impression.

- **While working.** For example, guests sitting at the wedding you are photographing might be looking for their own wedding photographer. As a potential client, they are watching your performance. (There have been many times where the guests approached me at the end of the day to inquire about my services because they were pleased with the way I conducted myself on that day.)

- **Web site.** The wedding guests or friends might hear of you and decide to do an Internet search. These days, potential clients can read customer reviews about your performances on Web sites such as Yelp. That is why it is of the utmost importance to have a good Web site, professional marketing materials, a professional appearance, a good personality, and a great attitude. These are all factors when it comes to attracting your clients.

- **Appearance.** The idea that you should dress for success is important, both when you are meeting the clients for the first time and when shooting their wedding, as you can see from Figures 1-9 and 1-10. If you show up dressed casually, you are sending a casual message; if you show up dressed well, the clients will know that you are serious about what you do and that you are taking them

seriously. This also goes for your appearance when you are shooting the actual wedding because every guest is a potential client or referral.

Building a relationship with your clients is essential to being a great wedding photographer. It starts with the first meeting and continues long after the happy couple has their images. Keep in mind that many of your past clients are the ones to bring you your new clients.

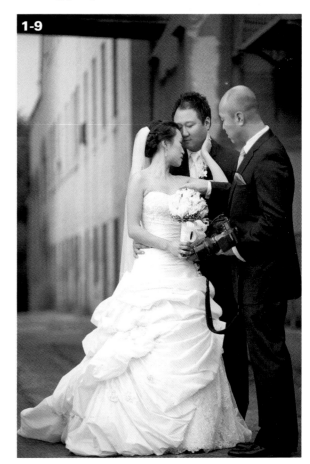

1-9

ABOUT THIS PHOTO *Dressing well and having a professional appearance lets clients know that you take this day as seriously as they do. Here, I am directing the bride and groom. Taken at ISO 200, f/2.8, 1/640 second. Photo credit: Jenn Gaudreau*

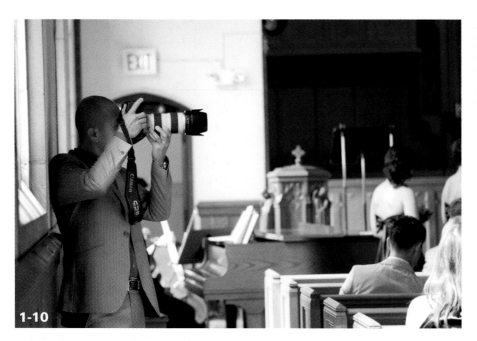

ABOUT THIS PHOTO
It is important to stay out of the way, while still making sure I cover the event thoroughly (and look professional doing it). Taken at ISO 1600, f/4.0, 1/100 second. Photo credit: Brandon Springer

1-10

REALISTIC EXPECTATIONS

It would be nice to think that you will book every prospective client who inquires about your services. However, it is important to know and accept that this will not happen (nor should you attempt to).

When you meet with prospective clients, they are trying to see if you are able to meet their needs and be the wedding photographer they want to capture their special day. This works both ways, and you should use that first meeting with them to see if the clients are a good fit for the way you work. It is much better to realize up front that for some reason the relationship just isn't going to work and that the couple should find a photographer better-suited for their needs.

Determining if the client-photographer relationship is a good fit starts with listening to the clients' needs and communicating what it is that you provide for them. If your shooting style is photojournalistic, and the clients want old-fashioned classic-looking images, you are probably not the right photographer for the job. If they are looking

for vibrant colors and you tend to shoot in black and white, then they will not be happy with the final product. On the other hand, if the clients have already checked out your Web site or seen your work because you shot a friend's or family member's wedding, chances are they already love your work and want to find out if you are available on their date. The key is to effectively communicate to them what you provide by discussing your style and showing them through your portfolio.

THE IMPORTANCE OF CLIENT COMMUNICATION

Honesty is very important when it comes to the client- photographer relationship. You need to listen to what your clients want and then tell them what it is you do. As the wedding photographer, you job is to fill a particular need and fill it to the best of your ability. If they want a service that you can't provide, make sure they know that up front, or their disappointment when you don't deliver the service they expected can damage the

relationship and is likely to cost you work in the future with lost referrals. Use examples of your work to show what it is you do and to give the prospective clients an idea of your skill and style. If they are getting married in a church, show images that they can relate to, like Figure 1-11, so that they can see themselves in your work.

Ask the clients for a list of what they are requesting and work together to determine if it is possible for you to address everything on it. This includes the events you will cover, the times you are expected to be there, and what type of products they can receive after the wedding. It will also cover the use of second photographers or assistants, travel costs, and any other factors involved in photographing the wedding. It is a very good idea to be as specific as possible and to write these things into a contract, because this is business after all. Even if the clients are friends or family, they are also now clients, and a contract is not only professional, but also it specifies what they expect and what services you are being hired to provide.

COVERING THE DAY

The big day is here and the pressure is on, because when it comes to shooting a wedding, there are no second chances. No one is going to stop the ceremony or hold up the processional if you put the wrong lens on the camera. There is only one chance to get it right. Having a detailed timeline and the proper preparation are critical in having the day go smoothly. Covering the wedding day can start way before the ceremony and includes a lot of special moments and some that are made special because you recorded them, like the bride on her way to the ceremony in Figure 1-12. Making sure that you are in position for that type of shot takes planning that wouldn't be possible without knowing the timeline of the day.

TIMELINE

Knowing the wedding timeline enables you to plan when to take the required shots. The more complete the timeline and schedule are, the easier it is to make sure you cover everything. Here is a typical timeline for wedding photography:

- Bride getting ready
- Groom getting ready
- Bride photos with her family

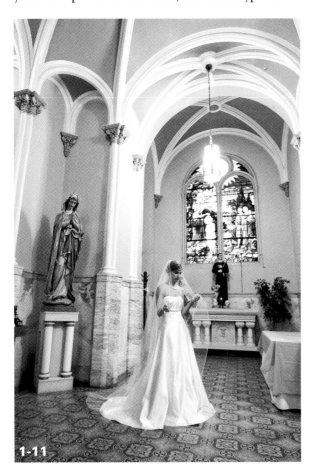

1-11

ABOUT THIS PHOTO *Using examples that closely match what the bride and groom are looking for will help you both be on the same page. Taken at ISO 3200, f/2.8, 1/60 second.*

ABOUT THIS PHOTO *Traveling with the bride requires planning and a level of comfort that comes from a lot of time and communication. Taken at ISO 200, f/1.4, 1/60 second.*

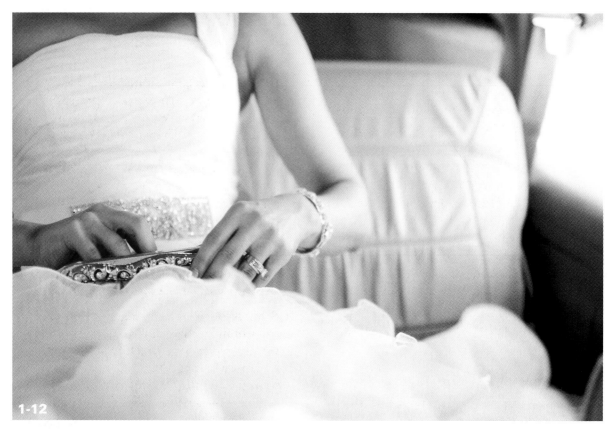

1-12

- Bridal party photos
- Groom photos with his family
- Groomsmen
- Bride and groom photos
- The processional
- The vows
- Ring exchange
- First kiss
- Couple walking down the aisle
- Reception details
- Family photos

- Random shots of the guests posing together ("grab and grin photos")
- Entrance of the newlyweds
- First dance
- Toasts
- Cake cutting
- Candids

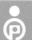 *tip* It is a really good idea to make sure that all the image opportunities are covered in the timeline and that all the parties involved in the wedding are aware of the timeline.

The wedding timeline is, at best, a guideline because no matter how hard you try, there will be times when things run late or ahead of schedule and the timeline needs to be adjusted. Just remember to be flexible, and when things go off track, you need to be able to adjust on the fly. Be prepared to wear different hats that day.

At times it will seem that you are not just the couple's wedding photographer but the wedding planner as well, because it is up to you to make sure you work efficiently and not slow or stall the wedding by taking too long with the images. As you are also responsible for capturing those special moments at the wedding like the toast and cake cutting, it is important that you are helping to make sure everything stays on track. However, at the end of the day, the photos will live on a lot longer than the relationship the couple had with the wedding coordinator.

PREPARATIONS

The Scout Motto is "Be Prepared," but it should be the wedding photographer's motto as well. Weddings move fast, and there is little wasted time, so you need to be prepared for every situation before it happens. Part of this is having a timeline of the day, but the rest is all up to you.

- **Charge your batteries.** This might seem like a simple thing to do, but people forget, and a dead battery at the wrong time can be a disaster. Make sure you have fully charged batteries in your cameras and flashes. And always have several backups ready to go.

- **Format your memory cards.** Because digital memory has replaced film in photography, you now need to make sure you have enough memory on hand to cover the wedding. Make sure that your memory cards are empty, ready to go (you have downloaded and backed up any images from your previous job on your hard drive), and easily accessible during the wedding. Again, always have plenty of spare cards. While it is rare, a memory card can go bad.

- **Have a backup camera handy.** Most wedding photographers carry at least two camera bodies so that they can have two different focal length lenses available at all times. Another reason to have at least two camera bodies is that you don't get a second chance to shoot a wedding, and if there is a mechanical problem with one camera, you need a spare just in case. The worst case scenario sometimes comes true, and I know of photographers who had their gear stolen during the ceremony and did not have a back-up to use. Sometimes it is not a bad idea to have a spare set of gear in your car for emergencies.

- **Scout the locations.** Having a plan on where to shoot individual and group portraits makes the whole process easier, and part of that is knowing where to shoot. Arrive early and scout the area for the best locations or, if possible, scout the location before the wedding day. Attending a rehearsal is a great way to find out how the schedule will go during the ceremony as well as to figure out what the lighting situation is at the site. Even if the location is one that you have shot at before, it is best to check to make sure that it is as you remember and that it hasn't been changed. Figure 1-13 was shot before the guests arrived at the reception and at the same time, I was able to check out the placement of the tables, and how best to approach the actual photography without interfering with the guests.

- **Have a shot list.** Discuss what images are most important to the bride and groom so that they will feel that the day was captured to their liking, and keep a list of them with you. Many times they will want a photo with a favorite friend or relative, and you really don't want to miss taking it.

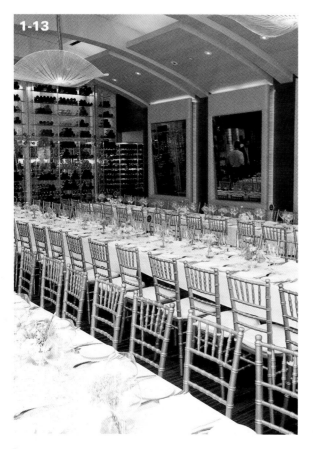

ABOUT THIS PHOTO *The reception setting before the guests arrived. Taken at ISO 1250, f/5, 1/80 second.*

Again, keep in mind that things change without notice during a wedding. You need to be able to think on your feet and adjust when necessary. This is where the timeline and shot list will really help because it gives you a plan of what should be happening when, and will help you get things back on track. If you are prepared, you can focus on capturing the day and not on whether the battery will last or where to do the group shots.

DELIVERING THE GOODS

Although the wedding may be over for the couple, you still have more work to do in order to finish the images and deliver the final product.

While there is no set timeline, the faster you finish the product, the happier your clients will be. The wedding day is such an emotional experience for the couple — you want to help enhance that by delivering the photos as quickly as possible.

Now is the time to import, sort, and edit your images so that the best images, those that really captured the essence of their day like the portrait of the bride and groom in Figure 1-14, are ready for the clients to view. Several software applications allow you to do this efficiently. First, I use a software package called Photo Mechanic (www.camera bits.com) to quickly sort, categorize, and input

ABOUT THIS PHOTO *Portraits of the bride and groom are an important part of any wedding package. Taken at ISO 100, f/2.8, 1/200 second.*

IPTC (International Press Telecommunications Council) data into my images before importing them into an image-editing program such as Adobe Photoshop, Adobe Photoshop Lightroom, or Apple Aperture for additional editing.

tip If you have back-to-back weddings, you might consider outsourcing the editing process to companies like Photographer's Edit (www.photographersedit.com) so you can deliver the final products to the clients in a timely fashion. This cost is absorbed by you, but with the extra time you can be out shooting other weddings, this increases the bottom line.

PROOFS

Two different types of proofs are commonly used nowadays: The first is the online gallery (see Figure 1-15), and the second is the printed proof book. Each has its advantages. I tend to lean toward the online gallery for obvious reasons: I can access it anywhere, order prints and other products directly from it, and trust that the quality of its products reflects the quality of my work.

A Web gallery is easy to make when you use a company that specializes in creating them, such as Pictage.com, which creates the gallery automatically from the images that you upload. You can easily share the gallery with the bride and groom, and they can share it with anyone else that they wish to. This enables many more people to view the gallery, and it can result in higher print sales.

The second method is showing the wedding proofs in a proof album, which is a book with a small thumbnail version of each photo. It allows the clients to see the images printed in a more traditional, catalog-like way. The advantage to the proof book is that it can be a better experience for

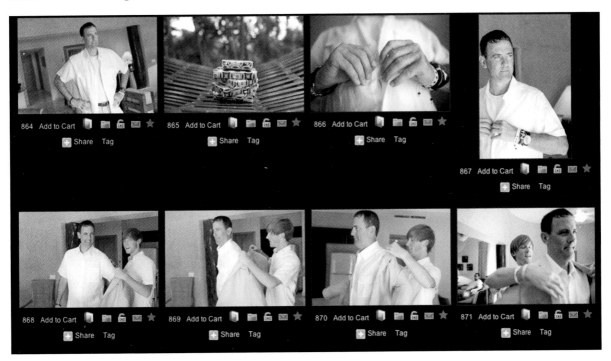

1-15

ABOUT THIS PHOTO *A Web gallery proof makes it easy to share the images and order prints online.*

your clients when they sit together and page through a real printed book, picking out their favorite images, rather than viewing them on a computer screen; the disadvantage is it is much harder to share the proofs with others, especially if they live far away. Having both an online and a printed option might be a good idea to offer to your clients.

PRINTS AND WEDDING BOOK

The final products for most newlyweds are the prints and wedding book. These are the keepsakes that last a lifetime, and they need to be of the highest quality. The prints will be on display in their home as a reminder of the happy wedding day and represent your work to anyone who sees the images. Never underestimate the power of word-of-mouth marketing. Every image that you have taken that is on display in a client's house is advertising for your business.

With many of the Web packages, it is easy to order prints (see Figure 1-16). Often clients can order prints online using the Web gallery and the proof book, which makes it easy for you. When it comes to the wedding book or album, there are more steps involved in completing the final product. There are many useful album-designing tools available that allow you to create the book yourself. Many album companies offer their own in-house software that you can use to help with the process. Pictage.com actually offers a free album design service. You might not like the idea of designing the book yourself; if this is the case, there are plenty of album designing companies that provide this kind of service. If creating the album yourself is not something you enjoy doing, outsourcing that work to a company like Pictage, for example, can help you focus more of your time on other parts of your business that you enjoy more.

1-16

ABOUT THIS PHOTO *Many Web packages allow you to order prints directly from the site.*

Assignment

Capture a Special Moment

Photographing weddings is all about capturing the special moments that unfold throughout the day, and this assignment is to capture one of those special moments and share it on the Web site. Although moments like the ring exchange, the bride and groom exchanging their vows, and the first dance are planned, in those moments real emotions occur spontaneously. The unplanned moments are much harder to catch, but with careful planning, you can be prepared for them when they do happen. Some things that can help when it comes to capturing those special moments include staying focused, always having your camera ready, absolutely pay attention — especially during the ceremony.

Remember that the most special moments are all about the emotion, and that the images that capture this are the images that will stand out with your clients. This image was captured at ISO 2000, f/2.8 and 1/125 of a second and, while it was taken during the ring exchange, it is the emotions on the groom's face that make it a great image. I was watching the scene through the viewfinder and instead of watching the hands, I focused on the face.

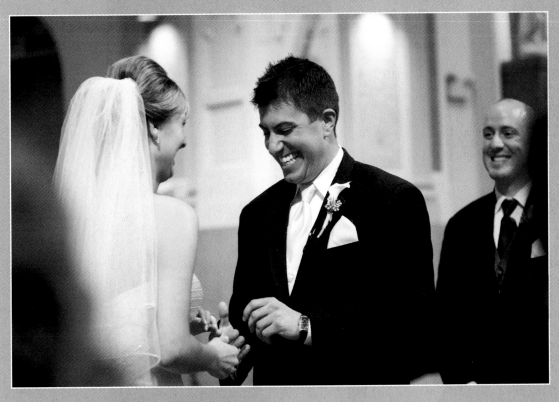

 Remember to visit www.pwassignments.com after you complete the assignment and share your favorite photo! It's a community of enthusiastic photographers and a great place to view what other readers have created. You can also post comments and read encouraging suggestions and feedback.

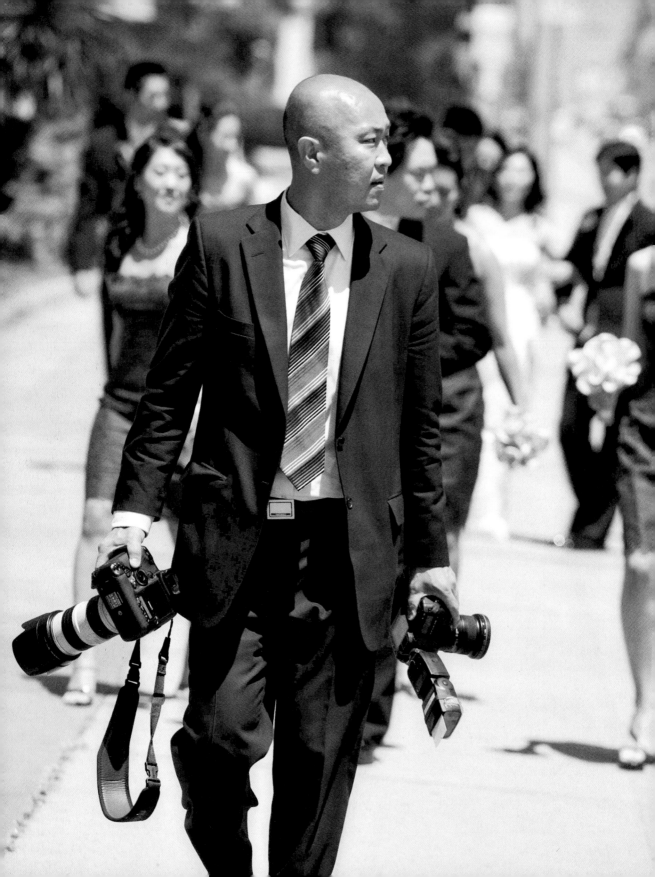

GETTING THE MOST OUT OF YOUR GEAR

CAMERA

LENSES

LIGHTING TOOLS

ACCESSORIES

One of the most common questions you will ask yourself when you are deciding whether to get into wedding photography is, "What gear do I need to purchase to get started?" Obviously, you need basic tools such as a camera and a lens to make photographs. But can any camera and lens work or do you need special equipment to get the job done? With so many brands, options, and choices available, it can be overwhelming to decide what gear to buy. The answer to that question lies in your dedication to wedding photography and whether it is a full-time career or a weekend or part-time job. My wedding photography gear, shown in Figure 2-1, might seem like a lot to some but will look sparse to others. As with most tools, there are

differences in price and capability, and the final decision on what gear to use should be something you are comfortable with. As you grow as a photographer, you will add new gear and sell or retire old gear. It pays to be familiar with the advances in the system you use, be it Canon, Nikon, or another camera manufacturer.

CAMERA

There are a great many cameras on the market and it seems like there are more coming out every month. When it comes to picking a camera for wedding work, here are some things to keep in mind:

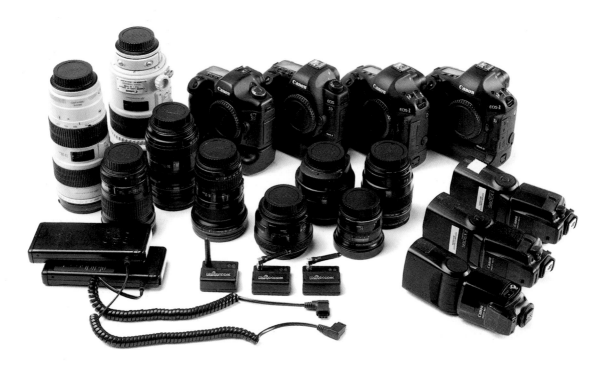

2-1

ABOUT THIS PHOTO *Cameras, lenses, flash units, batteries, and radio triggers are all part of my wedding photography gear.*

■ **Megapixels.** Digital cameras use a sensor to capture the image instead of film, and then the image is stored on a memory card. The megapixels refer to the number of image sensor elements on the sensor, and the more megapixels, the greater the resolution of the images. The megapixel count was more important when digital cameras first became mainstream and it seemed like the megapixels were doubling every six months. A camera with 10 megapixels or more is absolutely sufficient for photographing weddings (and most other types of photography).

■ **Full-size versus cropped sensor.** There are two sizes of sensors in digital cameras: those that are the same size as a traditional 35mm piece of film (full size) and those that are smaller or cropped. Neither one is inherently better or worse than the other, but there are some things to know about using a cropped sensor. Because the cropped sensor is smaller than the full-frame sensor, it records less of the image compared to a full-frame sensor with the same lens. This means that the wide-angle lenses don't seem as wide, and the telephoto lenses seem to have a greater reach. The simple solution to figuring out what the effective focal length is for a cropped sensor is to multiply the focal length by the crop factor. For example, if your camera sensor has a crop factor of 1.5x, a 50mm lens acts like a 75mm lens, a 20mm acts like a 30mm lens, and a 200mm acts like a 300mm lens. Not all cameras have a 1.5x crop factor, so check your camera manual for the specification for your cameras.

■ **High ISO/low noise capability.** The newer cameras have better high ISO/low noise capabilities than ever before, which means you can use ISOs of 1600 and 3200 with confidence and without having to worry too much about digital noise, as shown in Figure 2-2. This is really helpful for wedding photography, especially when you are shooting indoors in darker churches and buildings when using a flash is not allowed.

■ **Rugged construction.** Cameras are tools, and while you should clean them and take care of them, they still need to stand up to a fair amount of use and abuse. The better the camera is built, the longer it will last. For example, the professional series of Canon cameras includes cameras such as the Canon Mark 1D Mark III, with weather sealing and magnesium alloy construction, which is lighter than but just as rigid as aluminum making it really durable.

■ **Autofocus capability.** Autofocus is really useful but only when it actually works. Some cameras have better autofocus capabilities than others, and it is something to check out when considering a camera. Many times the autofocus will work great in bright light but have problems when trying to focus in low light.

> **tip** Renting a camera before buying it can help you to decide how well the camera works in a variety of lighting environments. Check out www.lensprotogo.com as a good source for online rental of gear.

ABOUT THIS PHOTO *Photographing the bride getting ready without using a distracting flash can mean using very high ISOs like I did in this image where I needed to use ISO 3200, but there is still very low noise. Taken at ISO 3200, f/2.8, 1/250 second.*

2-2

■ **Vertical grip/extra battery pack.** Many cameras have the capability to use an extra grip and battery pack, which makes the camera body larger, as shown in Figure 2-3. While the extra expense and the extra size and weight might make you pass on this accessory, it really is very helpful to have. The extra battery power means that there is less chance you will run out of battery power during the shoot.

There are no second chances when shooting a wedding. There is only one opportunity to get the first look or that ring exchange, so it is imperative that your camera is in good working order; and while all cameras can have problems, the professional lines of cameras from the top camera manufacturers cost more but are built better and, therefore, are more reliable. This gives you the peace of mind that your camera will be in good working order when you need it. Full-time wedding photographers always carry a second camera body, and many even have a third backup body just in case something goes wrong.

Camera manufacturers know that the pros demand a product that must be reliable and be able to take a few knocks and still continue working. Weddings often have a large number of guests to work around and a variety of locations to shoot in, and your gear needs to stand up to the heavy use and possibly abuse. When shooting in a crowd, as shown in Figure 2-4, you will want to make sure your equipment can handle the knocks.

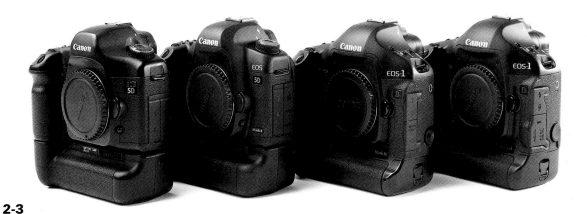

2-3

ABOUT THIS PHOTO *You can see that the extra battery/vertical grip on the two Canon EOS 5D cameras makes them the same size as the two EOS 1D and gives them roughly the same battery life.*

ABOUT THIS PHOTO *When you are shooting right in the thick of things, a pro camera body is something that you can rely on. Taken at ISO 2500, f/2.8, 1/140 second.*

That isn't to say that consumer cameras aren't up to the challenge, but they are not designed to be as tough as the professional models. For example, weddings often take place outdoors, and to get the shot, your camera is exposed to the elements. In Figure 2-5, water and sand were present, two things that can do real damage to a camera if it is not sealed against the elements like professional cameras are. Many consumer-level cameras simply are not able to hold up through the different locations and environments that a wedding photographer shoots in every weekend of the year.

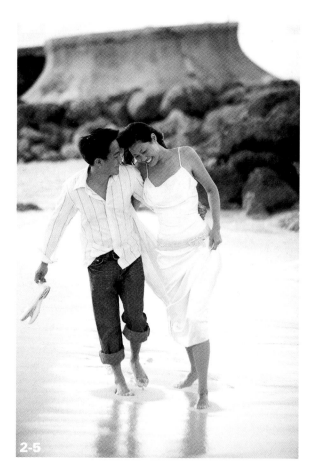

2-5

ABOUT THIS PHOTO *When shooting outdoor weddings, your gear can be exposed to the elements, like it was here at this wedding in the Bahamas right on the water. Taken at ISO 800, f/2.8, 1/200 second.*

Just as you should dress professionally, you should also use professional-level equipment to capture the essential shots you need. At today's weddings, even some of the guests bring professional gear. You will want to make sure your equipment is up to par with theirs, if not better.

LENSES

It is really important to invest in good lenses or "good glass." While camera technology seems to improve year after year and there always seems to be a newer and better camera to buy, a great lens can last a lifetime.

The first feature of a lens to look at is the focal length. The focal length is important because it determines the angle of view of a lens. The greater the focal length, the narrower the angle of view, which means less of the area in front of the camera will be in the scene. Alternatively, things that are far away, or seem to be taking up very little area in front of the camera, appear to be closer when viewed through a lens with a long focal length. In practical terms, the bigger the number, the closer things appear. To photograph items that are far away, it takes a longer focal length, while getting a wide view requires a shorter focal length.

Lenses are divided up by the focal lengths they cover, from the wide angles to the telephoto views. None is better or worse than any other, but you need to use the right lens for the situation to get the best results.

WIDE-ANGLE LENSES

Wide-angle lenses are those where the focal length is wider than 50mm on a full-frame sensor or 35mm on a cropped sensor. This allows you to capture much larger scenes, as shown in Figure

2-6. Wide-angle lenses work great when you need to get everything in the same frame, but there are some drawbacks because they can cause distortion in your images.

There are two distinct types of distortion to watch out for when using wide-angle lenses. The first is that objects that are in the foreground, that is, closer to the lens, can appear to be disproportionately bigger than objects that are in the mid-ground or background; and the things in the background, like the couple in Figure 2-7, can seem very far away. This is called *wide-angle distortion* or *extension distortion*. The second is that as objects get close to the edge of the frame, they can seem to curve, when in reality they are straight, which is called *barrel distortion*. Today's wide-angle lenses are built to minimize this distortion as much as possible, but it does still exist. Fisheye lenses are extreme wide-angle lenses where the image distortion is very noticeable. The curving of the edges of the frame is part of the look when using a fisheye lens and care needs to be taken that you don't cause an unwanted distortion to the subject.

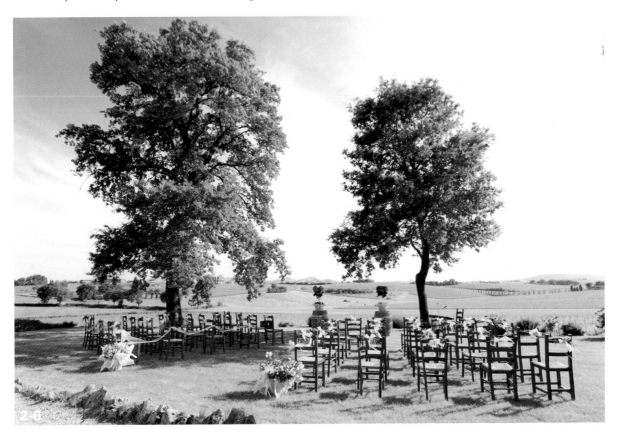

ABOUT THIS PHOTO *Capturing the whole wedding location in a single frame takes a wide-angle lens. Taken at ISO 200, f/8.0, 1/320 second.*

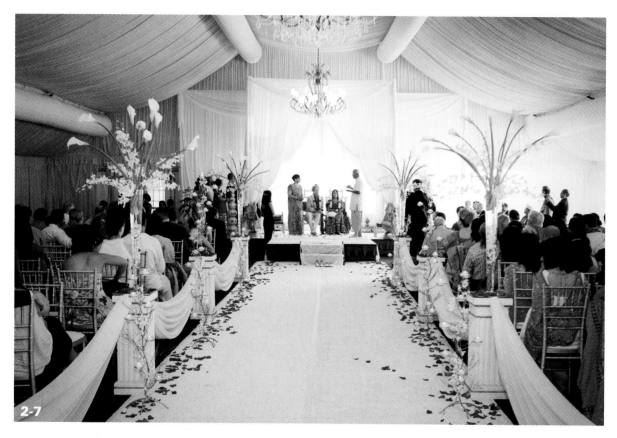

2-7

ABOUT THIS PHOTO *A wide-angle lens can make your location look very large, because objects in the background appear to be very far away. Taken at ISO 1600, f/2.8, 1/125 second with a 16-35mm Canon lens set to 35mm.*

Even with the distortion problems that can occur, a wide-angle lens is really important when you are photographing a wedding because it is usually the only way to get the whole scene into a single image, and most clients will want that type of shot.

NORMAL LENSES

Normal lenses are those that capture the scene in front of the camera roughly the same way that the human eye views the scene. This is about 50mm focal length on a full-frame sensor and 35mm on a cropped sensor. The advantage to shooting at these focal lengths is that the scene will seem to have the correct perspective and look normal to the viewer. In Figure 2-8, the groom and his groomsmen look very natural when shot with a normal focal length as they pose on the stairs. There is no distortion on the sides of the image, and everyone looks exactly the way they did when the shot was taken.

ABOUT THIS PHOTO

I shot this great group shot using a 24-70mm f/2.8 lens at 42mm, which is roughly the same view as the human eye. If you were standing in my location, this is how the people would look. Taken at ISO 800, f/4.5, 1/160 second.

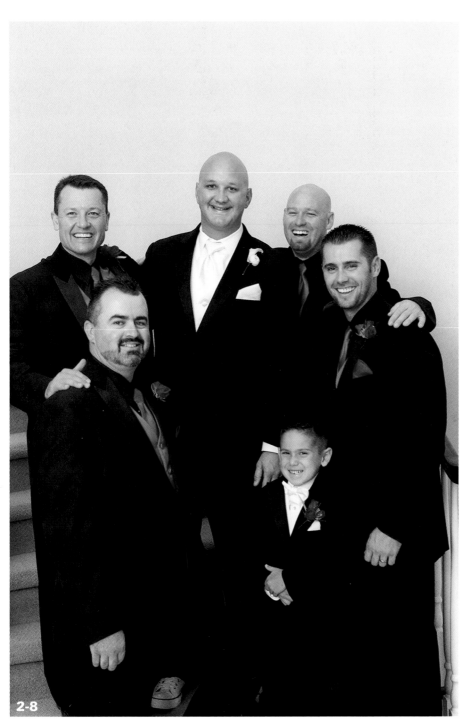

2-8

ABOUT THIS PHOTO
Being able to capture the emotion on the faces of the subjects is important, and being able to do it without intruding is where a telephoto lens comes into play. Taken at ISO 1600, f/2.8, 1/125 second with a 70-200mm lens.

2-9

TELEPHOTO LENSES

With telephoto lenses, you can get in close and fill the frame with the subject without having to physically intrude into the moment. In Figure 2-9, I was able to get in close, capturing a great moment without invading it. Telephoto lenses have focal lengths that are longer, in some cases much longer than normal lenses.

Telephoto lenses can cause some distortion by compressing the scene. Items in the background seem much closer to the foreground. This compression can cause areas that should be wide open to appear a little cramped. Look at the couple in Figure 2-10, who were captured as they walked down a path, and notice how close the tree behind them seems; in reality, it was much farther away. This is known as compression distortion.

ABOUT THIS PHOTO *The couple captured with a telephoto lens, which caused some compression, as they walked down a path. Taken at ISO 2000, f/3.5, 1/200 second with a 70-200mm lens set to 200mm.*

2-10

FIXED FOCAL LENGTH

These are lenses that have a single focal length, and while they don't offer the versatility of a zoom lens, there are still good reasons to have a couple of these in your wedding camera bag. The first reason is that they can have a maximum aperture that is greater than any zoom lens, which allows them to be used in much darker areas. Because of this, they can also have a very shallow depth of field, making them great for creative blurring, as shown in Figure 2-11. Another plus is that fixed focal-length, or prime lenses, as they are also known, can be cheaper than a zoom equivalent, but not always.

ZOOM LENSES

Zoom lenses are really great because they allow you to cover a wide range of focal lengths without having to change anything on your camera. Zoom lenses are great tools for wedding photographers because you can capture the same scene in different ways very quickly and without having to actually move.

2-11

ABOUT THIS PHOTO *The sharp focus and shallow depth of field are possible with a 50mm f/1.2 lens used at f/1.8. This allowed me to make sure that the focus of the photo was the man preparing his speech on the right as opposed to the group of men on the left. Taken at ISO 2500, f/2.8, 1/320 second.*

The three zoom lenses I use are shown in Figure 2-12 and are as follows:

- Canon 16-35mm L f/2.8
- Canon 24-70 f/2.8 L USM
- Canon 70-200mm L IS f/2.8

Combined, these lenses give me a focal length range from really wide at 16mm to telephoto at 200mm, and because they are all constant aperture lenses, my maximum aperture for all the focal lengths is f/2.8. Although they cost significantly more than some other lenses, having the f/2.8 maximum aperture makes a big difference in helping you obtain professional-quality results with your photographs.

CONSTANT APERTURE VERSUS VARIABLE APERTURE LENSES

Zoom lenses come in two very different types, and it is important to know which one you have and are using because it can drastically change the exposure settings. With constant aperture zoom lenses, it doesn't matter what focal length is being used; the maximum aperture stays the same. These constant aperture zoom lenses are usually considered professional-quality lenses and come with a larger price tag, but there are two big advantages to using them. The first advantage is that the aperture doesn't change when you are zooming in or out, meaning that your exposure

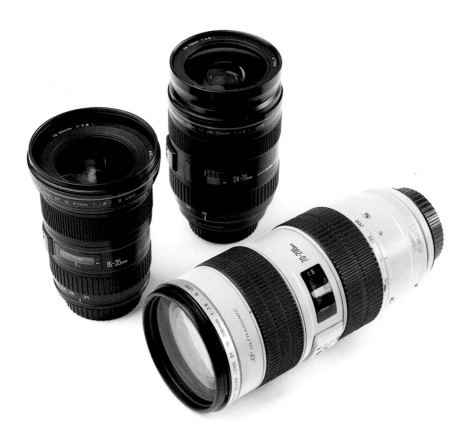

2-12

ABOUT THIS PHOTO
The three main zoom lenses in my wedding camera bag.

settings won't change when you change focal lengths (as long as the light doesn't change). I was able to set the exposure settings for Figure 2-13, and because it was a constant aperture zoom lens, I was able to zoom in and out until my composition was what I wanted without worrying about the exposure settings changing. The second

2-13

ABOUT THIS PHOTO *When photographing the bride on the stairs, I set the camera to manual mode and used the zoom on the 24-70mm lens to compose the image. Because the lens has a constant aperture, the opening in the lens didn't change as I adjusted the focal length, allowing me to concentrate on the composition. Taken at ISO 1250, f/2.8, 1/160 second.*

advantage is that these zoom lenses usually have a wider maximum aperture than the variable aperture counterparts, so they are better for low-light situations, and you have more control over the depth of field.

The variable aperture lenses are those lenses where the maximum aperture changes as the lens changes focal lengths. So as the lens zooms in close, the maximum aperture gets smaller, meaning that you need to adjust your exposure settings constantly if shooting in manual mode. (If you are shooting in any mode other than manual, the camera will adjust the exposure settings.) The advantages to these lenses are their price — they are considerably cheaper than their constant aperture counterparts — and their size — they are much smaller than the constant aperture counterparts. If this is the type of lens you have and are using, then you need to pay close attention to your exposure settings as you zoom in and out.

LIGHTING TOOLS

As a photographer, one thing you always have to think about is finding a good light source. Without good light, no matter how good your gear is, you are not going to get great results. There are times when you need to create the light or at least modify the light in the scene to get a proper exposure or to even out the light that is already there. This is when a few flashes can really save the day. Even in a very dark room, a few properly placed flashes can get results like the image shown in Figure 2-14, where the cake came out looking good enough to eat.

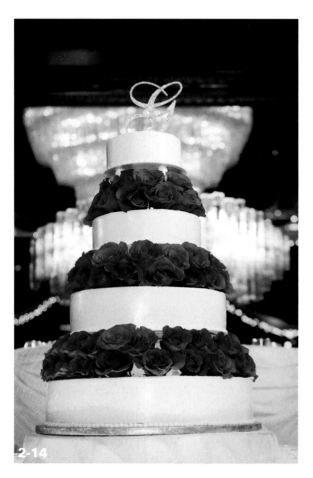

2-14

ABOUT THIS PHOTO *Even though the reception room was almost pitch black, I was able to evenly light this wedding cake using multiple flashes, and it would have been impossible to get the photo any other way. Taken at ISO 1600, f/3.5, 1/50 second.*

My entire lighting kit, shown in Figure 2-15, isn't very big, but it is powerful and best of all, it is portable, so I can use it quickly and efficiently. The kit includes a number of flash units that can be used on or off camera, a selection of light modifiers for the flashes, some extra battery packs, and a set of radio triggers called radiopoppers that allow the flashes to be used off camera easily. I

also carry a few small light stands that allow me to place the off-camera flashes where they can do the most good.

FLASH

One of the easiest ways to add a little light when needed is with a flash. That's when the flash units come into play. Every camera manufacturer makes a dedicated flash unit for its system, for example the Canon Speedlite system or the Nikon Speedlights. These flash units are compact and powerful, a great combination for use on location. Most of the flash manufacturers also have external battery packs available for their flash units. For example, I use the Canon CP-E3 battery packs with the Canon Speedlites. These battery packs allow for faster recycling time for the flashes (meaning the time between flashes is reduced). Also, because the battery packs have a lot more power, I can shoot an entire wedding without needing a fresh set of batteries. Each manufacturer has a range of flash units to pick from that differ in power, size, features, and price. Here are a few things to consider when choosing a flash:

■ **Power.** Not all flashes are created equal. To determine the power of the flash, you need to look at the guide number. The guide number is the measurement of how powerful a flash is taken by measuring the illumination using a standard set of criteria. The important part is that the higher the guide number, the more powerful the flash. The more powerful the flash, the more options you have when using it.

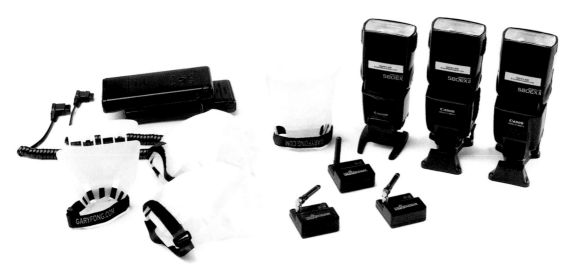

2-15

ABOUT THIS PHOTO *The Canon Speedlites along with a variety of light modifier tools, extra battery packs, and a set of radiopopper flash triggers.*

> **tip** Even when you are using battery packs, it is still good practice to have an extra set of batteries as a backup.

- **Size.** These flash units are tiny compared to the studio type of lights, making them easy to pack and carry on location.

- **Features.** Look for a flash that has the ability to rotate the flash head and adjust the power (flash output) manually. This gives you the most use out of the flash. Many of the cheaper flash units don't have an adjustable flash head, making them impossible to aim or adjust.

- **Price.** Flashes can be rather expensive, but you are better off getting a better flash for more money than getting a cheaper flash that will need replacing when the limitations in power or features become a problem.

The real power of the flash unit is that it can be used both on the camera and as an off-camera light when mounted on its own light stand and triggered by a master flash on the camera or a remote trigger. This flexibility allows you to add the light exactly where it is needed and gives you control over how much light is used in the photograph. Using a single flash to help balance out the light in Figure 2-16 made for a better image, and the gentleman giving the toast and the background are both properly exposed.

Using one accessory flash on your camera might help add light to the overall scene, but to really take your photos to the next level, you need a little more control. With three flash units — two off-camera for extra fill where needed and one on the camera for a little extra light and to trigger the two off-camera units — you can really control the placement of the light.

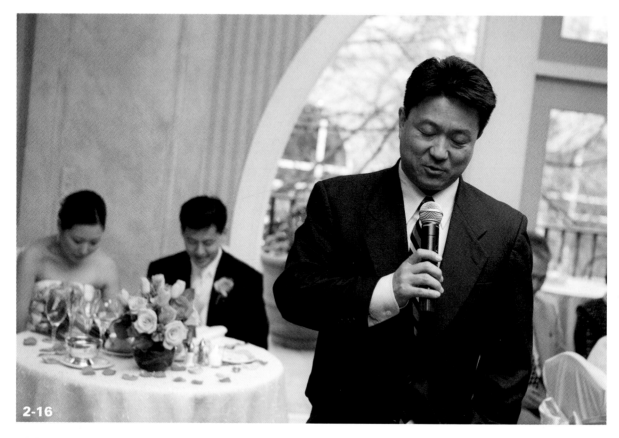

2-16

ABOUT THIS PHOTO *Using a flash here helped to balance out the bright light that was coming in through the windows behind the speaker. Taken at ISO 640, f/3.5, 1/80 second.*

LIGHT MODIFIER TOOLS

The biggest drawback with using accessory flash units comes from their size: Because they are small, they produce a very small hard light that is not very flattering for wedding portraits. This is where some light-shaping tools can really help to make that small hard light into something a little more flattering. In Figure 2-17, a diffuser was used on the flash to create a softer light and a more pleasing portrait.

The rise in use of small flash units has created a large market for small flash modifiers. These are tools that change the size and quality of the light produced by the small flash. The basic concept is

the same with all of them as they try to turn a small hard light source into a bigger, more flattering light source.

The good news is that there are many options available for modifying the light produced from small flashes, including small softboxes from LumiQuest, such as the Soft box LTp, which is 120 square inches of surface area (making it over 40 times larger than the flash head). These modifiers can be easily attached to the flash using a hook and loop type fastener and when not in use can fold flat. Other options are the light modifying tools created by photographer Gary Fong, including the Lightsphere and the Whaletail

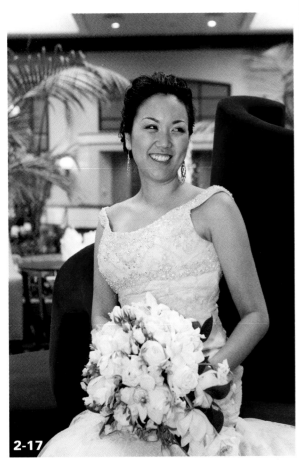

2-17

ABOUT THIS PHOTO *Creating a softer, bigger light from your flash really helps with portraits because the softer light is much more flattering. This was taken at ISO 1250, f/4, 1/160 second.*

modifiers. These tools produce a more pleasing light by diffusing the flash, but they are also compact and don't add much size or weight to the flash unit.

One of the goals of all light modifiers is to take a small hard light and create a bigger, softer light. Keep in mind that given that modifying the light output usually involves covering the flash head, you might have to increase the power to get the right amount of light into the scene.

> **tip** Using the same flash units for all your flashes means that any modifier you buy will work on all the flash units you have.

ACCESSORIES

You have your camera, lenses, flash units, and a set of light modifiers, and you are all ready to go out and shoot a wedding. However, there are a few more pieces of equipment that can really make the whole process much easier. These include light stands for placing off-camera flash units where you need extra light and a set of radio triggers so that the flashes fire no matter where they are. Finally, it is important to have a bag to carry all your gear in.

- **Light stands.** One important accessory is a set of lightweight light stands. These allow you to place your flash units where you want them and they can do the most good. Figure 2-18 shows two of my speedlites mounted on a set of lightweight stands. When it comes to picking out light stands, look for ones that can fold up easily and don't take up much space. Because these are not going to be holding up studio lights, just the much smaller and lighter flash units, they really don't have to be very heavy duty.

- **Radio triggers.** Most of the flash systems available today allow you to use a master flash to trigger the off-camera flash units. The downside to this is that the flashes usually have to see each other, meaning that the receiver on the off-camera flash has to face the camera to work. A great solution to this is to use a set of radio triggers that are not line-of-sight. You can see the radio triggers

(radiopoppers in this case) attached to the lights in Figure 2-18. These triggers allow the off-camera flash units to be triggered no matter where they are, even out of sight of the main flash and the photographer.

■ **Camera bags.** There are a great many camera bag manufacturers, and an even bigger number of different camera bags. Find one that protects your gear and is comfortable enough to carry around all day. One that I like to use is made by Think Tank Photo (www.think tankphoto.com). The bags are made by photographers with photographers in mind. I love their durability, design, and the variety of storage spaces. The two cases I use the most are shown in Figure 2-19, and they keep my wedding photography gear safe and sound.

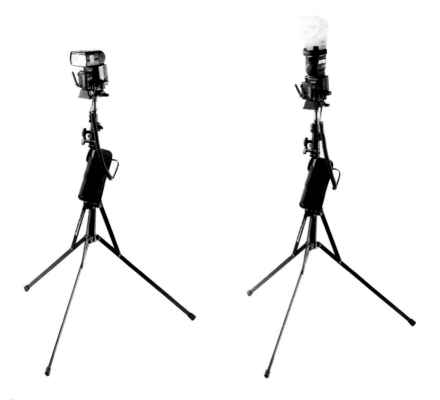

2-18

ABOUT THIS PHOTO *Putting a small flash unit on a light stand allows you to place it where it can do the most good. Here, triggers (www.radiopoppers.com) are attached.*

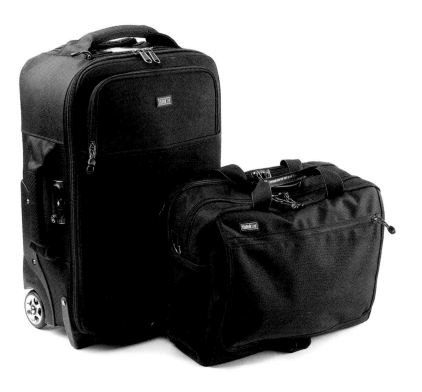

2-19

ABOUT THIS PHOTO *I use these camera bags from Think Tank Photo and really like the size and weight of the pair.*

Assignment

Same Scene, Different Focal Lengths

One of the easiest ways to learn about different focal lengths and how a wide-angle or telephoto lens can cause distortion is to shoot the same scene using two different focal lengths, preferably two very different ones.

There are two methods to try here: The first is to stay in one spot and photograph the scene in front of you using a variety of focal lengths to see how much of the scene you can capture and how the location you shoot from affects your subject. Remember that when you are using a wide angle, things in the foreground seem closer while things in the background seem farther away; and when you are using a telephoto, the background is compressed. The second method is to move so that as you change focal lengths, the subject stays the same size. This method will help show you how different focal lengths can change how a person looks and how the background will be very different depending on the focal length. Try both methods and post your favorite shot to the Web site.

The choice of focal length is really important in rendering the scene in the best way possible; a wide angle can really make a small room look very large. Using a very wide angle, in this case a Canon EF16-35mm lens at the 16mm focal length, allowed me to capture the whole room in a single frame. The use of the wide-angle lens also creates a feeling of space due to the wide-angle distortion. Another reason to use a wide-angle lens was that there was limited space to photograph from. Standing in the corner meant that I could not back up any farther, and a longer focal length would have meant cropping the sides.

 Remember to visit www.pwassignments.com after you complete the assignment and share your favorite photo! It's a community of enthusiastic photographers and a great place to view what other readers have created. You can also post comments and read encouraging suggestions and feedback.

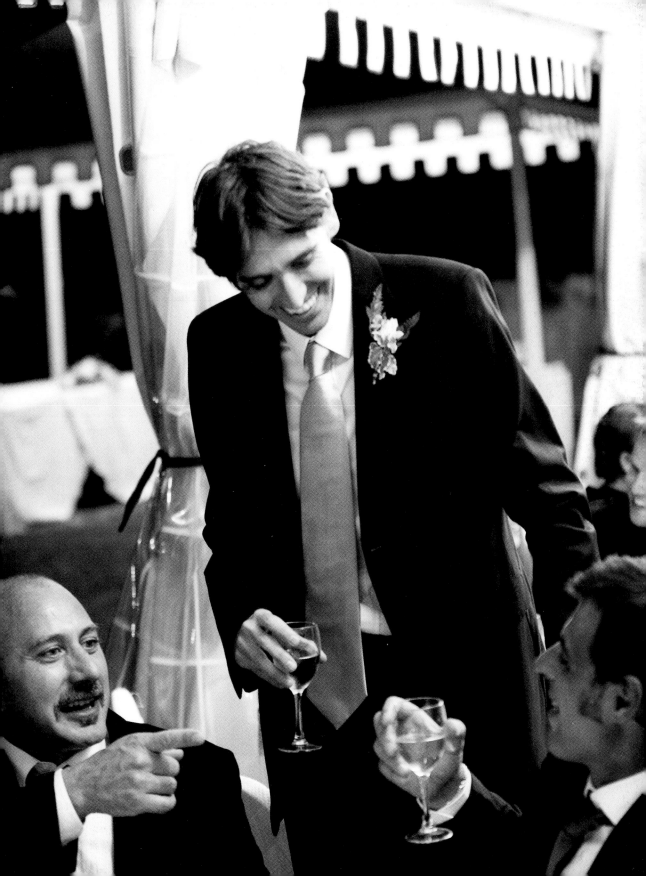

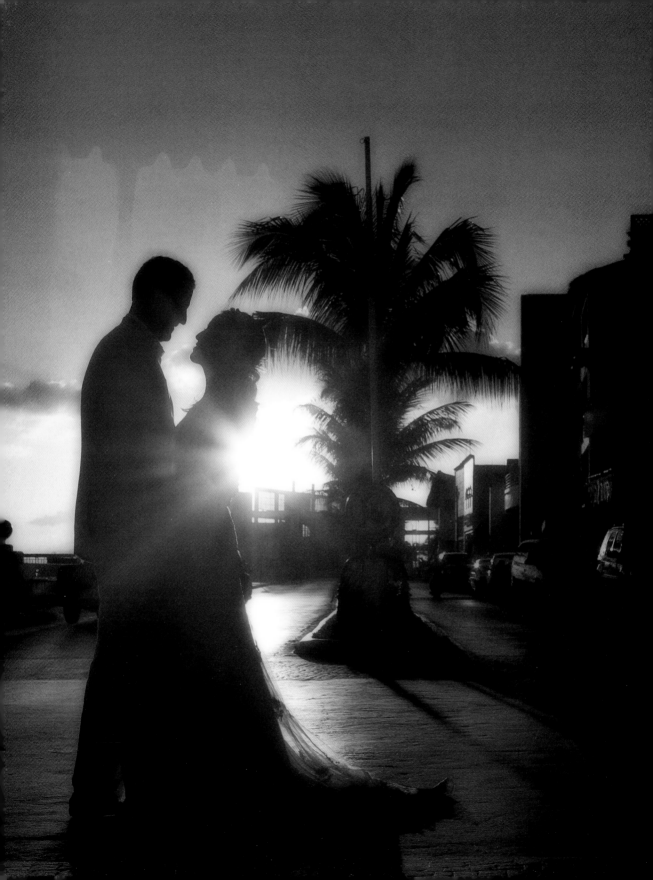

EXPOSURE AND COMPOSITION

The basic elements that make up a photograph are *exposure* and *composition*. The exposure is how much light is captured by your camera's sensor. You control the amount of light that is captured by setting the shutter speed, aperture, and ISO. The goal is to have the right amount of light reach the sensor so that the image captured isn't too bright or too dark. The composition of your images includes where you place the elements in your photograph and, just as important, what you include and exclude when you press the shutter release button as you can see in Figure 3-1. This chapter covers the basics of both exposure and composition and looks at some of the challenges you encounter with wedding photographs.

EXPOSURE

A photograph is created by capturing light. Your camera and lens are the tools used to capture that light. As the photographer, your job is to control the amount of light that reaches the sensor. The basic controls that manipulate exposure are *shutter speed* (the length of time the shutter is open to receive light), *aperture* (the size of the opening in the lens that lets light reach the sensor) and *ISO* (the sensitivity of the sensor), but before you can pick the settings to use, the light in the scene has to be measured.

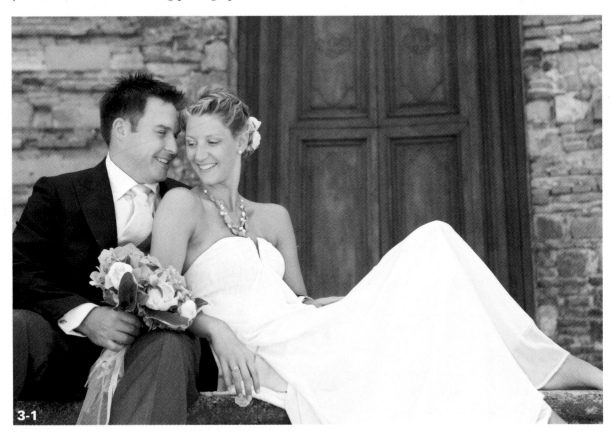

3-1

ABOUT THIS PHOTO *Getting the exposure right is really important, especially when it comes to photos of the bride and groom in their wedding attire. The photograph needs to show both the bright white of the dress and the deep dark areas of the tuxedo. The composition is what makes the image stand out. Taken at ISO 250, f/4, 1/500 second.*

METERING A SCENE

It is imperative that you are able to read the light in any given scene, and the tool you use to do this is a light meter. The good news is that your camera has a built-in light meter that takes a reading of the light through the lens. This allows the camera to measure the light in your scene and only the light in your scene. The light meter in your camera reads the light that is reflected back in the scene and is called a reflected light meter for this reason.

When the light meter reads the light, it tries to determine what the overall brightness of the scene is, and then uses this information to suggest what combination of ISO, shutter speed, and aperture is needed to get a good exposure. The problem arises when you realize that the camera doesn't actually know what the subject of your photo is. The computer in the camera takes the readings from the light meter and tries to pick the correct exposure. This usually means that the light meter readings are averaged out, creating a setting that will try to get the average light in the scene. This works for a lot of photo subjects but not all, and there are certain circumstances where this doesn't work at all. Those exposure challenges, such as scenes that have a lot of very light colors like a bride in a wedding dress, can cause the camera's light meter to underexpose, making everything look too dark; and very dark scenes, such as a groom in a tuxedo, can cause the light meter to overexpose, making the image too light. (How to overcome these challenges is covered a little later on in this chapter.)

Most camera manufacturers have given you not one, but three choices when it comes to using your camera's built-in light meter: spot metering, center-weighted metering, and a scene metering mode. For Nikon cameras, the scene metering mode is called Matrix metering and for Canon cameras it's called Evaluative metering, while

Sony calls it Multi-segment metering. Each of these modes has its place depending on the subject being photographed. The spot-metering mode looks at a very small part of the overall scene and ignores the rest, and on the newer cameras, this spot meter area is taken from the area that you are focusing on (see Figure 3-2).

Center-weighted metering reads the light from the center spot-metering area and looks at the surrounding area as well, but pays more attention to the center area. Center-weighted metering pays less attention to the values at the edges of

3-2

ABOUT THIS PHOTO *Because the couple is only a small part of the scene, a spot metering reading on them is important to make sure that the light being read by the camera is only from the subjects. Taken at ISO 200, f/5, 1/400 second.*

ABOUT THIS PHOTO *Using center-weighted metering allowed for the important elements of the scene to be read, but the areas toward the edges were ignored, especially the area of very bright sky that is overexposed at the top of the image. (However, the subject is correctly metered.) Taken at ISO 800, f/3.5, 1/250 second.*

the scene and is usually used for portraits where the subject doesn't fill the whole frame. It pays less attention to the surrounding edges because they aren't as important as the actual subject. As you can see in Figure 3-3, the area of very bright sky is overexposed and has turned completely white because it was not used in the exposure calculation. If it had been, then the rest of the image would more than likely have been underexposed, but leaving detail in the sky. The third metering mode is the scene metering mode, which looks at the whole scene but pays special attention to the focus area and tries to determine the best exposure (see Figure 3-4). One way that camera manufacturers are trying to improve the scene metering modes of their cameras is by using a database of images and comparing the meter readings to that database, which in turn allows the camera to actually guess at the subject being photographed, which increases the odds that the exposure setting will be the right one for the scene.

When it comes to wedding photography, all these metering modes are useful, depending on the situation. What really starts to matter is what you do with the information that the camera receives from its built-in light meter and how to use it to get the best exposure for any situation. The information from the light meter is used to show you what the camera believes the correct exposure is and whether the current settings are going to overexpose or underexposure the scene. The camera also uses these settings to determine the aperture and shutter speed, depending on the exposure mode of your camera. The four most important exposure modes on your camera and how they are affected by the light meter are as follows:

■ **Full auto mode.** In this mode, the camera sets both the aperture and the shutter speed, and in certain cases, the ISO as well, to capture the right amount of light to get a proper

3-3

exposure. You have very little control over the settings, and this might be a great mode to use when you just start taking photos, but not so great if you want to control the exposure yourself.

■ **Shutter speed priority.** In this mode, you set the desired shutter speed, and the camera then sets the aperture depending on the light meter reading.

■ **Aperture priority.** In this mode, you set the desired aperture, and the camera then sets the shutter speed depending on the light meter reading.

3-4

ABOUT THIS PHOTO *When you have a scene that has no real bright spots or dark spots and the tone is pretty constant, then the scene metering works well to get the proper exposure. Taken at ISO 400, f/3.5, 1/500 second.*

■ **Manual mode.** In this mode, you set the shutter speed and the aperture, and all the camera does is suggest what the correct exposure should be. While it can be intimidating, it gives you the most control over the exposure.

SHUTTER SPEED

Photography is about capturing a moment in time, and the shutter speed is what controls how long that moment is. The shutter speed controls how long the shutter is open, allowing light to reach the sensor when the shutter release button is pressed. The faster the shutter speed, the less light is allowed to reach the sensor, while the longer the shutter speed, the more light is allowed

to reach the sensor. The shutter speed is described as a fraction of a second, usually as 1/250, 1/125, 1/60, 1/30, 1/15, and so on. Each time you double the shutter speed, twice as much light is able to reach the sensor. When you halve the shutter speed, half as much light is able to reach the sensor.

When the subject of your photo is moving, you need to decide if you want to freeze the action or show the motion.

■ **Freeze the action.** To capture a moment in time, the shutter of the camera opens and closes in a fraction of a second. The faster the subject is moving, the faster the shutter speed needs to be to freeze it. A faster shutter speed,

such as 1/1000 second, freezes the action. This doesn't come into play as much with wedding photography given that most times the subjects are moving relatively slow, but you can still use it to make sure everything is frozen in place, as shown in Figure 3-5.

■ **Motion blur.** There are times when you want to be able to show motion in your photographs. A slower shutter speed, such as 1/15 second, shows motion blur. When you leave the shutter open longer, objects that are in motion in your scene will look blurred, while the objects that are still in the scene remain in sharp focus, as shown in Figure 3-6.

When you shoot using longer lenses, it is also a best practice to use faster shutter speeds so that any small camera shaking that happens does not affect sharpness of the image. This *camera shake* can happen when you handhold a camera at too slow of a shutter speed. At longer focal lengths, not only is the subject magnified but the camera shake is magnified as well. The simple rule to avoid camera shake is to use a shutter speed that is 1 divided by the focal length of the lens. For example, if you use a 200mm lens, the minimum shutter speed should be 1/200 second.

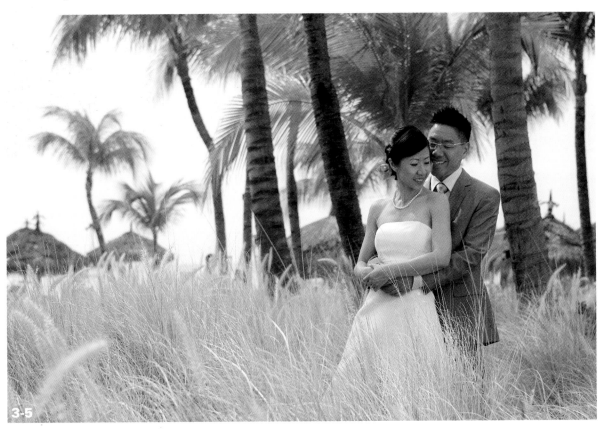

ABOUT THIS PHOTO *When shooting outside in bright sunlight, you can use high shutter speeds and freeze all movement. This outdoor shot was taken using 1/1000 second and froze everything, even the movement of the grass. Taken at ISO 200, f/5, 1/1000 second.*

3-6

ABOUT THIS PHOTO *Using a rather slow shutter speed of 1.5 seconds allowed the motion of the people around the kissing couple to be seen. Having the bride and groom hold still allowed them to stay in focus and not blur. Taken at ISO 200, f/8, 1.5 seconds.*

APERTURE

The aperture is the opening in the lens that light passes through as it travels to the sensor. The size of the opening determines how much light can pass through it at any time. A bigger opening allows more light to reach the sensor, and if the opening is made smaller, less light reaches the sensor. Because the aperture is the opening in the lens, the available apertures that you have to work with are dependent on which lens is attached to your camera.

x-ref

Refer to Chapter 2 for more information on how the lens and aperture are related.

The size of the opening is referred to as an f-stop, which is a mathematical way of describing the opening, and it is written as f/1.4, f/2, f/2.8, f/4, f/5.6, f/8, f/11, and so on. Each of the f-stops is related to the one next to it in a very important way — it lets in exactly twice as much or one half as much light, depending on which way you change it. So if you are using f/4 and you change

to f/5.6, the amount of light let through is halved, but if you change from f/4 to f/2.8, then the amount of light let through is doubled. Most of the cameras available today allow you to adjust the aperture in 1/3 or 1/2 increments. You can check your camera manual for how to set this on your camera.

Changing the f-stop results in more or less light reaching the sensor, but this action has other consequences as well: Most important, it changes the depth of field.

The *depth of field* (DOF) is the area in front of and behind the subject that appears to be in acceptable focus. By controlling the depth of field, you can control how much of the image seems to be in focus. The area that is affected starts one third in front of and continues two thirds behind the actual focus point. When you use a large aperture (smaller f-number), the area is very small, creating a shallow depth of field, and when you use a small aperture (large f-number), the area in acceptable focus is larger, creating a deep depth of field.

The depth of field control is one of the most important controls in photography because it allows you to control what is in focus and what isn't, which in turn allows you to dictate what the subject of the image is. To make the wedding rings and the hands holding them the focus of the photograph in Figure 3-7, I used a very shallow depth of field.

Another factor that plays a part in the depth of field is the distance between the camera and the subject of the photo. The greater the distance between the camera and the subject, the greater the depth of field area, while moving the camera in really close creates a shallower depth of field.

There are times when a deep depth of field is called for and, when it comes to weddings, this is usually when you are shooting the group portraits, especially if the subjects are posed at different

3-7

ABOUT THIS PHOTO *By using a very large aperture, in this case f/1.8, it is possible to create a very shallow depth of field, making the part of the subject that is in focus really pop out of the background. In this case it is the wedding rings and the hands holding them. Taken at ISO 1000, f/1.8, 1/400 second.*

planes, as shown in Figure 3-8. To keep the whole group in acceptable focus, a deeper depth of field is needed, which can mean that you need to increase the ISO or need to decrease the shutter speed to get the proper exposure with a smaller aperture.

tip — Photographers often use the terms *shooting wide open*, which means to be using the widest aperture available on their lens, and *stopping down*, which refers to making the aperture smaller, letting in less light but increasing the depth of field.

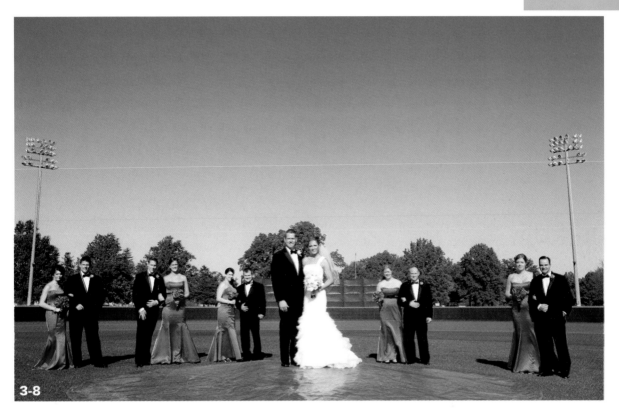

3-8

ABOUT THIS PHOTO *By using a small aperture, in this case f/13, the image has a deep depth of field: The wedding party placed behind the couple and even the lights are in focus enough to make the ballpark location clear. Taken at ISO 100, f/13, 1/160 second.*

ISO

The third setting that goes into controlling your exposure is the ISO. The ISO setting comes from the days of film photography where the sensitivity of the film needed to be standardized. This was so photographers would know how sensitive the film was and could adjust their exposure accordingly, and the same holds true for digital photography. There is a simple logic when it comes to ISO: The higher the number, the more the signal from the sensor is amplified and the less light is needed. Each time the ISO doubles or halves, the sensor is effectively twice as sensitive to light or half as sensitive to light. For example, if you are using an ISO of 800 and change it to 1600, the sensor is now twice as sensitive to light. If you change the ISO from 800 to 400, the sensor is effectively half as sensitive to light.

The only downside to using higher ISOs is that the amplification of the signal can introduce digital noise into your image. This shows up as random, colored dots, especially in areas that should be a smooth tone. This is also one of the areas that camera manufacturers have really improved on in the last few years, and cameras now can produce images that are virtually noise free at higher ISOs than ever before.

> **tip**
> Test the high ISOs on your camera and decide what level of digital noise you can live with, because all camera models are different.

PUTTING IT ALL TOGETHER

The three settings that are used to control the exposure all work together because they use the same measurement when talking about the amount of light: the *stop*. When you double the amount of light, it is called a stop. It doesn't matter if you do that by doubling the size of the aperture or leaving the shutter open twice as long; each change is a full stop and is equivalent. What this means is that you can adjust the exposure using any of the controls interchangeably. For example, because light is measured by stops, you can pick the aperture you want and adjust the shutter speed to make sure the exposure is right. Therefore, if you want to take a photo with a shallow depth of field so that the subject pops off the background, start with an f-stop of f/4, a shutter speed of 1/250 second, and an ISO of 400, which will give the proper exposure. If after you take the photo, you realize that the depth of field is still too deep, open the lens up one full stop to f/2.8. However, now there is too much light coming through the lens and reaching the sensor, so you need to adjust the shutter speed and/or the ISO to get an equivalent exposure. You can remove a full stop of light by halving the time the shutter is open from 1/250 of a second to 1/500 of a second. This will allow exactly half as much light to reach the sensor. You can also reduce the ISO one full stop by changing the ISO from 400 to 200, making it exactly half as sensitive to light.

EXPOSURE CHALLENGES

Weddings come with special exposure challenges, mainly due to the traditional white wedding dress for the bride and dark suit or tuxedo for the groom. Consider the bride in her white dress first. The problem is that when the camera's built-in light meter looks at a scene with a large amount of white or light colors in it, the settings that it recommends usually underexpose the

image, causing the white dress to be gray, not white, which could have easily happened in Figure 3-9. However, because I adjusted the exposure accordingly, the bride is lovely in white, as she should be.

There are a couple of different ways to deal with photographing a scene that is predominantly white, the easiest of which is to use the spot metering setting in your camera and make sure you take the reading from the bride's face. This works in most situations because the light meter

3-9

ABOUT THIS PHOTO *Scenes with a lot of white can really throw off the camera's built-in light meter. This shot of the bride dressed in white in front of the bright white windows can make for a very difficult exposure. Taken at ISO 400, f/4, 1/320 second.*

reading is taken from an area that is not solid or predominantly white. The second method is to shoot in Manual mode and purposely overexpose the image until the whites of the dress have detail, but look white and not grey, as in Figure 3-10. You do not want to overexpose the dress to the point where the detail is lost and the dress just looks pure white.

3-10

ABOUT THIS PHOTO
If the exposure setting were determined by the camera's built-in meter, this bride posed outdoors in a bright white dress lit by direct sunlight would have been severely underexposed, because the camera would have tried to average out the scene to an 18% gray. Taken at ISO 100, f/4, 1/250 second.

To purposely overexpose the image until you have a true representation of the scene takes a little practice, but once you get the exposure correct, you can take a series of photographs without worrying about the exposure changing. The following steps should help you get the best exposure in this situation:

1. **Set the camera to aperture priority mode or the mode that allows you to set the aperture and the shutter speed.**

2. **Set the metering to spot metering.**

3. **Pick the aperture that you want to use.**

4. **Set the focus point on the bride's face.**

5. **Press the shutter release button halfway down to engage the camera's built-in light meter.** Make a mental note of the shutter speed that the camera believes will give a proper exposure.

6. **Adjust the exposure by using the exposure compensation setting on your camera.** Choosing plus numbers will add more light so I recommend starting at +1.

7. **Take a photo.**

8. **Check the photo on the back of the camera.** If the image seems underexposed, then you can increase the exposure compensation; if the image is too bright, then decrease the image compensation.

9. **Take another photo and check the image on the back of the camera.** If you use the blinking highlight warning, then any area in your photo that is pure white will blink. Remember, it is rare that the dress will be pure white, so if the dress is blinking, the image probably is overexposed.

10. **If the image is still too dark, repeat Steps 9 and 10 until the exposure is what you want.**

When it comes to photographing the groom in his tuxedo, or several men in dark clothing, as shown in Figure 3-11, the camera's built-in light meter has a tendency to set the exposure settings to overexpose the image. This is because the light meter suggests exposure settings to create an average, and because most of the frame is filled with

ABOUT THIS PHOTO *Purposely underexposing the scene slightly will render the dark areas correctly while also making sure the skin tones are right. Taken at ISO 800, f/3.5, 1/200 second.*

dark areas, it tries to lighten those areas. This also causes the faces of the groom and the other people to be overexposed, creating a washed-out image.

The solution when shooting dark scenes is to purposely underexpose the scene so that the darks stay dark, or to make sure that you get a light reading that ignores the large dark areas. You can do this by using the spot-metering mode and making sure that the metering area is focused on a part of the image that has a neutral tone, like the groom's face. It is also possible to follow the steps earlier in this section, but instead of overexposing as you would for the bride, you would slightly underexpose for the groom. This means you would increase the shutter speed, or decrease the aperture or ISO. Keep in mind that the groom's tuxedo is probably not pure black, so don't underexpose so much that everything is too dark. When it comes to a mix of very dark and very light areas in the same image, using the spot meter on the face of the bride or groom will work to keep the exposure correct, even in those tough situations, as shown in Figure 3-12.

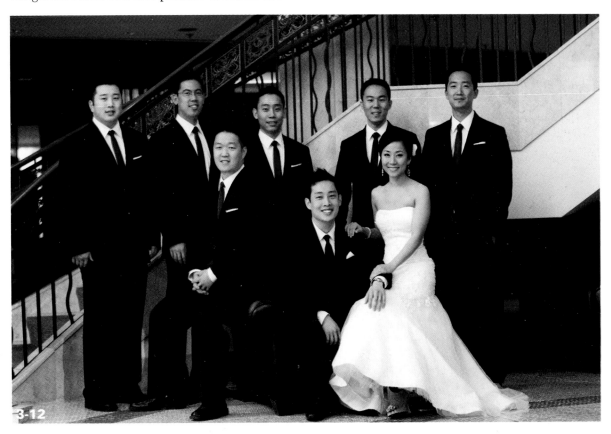

3-12

ABOUT THIS PHOTO *Putting a bride, dressed in her beautiful white dress, among the groom and his entourage, all dressed in dark tuxedoes, can be a challenge that spot metering can help you overcome. Taken at ISO 1600, f/2.8, 1/250 second.*

COMPOSITION

The composition is what you choose to include in your photograph and where the elements in your image are placed. Once you have mastered the exposure, you can start to concentrate on the composition, because it is the composition that can really turn a good photograph into a great photograph. Take Figure 3-13, for example. The placement of the couple and the horizon line were no accident; using the Rule of Thirds here helped create a pleasing image.

BASIC RULES OF COMPOSITION

When it comes to composition, there are no rules set in stone, but there are some things that can really help you create pleasing compositions. The most common and widely used composition guidelines are the Rule of Thirds and using leading lines.

■ **The Rule of Thirds.** The Rule of Thirds is one of the most common and popular composition rules for photographers. This rule is applicable to all types of photography, from

3-13

ABOUT THIS PHOTO *This photograph of the bride and groom uses the tried-and-true Rule of Thirds to create a pleasing composition. Notice the placement not only of the bride and groom, but of the horizon line as well. Taken at ISO 100, f/8, 1/80 second.*

portraits to landscapes, and works really well for wedding photography. To follow the rule, imagine lines that divide your image into thirds both horizontally and vertically, like a tic-tac-toe grid. When composing your images using the Rule of Thirds, you place the important elements of your image at one of the four points where these lines intersect. The placement of the couple and the horizon in Figure 3-14 follows the Rule of Thirds and creates a pleasing image.

tip

Place the horizon line in your photograph one-third of the way from the bottom of the frame or one-third of the way in from the top of the frame, depending on the subject. Having the horizon line in the center of the image can look plain and boring.

■ **Leading lines.** There are lines everywhere, sometimes really obvious and other times much more subtle, and you can use these lines to strengthen your composition. When you

ABOUT THIS PHOTO *Not only is the happy couple placed one-third in from the left and one-third up from the bottom right where two of the intersecting lines in the Rule of Thirds are, the horizon is placed one-third up from the bottom also following the Rule of Thirds. Taken at ISO 100, f/8, 1/500 second.*

use leading lines in your composition, the placement of the lines helps draw the viewer's eye to the subject and into the frame. Leading lines are more difficult to use than the Rule of Thirds because you need to not only place the subjects where you want them, but also use elements of the environment. For example, look at the yellow line painted in the road that leads your eye to the couple in Figure 3-15; it is hard not to follow it into the image. The composition in Figure 3-15 is

reinforced with the line created by the hill leading in from the right of the image. All these lines in the image reinforce that the couple is the main subject of the photograph.

At times, the lines used in your images are not as clear as the painted street lines, but are still present. There are three different types of leading lines: diagonal lines, straight lines, and curving lines.

3-15

ABOUT THIS PHOTO *This photo of the bride and groom uses the line in the road to draw the eye into the frame and to the couple. As a bonus, the subjects are placed a third in from the left and a third up from the bottom, at one of the intersecting lines created by the Rule of Thirds.*

> **Diagonal lines.** These can be some of the strongest for composition, because they lead the viewer's eye from the outside edge, especially when they are close to the corners of the image, toward the main subject.

> **Straight lines.** Using straight lines in your image can run either horizontally or vertically, as the trees do in Figure 3-16. These

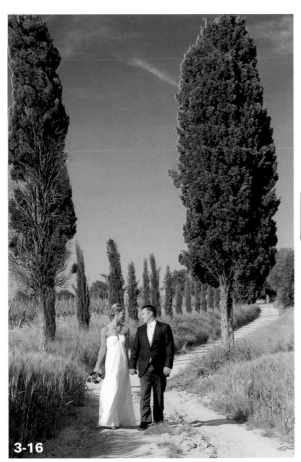

3-16

ABOUT THIS PHOTO *Posing the young couple on this outdoor path helps lead the viewer's eye to them. Taken at ISO 100, f/8, 1/400 second.*

lines can create a sense of strength and power in your images and can also work to frame your subject. Horizontal lines can add a sense of rest or stability to your images and can also be used as a divider around which your image can be built. A great example of a horizontal line is the horizon, but keep in mind that the horizon needs to be level or your image can feel very unbalanced. It is also a good idea to place the horizon line at one-third up from the bottom or one-third down from the top and not directly in the middle of your image. Because wedding photography is chiefly about photographing people, you have numerous opportunities to use straight lines: Arms, legs, and bodies can all be used in your composition. However, make sure that you do not pose the people in unnatural positions just to create or use a vertical line.

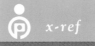

x-ref

For more information on posing people, see Chapters 7, 8 and 9.

> **Curved lines.** The third type of line is a curved line, and it can be a really great thing, because it not only leads the viewer's eye into the image, but it can also help to keep the viewer there. Because curved lines have some motion in them, the viewer's eye travels around the image. Many times the curved line in your image is the shape of the person's face or body. The simple curve of a hip or position of a shoulder can change the flow in an image.

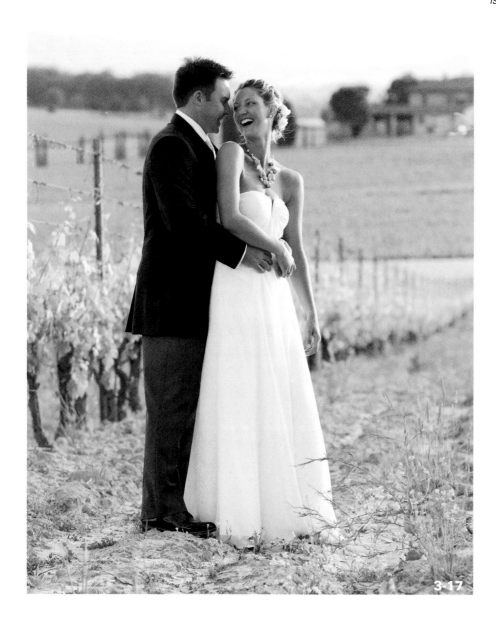

3-17

WHEN TO BREAK THE RULES

Composition is all about personal choice, and many times it is a good idea to disregard the rules and just go with what you like and what you think looks good. As I said previously, the Rule of Thirds dictates that you divide the scene into thirds with two imaginary horizontal and two imaginary vertical lines and then place the main subject at a point where these lines intersect. Many times it is just fine to place the image right in the center of the frame, ignoring the Rule of Thirds, as shown in Figure 3-17. When you place the subject in the center of the photograph, it can give the image a punch that it wouldn't have with the Rule of Thirds.

Placing your subject in the middle of the frame to break the Rule of Thirds isn't the only way to break the rules. For example, it is also possible to create a strong composition by ignoring the leading lines and placing the subject between the lines in the frame, as shown in Figure 3-18.

Composition really is subjective; don't let anyone tell you what is right or wrong. If all the wedding photographers out there took photos in the exact same way, the uniqueness and individuality that makes photography a great art form would be lost. The more photographs you go out and take, the easier it becomes to create photographs with a strong composition.

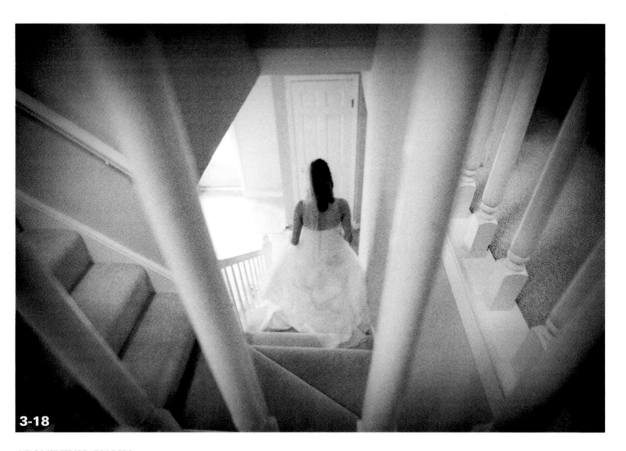

3-18

ABOUT THIS PHOTO *Putting the subject in the middle of the frame might not follow the Rule of Thirds, and the two vertical banisters that frame the bride are not leading lines, but the composition still works even though it breaks the rules. Taken at ISO 800, f/2.8, 1/50 second.*

Assignment

Equivalent Exposures

As discussed earlier in this chapter, certain combinations of shutter speed, aperture, and ISO give you the same exposure or equivalent exposures. For example, a photograph taken using ISO 200, f/2.8, and 1/500 second records the same amount of light as one taken at ISO 200, f/8, and 1/60 second. As the aperture is made smaller, the shutter is left open longer, resulting in the same amount of light reaching the sensor.

Just because the exposure is equivalent, it doesn't mean that the images are the same. The depth of field is very different due to the different apertures, and because the shutter speed has changed, there could be more motion in the image than with a higher shutter speed. Go out and photograph the same scene using a variety of equivalent exposures to see what difference they make to the look and feel of the image. Does using a shallow depth of field and fast shutter speed give the same feeling as a deep depth of field and slower shutter speed? Post your favorite of the bunch to the Web site to share.

These two images of the same couple have the same exposure but as you can see, the much slower shutter speed on the second image (on the right) gives the image a very different feel. The left image was shot at ISO 1000, f/5.6 and 1/1000 second, freezing the action, while the right image was taken at ISO 50, f/16 and 1/4 second.

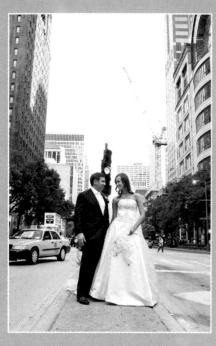 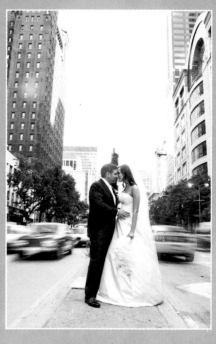

 Remember to visit www.pwassignments.com after you complete the assignment and share your favorite photo! It's a community of enthusiastic photographers and a great place to view what other readers have created. You can also post comments and read encouraging suggestions and feedback.

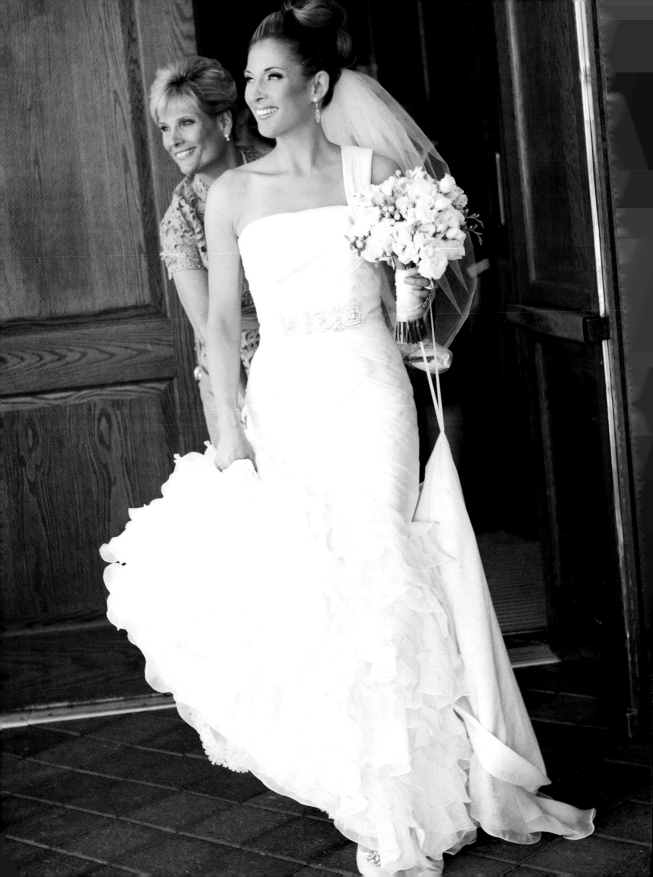

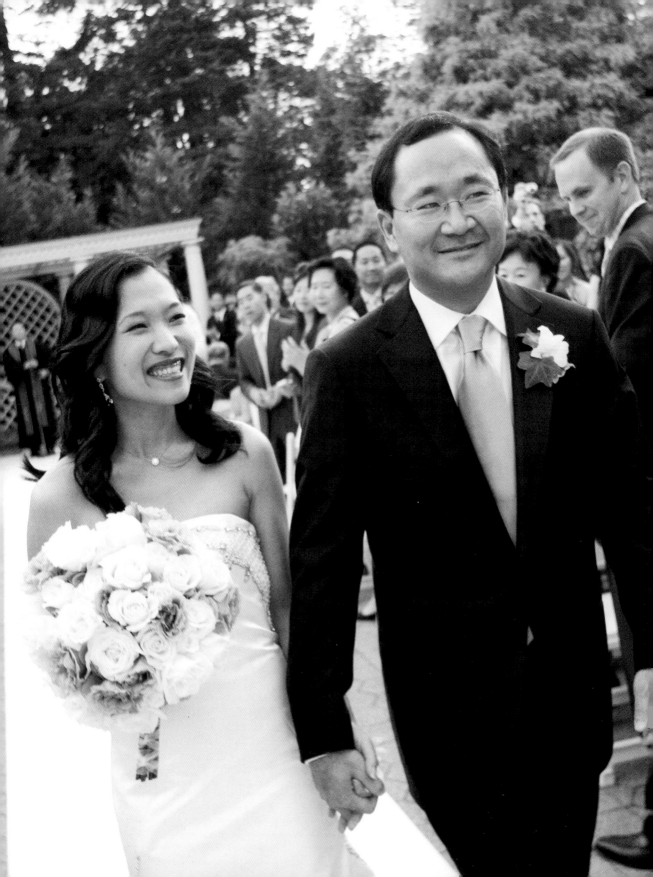

With so many wedding photographers out there today, the question is, how will you stand out and set yourself apart from all the others? If a prospective client asks you this same question, how will you define your style? Some different styles have already been established with wedding photography, including the traditional style and photojournalistic style. Many other wedding photographers use random words to describe their style, such as modern or edgy, but what does that actually mean to you? It is important to learn about some of these different styles and most important, to experiment and find where your photography fits in. In the end you have to develop a personal style that is unique and makes you stand out in a positive way. This doesn't

mean that you should shoot each and every wedding the exact same way every time; you need to be flexible and to be able to mix styles depending on the situation. For example, the portraits can be more traditional, while photographs of the ceremony and reception can be more photojournalistic. And sometimes the client will hire you based on your creativity. In Figure 4-1, I broke the rules of composition and cropped the image in a way that was unexpected.

The more traditional approach for this shot would be to capture the couple at full length from head to toe with some room around them showing the background for a sense of location. I took the safe traditional shot first, but then increased the focal

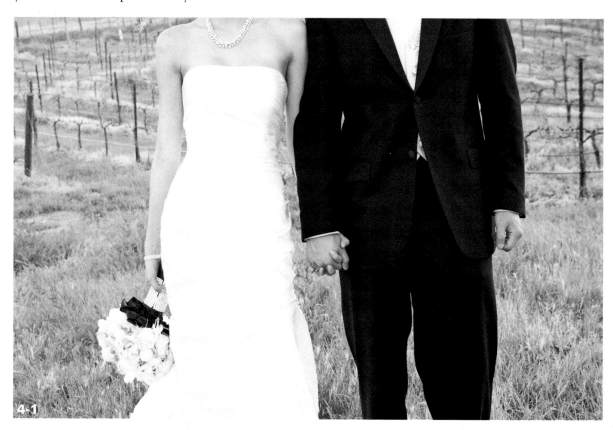

4-1

ABOUT THIS PHOTO *The nontraditional crop of this image allows the viewer to see the couple in a different light and does bring the focus more to the attire and the hands. Taken at ISO 640, f/6.3, and 1/400 second.*

length so that the image focused in on their bodies, which allows the viewer to focus on different aspects of the couple. And even though you cannot see their faces, there are enough details present that the couple recognize themselves. I also liked the way their holding hands implies the love and affection for each other and allows the viewer to see them in a way that you would not normally see them.

WHAT IS STYLE?

In the past, clients didn't have many options to pick from when it came to wedding photography styles. There was a traditional style, which involved a lot of very formal poses and taking photos in a studio before or after the wedding day. As smaller cameras were introduced and became easy to use, a new breed of wedding photography style emerged. This style was based more on reporting the day and considered a photojournalistic style. Nowadays many wedding photographers mix the styles into something that is unique to them.

TRADITIONAL

Traditional wedding photography consists of taking a set of posed wedding images. Each photograph is meticulously set up and controlled. The subjects are carefully arranged in the frame and posed, usually looking directly at the camera. The final set of images all have the same look and feel to them, creating a very uniform wedding album. Traditional wedding photographers are usually very skilled in portrait photography, as that is what they mainly do. This skill is really important, and every wedding photographer needs to study the traditional methods of posing not only the bride and groom but groups as well. The portrait style of the traditional wedding photographer has lasted since weddings were first photographed and is still very much in use today. The reason for this is that many people like this style and like the posed look to their images, and I used that when setting up the group portrait, as shown in Figure 4-2. When done well, traditional wedding portraits can be absolutely beautiful.

ABOUT THIS PHOTO
The groom and his groomsmen posed traditionally. Taken at ISO 1250, f/4, 1/80 second.

4-2

Study the masters of the past, especially the posing methods they used and the way they used the light to flatter the subjects.

One of the defining qualities of the traditional style wedding photographs is that there are rarely any candid images, and this can result in some missed opportunities. And since it can take a lot of time to set up each shot and nothing is spontaneous, this style might sound a little boring to some photographers. The results can also seem to lack some of that wedding day energy, and the subjects might look a little stiff and uncomfortable. Not everyone is at ease in front of the camera, and part of making this style work is the skill the photographer has to get the subjects to be comfortable in front of the camera. One final point to consider is that many times the photos from one wedding will look just like the photos from another wedding because the poses and lighting are identical. This is not necessarily a bad thing, since many times you are hired based on your past work, and if the clients really like that style of wedding photograph, you will be delivering them exactly what they want.

On the plus side, this style of photography can create a beautiful set of images that any bride and groom will appreciate, such as the portrait of the bride shown in Figure 4.3.

PHOTOJOURNALISM

Photojournalism is a method of reporting on a news story or event using images to tell the story. This style of photography has become really popular with wedding photographers and their clients and, instead of focusing on posed images, it focuses more on capturing the wedding day through candid photos, much like a reporter covers a story. The photojournalist-style wedding photographer tries to go unnoticed to be able to capture the real, raw emotions being displayed. Many people love the natural look and feel of

ABOUT THIS PHOTO *The bride posed, taken at ISO 400, f/5, 1/500 second.*

these images because they tend to more closely match their memories of the day. Clients who have grown up with cell-phone video and snapshots will also be more comfortable with this type of photography because they take candid photos and footage themselves. These clients tend to appreciate the authenticity of these types of images. Because the intent of a photojournalistic style is to capture the moment when it happens rather than set it up as a posed shot, you have to train yourself to be on the lookout for those special moments, and more important, you have to be able to capture them as they happen. Take the reactions to a slide show in Figure 4-4;

ABOUT THIS PHOTO *The groom and bride react to the slide show. Taken at ISO 2000, f/4, and 1/40 second.*

4-4

this moment could never be posed. One of my favorite photographers, Joe Buissink, taught me this trick: Whenever you see a "moment," even in your everyday life, train yourself to see it by snapping your fingers or saying "click" to yourself. It can be any type of moment as long as it reminds you to react to it.

To be a successful photojournalist, you need to learn the basic mechanics of the camera so that you don't have to think about them when you're shooting. Compare this to athletes who use muscle memory, training their bodies to react a certain way by repeating the same routine over and over again. Practice with your camera so that you can adjust the settings without having to think about it because there are no second chances. If you train yourself to adjust your camera automatically as the

light and situation change, you can focus on what is going on and capture those moments that unfold as quickly as they happen. To be successful in this style of wedding photography, you need to be prepared to react. Capturing the portrait in Figure 4-5 was easy, but capturing the couple kissing as the local couple looked on was only possible because I was ready for anything.

It is important to note that just because you call your style photojournalistic, it doesn't mean that you don't need to know how to pose your subjects. A good photojournalist will be in charge of the situation and know when to step back and let the scene unfold. On the downside, because many of the images are shot as they happen and not posed, at times the subjects might not look their very best in every shot.

4-5

ABOUT THIS PHOTO *The bride and groom along with a local audience. Taken at ISO 500, f/4, and 1/250 second.*

MIXED STYLES

Most wedding photography today is a mix of styles and not just strictly the traditional and photojournalistic styles. What this ends up looking like is a more traditional set of portrait images along with a set of images that tell the story of the wedding from the bride and groom getting prepared to the ceremony and the reception. Taking the story-telling ability of the photojournalist and combining it with the posing ability of the traditional wedding photographer allows you to offer a more complete package to the client. In my opinion, the ideal wedding photographer uses both of these styles as the client requests or as the situation demands.

For example, the bride getting ready while surrounded by her friends calls for a more photojournalistic approach, while the portraits of her in her dress are definitely more suited for traditional-styled portraits. Covering the wedding reception can be a great mix of styles. Having the bride and groom pose as they cut the wedding cake is a portrait-type shot, more in the traditional style; look for and capture candid moments during the toasts, when the guests' emotions are on their faces.

When it comes to mixing the styles, it is also possible to photograph the same subjects in more than one way. The groom and groomsmen in Figures 4-6 and 4-7 are photographed in two very

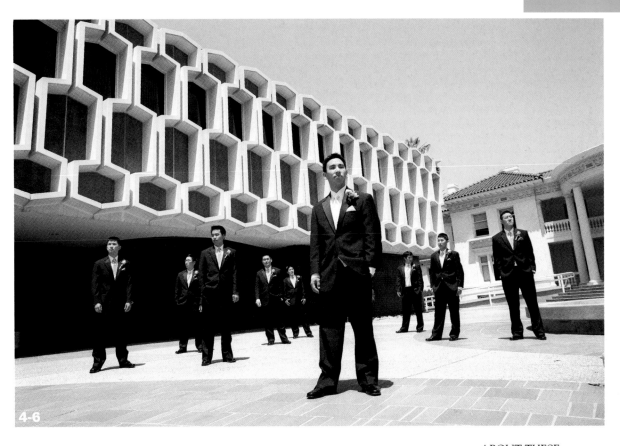

4-6

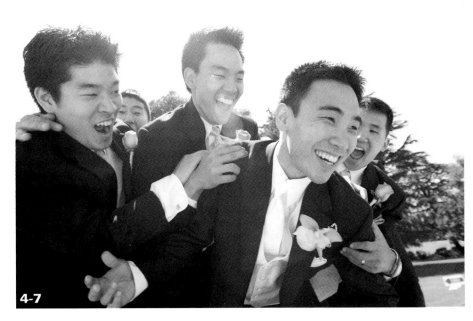

4-7

ABOUT THESE PHOTOS *These two shots of the same group show two different styles. In Figure 4-6 the men were arranged carefully in a more traditional manner and photographed at ISO 100, f/8 and 1/160 second, and then the group was pulled in close and given more leeway in their action and expression in Figure 4-7. Taken at ISO 100, f/5 and 1/160 second.*

different ways. I started with a more rigid and controlled posed image where everyone was placed exactly where I wanted them to be, and then moved onto a more relaxed group portrait with fewer specific directions and tried to let the personalities come out. It is important to note that the second shot, while looser and more relaxed, was not just a random moment, but actually set up and posed.

The mix of styles doesn't have to be 50/50 and doesn't mean you can't favor one style over the other. How you mix these styles determines your look and personal style. One thing that is true for both styles is that you need to practice, practice, practice — not on the job of course, but in the time between jobs — so that you can constantly improve.

WHAT TO LOOK FOR

When the clients get their wedding images back from their photographer, the images should tell the story of their wedding no matter what style or combination of styles were used.

When telling a story with your images, it is important to not only capture the overall scene but also the details that add depth and interest to the wedding story. The little nuances really help to tell the story just as well as photographs of the overall scene.

This story-telling concept is easily seen in movies and TV shows, especially the well-done movies or TV shows. When you watch a movie, the camera often pans back and forth, showing you the entire scene, then focuses in on an important detail, such as a person's face or hand, or even other parts of an actor's body, that conveys the emotion in the scene or an important detail.

Studying different types of media — movies, wedding magazines, fashion magazines, music magazines, music videos, movies, television shows, art, and so on — will help you see things in a different perspective. I have found that studying the news stories, especially the photojournalism pieces, help me build that story-telling ability.

One thing that you can try in order to hone this ability is to use a zoom lens, compose the scene using the widest focal length possible, and take a photo. Then start to zoom into the same scene using larger focal lengths and look for the details that will help tell the story. Keep zooming in, taking photographs all the time, making sure that each photo helps tell the same story.

As a wedding photographer, you are also the historian of the day, and many times the clients won't remember the small details of their day. Your job is to record those details for them and put them in a context that will allow the couple to enjoy them later. This includes coverage of the décor, the guests, the wedding program, the location, the food, and anything else that will help tell the story of the wedding in images.

CREATING A LOOK AND FEEL

When prospective clients see my portfolio, all the images have a similar look and feel. This doesn't mean that all the images are the same or even look the same. What it does mean is that the images are representations of my work and are representative of what I can do for my clients. The look and feel of your images are influenced by many different factors, but the composition and post-production are two that can make your images different from everyone else's. That doesn't mean that you need to take every shot in

a brand-new way, or need to make the whole wedding album sepia toned. What it means is when you show a prospective client your work, they can see how you will capture their day. Many times, especially when starting out, wedding photographers try to be all things to all clients. Part of this is because they want the business, but another part is that they don't have their own look and feel yet. The way you compose your images, the focal length choices, and the colors can all add to your style.

Part of my look and feel is the capturing of the real moments that happen between the bride and groom. For example, when I set up a pose for the bride and the groom, I watch carefully, and usually the couple will do something without any instruction to show their affection for the other. This could be a hug, kiss, smile, or some other small gesture, and because I am ready, I can capture those emotions.

FORMAL VERSUS INFORMAL

Part of your look and feel involves your approach to the wedding photographs: Whether you are a fan of formal images or informal images and how you want your photos to look. I prefer an informal look to my images, but this does not mean that they are not carefully set up and posed. For example, in Figure 4-8, I could have had the bride and groom face the camera or each other, but instead, I framed them in this dilapidated doorway that I thought had great character and would help in making the couple stand out, and had the groom lean up against the wall in a much more natural pose. This is an idea I like to call the *relaxed portrait*. It doesn't seem as still and formal as traditional wedding photos, but it also wasn't taken by accident.

4-8

ABOUT THIS PHOTO *An informal portrait of the bride and groom can be just as stunning as a formal portrait. Taken at ISO 400, f/4, 1/640 second.*

It is important to find out what the clients expect from you when it comes to portraits; if they are expecting a very formal look, then the relaxed portrait will not work. Nothing is worse than a client opening the proof book, expecting her photos to look a certain way, only to see something else.

USING COLOR

How you use color in your images when you take them and how you deal with color in post-production can also help define your style. You can adjust and change the color of any image using any one of the image-editing tools on the market or predefined software actions that create the same look consistently. These software actions are snippets of computer code that can consistently add a certain color or effect to your images without having to recreate all the steps to get the effect. Any color changes or effects should be done on images that are already great by themselves, not to try to fix an image. Think of the color adjustments as a little styling to the shot, as in Figure 4-9, where I started out using an action from Totally Rad! called Lux Soft, then added one of the Kevin Kubota actions called Soft & Grainy, and then toned the whole image using an Antique Tone action.

| | Post-production software and actions are covered in more detail in Chapter 11. |

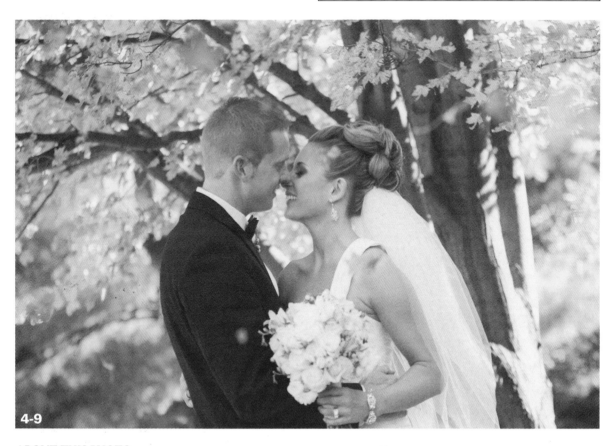

ABOUT THIS PHOTO *Change the feel of the image by changing its colors. Taken at ISO 800, f/2.8, 1/1000 second.*

When you use actions to change the color of your images, don't go overboard: Stick to a few looks that you like and that's it. Not every shot needs a color treatment; actually, only a handful of the images should be adjusted this way, or the treatment becomes common, and an image no longer stands out.

BLACK AND WHITE

Black-and-white photographs can feel timeless and classic. There are many different ways to change a color digital photo to black and white, and each gives the image a little bit of a different look. Software like Nik Software's Silver Efex Pro allows you to adjust every aspect of the transformation, and the best part is the color image is still available if you need it. This is one of the real advantages digital images have over film images. With film, to take a black-and-white shot, you needed to have black-and-white film in the camera. Today, you can offer your clients a color and a black-and-white version of the same image, as in Figures 4-10 and 4-11.

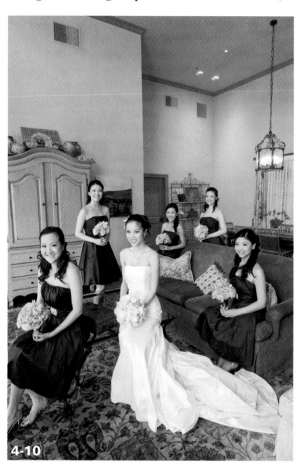

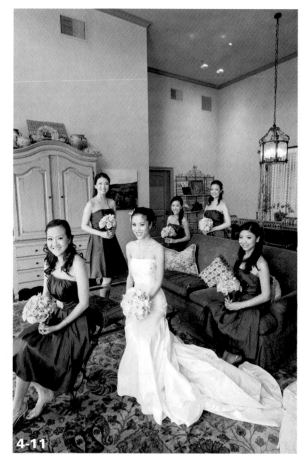

ABOUT THESE PHOTOS *Providing a color version and a black-and-white version of the same image gives your client more choices. Taken at ISO 1600, f/5, 1/60 second.*

BRANDING

Branding is really important; it sends a message about who you are as a business and as a photographer. Your branding needs to be consistent across your business cards, letterhead, and website. When you look at large successful companies, one thing they all have in common is great branding. You need to treat your business with the same time and energy as you would a very important client. This means that you should spend the time (and money) making sure that the company branding portrays the right message, that you are a professional wedding photographer. Many times photographers fall into the "I'll get to it later" or "this is good enough" trap when it comes to their Web sites and business cards. The thought is that you can change the logo or create better business cards later, but the truth is that once you have started to hand out cards or send people to your Web site, it is very difficult to change the brand. It is much better to start with a good logo and brand right from the start. Here are some things to consider when creating your brand:

- **Hire a graphic artist.** Just as you expect your clients to hire a professional wedding photographer for their big day, you should hire a professional for your really important projects. A professional designer can create a look for you based on your style and business. This makes you look more professional. Don't spend a good deal of time learning to take great photographs and invest in great gear only to skimp on the branding side of your business. Having a professional design will pay off in the long run.

- **Start with your logo.** Your logo is really important, because it is the one thing that can tie all the other pieces of branding and marketing together. Your logo needs to reflect your style. If your style of photography is traditional, your logo needs to have a traditional look and feel, but if your style is cutting-edge and hip, your logo needs to convey that. My logo as shown in Figure 4-12 was designed using my initials for a simple, clean, and professional-looking design. The circle in the middle represents the circle that you see when you look through the viewfinder of a camera. When it is red, it often means that the image is in focus and ready to be photographed. Looking farther in, there is a small ying and yang shape that divides the circle representing harmony and balance. I believe several elements such as light, composition, color, exposure, and emotion make up that that perfect photo, and my logo represents that concept.

- **Business cards.** Your business card is one of the most important pieces when it comes to branding yourself. Your card needs to impress everyone you hand it to. When photographers hand me their cards, I immediately judge them, right or wrong, by the style, design, and

4-12

ABOUT THIS FIGURE *The Kenny Kim logo.*

even the feel of their cards. My opinion is based not on their work but on the thought and care that they put into their business cards. Make sure that you are proud of your card and that you have it with you at all times. My card (shown in Figure 4-13) has my logo embossed on one side with the information on the other. I use a square card that tends to stand out from the normal 3.5" × 2" rectangle. I also suggest getting a business card holder, which keeps your cards looking new even if they have been in your pocket or bag for a while.

■ **Be consistent.** It is important to have consistency across all your different branding pieces. Your business card should have the same feel as your letterhead (that an easy one). Your Web site should have the same feel as any advertisements, your business card, and so on. If I get a card from a photographer and go to his Web site, I want to immediately know that it is the same person. This means that the color scheme, the logo, and even the fonts are the same, which gives the whole package the same look and feel.

4-13

ABOUT THIS FIGURE *The Kenny Kim business card.*

MARKETING YOUR STYLE

One of the most important things you can do when marketing yourself is to pick photos that you believe represent your style.

If you are a traditional photographer, a great posed shot of the couple or wedding detail will be better than a candid shot of the bride and groom dancing or a close-up of the ring exchange during the ceremony. If you tend to be more photojournalistic, then go with the shots that tell a story and portray the raw emotions.

You need to send the right message to attract the right clients.

TRADITIONAL MARKETING

Traditional marketing consists of placing advertisements in wedding magazines and newspapers and banner ads on wedding Web sites, and sending out mailings or even flyers and postcards at wedding expos. There is a lot of competition in the wedding photography business, and you can no longer just rely on ads in magazines and wedding Web sites or flyers to get you business, but that doesn't mean you should ignore the traditional marketing outlets. You need to make sure that you are keeping up with the competition and that when prospective clients look at a wedding magazine or Web site or go to a wedding expo, they see you represented there.

The real problem with traditional marketing is that you can get lost in a sea of advertisements. It is tough to stand out from the crowd. One key factor in helping you stand out from your competition, especially in the traditional marketing locations, is to only show your very best work. When it comes to traditional marketing, the message should be part of a whole campaign

that includes the blog, Web site, and social media; you need to make sure that your message is clear. One of the best ways to do this, as mentioned in the previous section, is to hire a graphic designer to help create your brand and your marketing materials. Use traditional marketing to drive prospective clients to your Web site and blog so that they can get more information on you and your services.

WEB SITE AND BLOG

Every business needs a Web site, and a wedding photographer is no different. A Web site enables your prospective clients to find you and look at your work at their leisure. The great thing about a Web site or blog is that you can control the content, and you can update it as often as needed. You can use the feedback from your clients to fine-tune the site and make sure that the message you want to get out is actually getting out.

There are many prepackaged Web site templates that you can use to create a good-looking Web site in just a few hours. This might be a way to start, but because the templates are available to everyone, other photographers might be using the same design. The idea is to stand out from the crowd, not be a part of it. Using a professional graphic artist or Web designer can make a big difference and ensure that your traditional marketing and your Web marketing, and even your social media, all have the same look and feel.

A Web site is made up of different parts, and there are a few things that every photographer's Web site needs to have — the most important being a gallery of images that show off your best work. These are the images that your prospective clients will see and judge you on. It is really important to make sure you are showing your best

work and that you update the work often. Another key section is the contact information that needs to be up-to-date and easily found. It is no good if the prospective clients can't get in touch with you to set up a meeting.

Many Web sites are set up as blog sites that allow you to share more information than a static site. The blog idea is that you are writing about and sharing images from your latest endeavors, and that these are related to the work you do (see Figure 4-14). It would not be useful for a wedding photographer to blog about landscape photography or sports photography unless it can somehow be tied back into wedding photography. Blog entries can help keep visitors to your Web site entertained, but to do that you need to make the commitment to update the blog regularly. This could mean that you post a few images from every wedding (with the client's permission of course) or once a week with a recap of your current work.

4-14

ABOUT THIS FIGURE *The www.kennykim.com blog.*

SOCIAL MEDIA

Social media has changed the world and has really changed the way that people find and hire vendors, including wedding photographers. People no longer simply search the Internet or the Yellow Pages; now prospective clients can ask their contacts on social media sites who they recommend, and those contacts can ask their contacts, and so on. This makes marketing difficult because the word of mouth is now on the Internet. The guests can see how you conduct yourself at one wedding and can spread word of it far and wide.

You need to get out on sites like Facebook and Twitter. Your clients expect it, and you can build relationships with people around the world based on how you portray yourself on the Internet. Once a client has seen your work, gotten a positive review from a friend, and read about you on your blog, the client feels like she knows you and your work before even talking to you.

It is vital to send a positive message to people and to use all these platforms to promote your business.

GETTING PUBLISHED OR FEATURED

Getting published can be a great way to market yourself. It isn't as hard as you would think, but it can be rather intimidating. There is no magic formula. You first find the magazines (or Web sites) that match your style of wedding photography and then (and here is the hard part) submit your work!

You might doubt that your work is good enough to be published, but there is no way to know this until you try. Just don't let it get you down if the images are not accepted. It might mean that you need to work on your craft and get better images or that your images were simply not the right fit. That does not mean that the publication or Web site will not consider the images again in the future.

Don't be afraid of failure; instead use it as a platform to learn.

All publications have their own set of requirements for submissions, and they usually are looking for images that fit with their style. For example, don't bother sending in the bright, colorful candid shot of the bride by the water to a magazine that is dominated by traditional black-and-white portraits. Study the images that are already featured; you will see that there is a repeated pattern with the images the publishers choose. Look for and photograph those details and moments next time you are shooting a wedding, and you will have a better chance of being accepted for publication. You can find contact information and submission guidelines in most publications or on their Web sites.

For example, build a Twitter account and tie it with a Facebook business/fan page. You can see my Facebook page in Figure 4-15. Be sure to update those pages showing your latest work. These pages are now showing up more and more on search engines and, by keeping the work fresh, you will get more business. It is important to keep in mind that everything you do can now be seen when you are connected through social media to this extent, so it pays to be up front and honest. If you are a part-time wedding photographer just starting out, make sure this is clear.

tip One way to drive traffic to your social media sites is to tag the images with the bride's and groom's names so that their friends can find the images easily and see them from their accounts. Just make sure you ask their permission first.

4-15

ABOUT THIS FIGURE
The Kenny Kim Facebook page.

Assignment

Experiment with Composition

The best way to work out your style is to experiment with your composition and see what speaks to you artistically. Do you feel the need to be in total control of every aspect of the image or can you shoot on the go, capturing great images to tell a story? Try creating some formal, posed photos where you are in control of the whole scene and try some photojournalistic photos where you capture the scene as it unfolds with little posing and control. Regardless, you need to be able to tell a story, and this means you need to know exactly what your subject is and why it is important. Using the basic rules of composition, you can draw the viewer to the part of the image you want to emphasize. Choose a photo that has composition you really love and post it to the Web site to share.

When people look at your images, or any image, the eye is drawn to the parts that are in focus first. By using a shallow depth of field, you can make sure that viewers are looking at what you want them to, no matter where it is placed in the image. This moment was captured using an aperture of f/2.8, which blurred the background and kept the focus on the hug, and a shutter speed of 1/200 to make sure the action was frozen. Because there was quite a lot of light, I was able to use an ISO of 640, keeping the noise to a minimum.

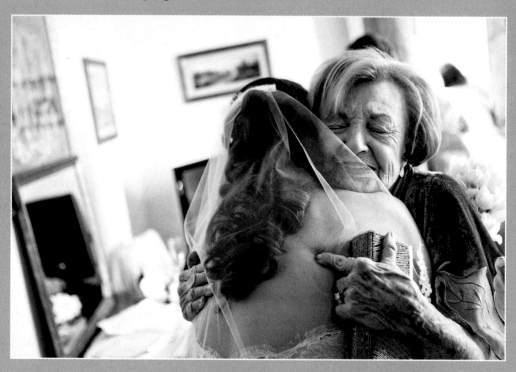

Remember to visit www.pwassignments.com after you complete the assignment and share your favorite photo! It's a community of enthusiastic photographers and a great place to view what other readers have created. You can also post comments and read encouraging suggestions and feedback.

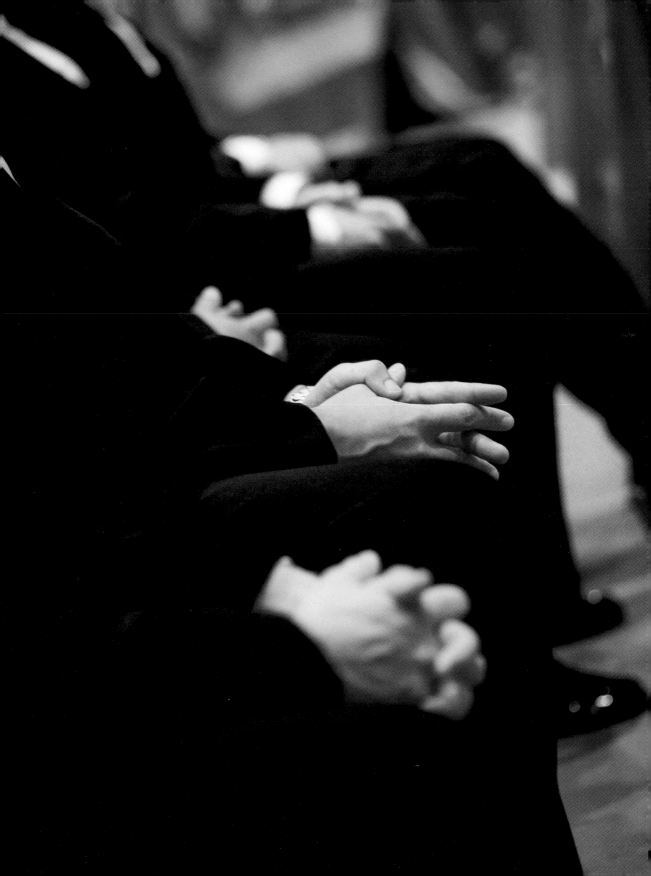

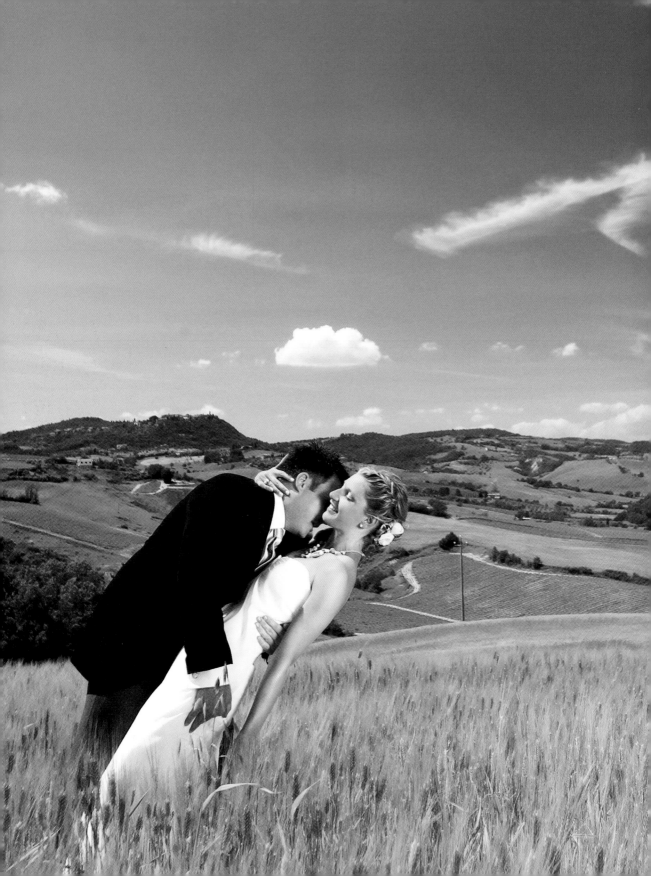

Exposure Considerations

Plan Ahead

Shooting outdoor weddings can seem easier than shooting indoor weddings. That isn't to say that you don't have challenges when shooting outdoors; you do, from the different exposure considerations to the constantly changing lighting conditions. As a wedding photographer working outdoors, you need to be constantly monitoring and adjusting your shutter speed, aperture, and ISO settings to get the best exposure. You also need to plan ahead for where the light will be, not just where it is. But as you can see in Figure 5-1, even in direct sunlight, you can get some stunning photographs.

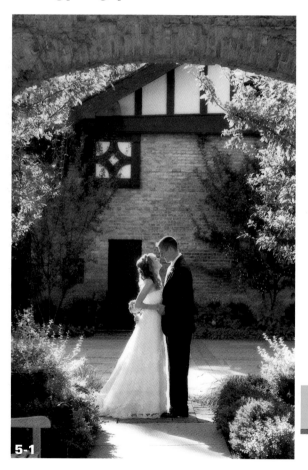

5-1

ABOUT THIS PHOTO *The bride and groom posed with the sun striking them at an angle, creating a backlight. Taken at ISO 1000, f/3.5, 1/1600 second.*

Outdoor light can vary from harsh light at midday to softer light in the shadows to golden light at sunset and low light after the sun has set. Each of these situations presents a different challenge to you, but with a little planning and practice, you can overcome the toughest lighting situations.

EXPOSURE CONSIDERATIONS

This section is all about how to control the light with your exposure controls. Be it the harsh, bright sun or the deep shadows, or a combination of the two, you have to learn how to get the proper exposure every time.

BRIGHT SUN

When people first start to take photographs, they hope for, and often seek out, bright sunlight. The bright sunlight makes it easy to get a sharp image because you can use high shutter speeds and small apertures. This seems to be great until you realize that the creative opportunities are limited. For example, it can be so bright that it becomes difficult to get a shallow depth of field even using the highest shutter speed and the lowest ISO.

The important part when dealing with direct sunlight is to watch the angle of the sun and where it is striking in the image. For example, the sun was directly behind the alter and toward the guests in Figure 5-2, but by using a low angle and not worrying if the sky became overexposed, I used the sunlight to backlight the bride being escorted down the aisle.

tip If you aren't absolutely sure of the direction the sun is coming from, look at the direction of the shadows the sun is creating. The way the shadows stretch back toward the camera's location lets you know the direction of the sun.

One quick and easy method of adjusting your exposure for the very bright sun is to purposely underexpose the image by using exposure compensation. This is a setting on your camera that allows you to adjust the exposure for any exposure mode other than Manual mode. For example, in Figure 5-2 I used Aperture Priority mode and set the aperture to f/2.8 to use a shallow depth of field. Then because the meter reading produced a blown-out image, one that has no detail in the lightest areas, I dialed in −2/3 exposure compensation, which underexposed the image by 2/3 of a stop, creating a better exposure. This allowed me to concentrate on the composition.

The quick and easy rule for using exposure compensation is that dialing in positive numbers will lighten the image, while dialing in negative numbers will darken the image. Because the exposure compensation is a global change based on the light meter reading, it is only effective when using modes that actually use the meter reading, so if you are shooting in manual mode, it will have no effect. Now, while exposure compensation may seem like the best way to adjust the exposure settings in difficult situations, you need to know what it does so that you can understand the downside.

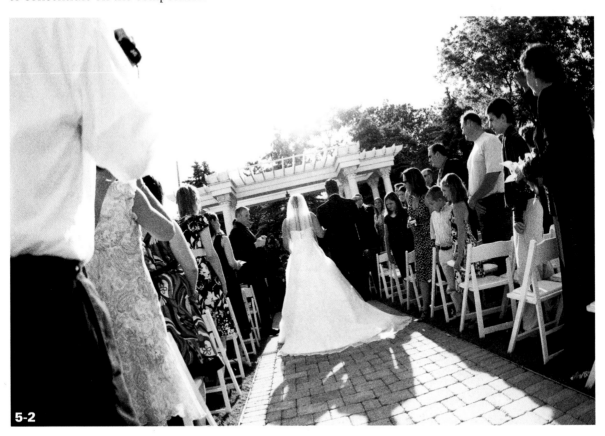

5-2

ABOUT THIS PHOTO *The bride being escorted down the aisle directly into the sun. Taken at ISO 100, f/2.8, 1/3200 second using −2/3 exposure compensation.*

When you dial in a positive number, the camera needs to let more light reach the sensor, and there are only two ways to do this: The first is to use a wider aperture; the second is to use a slower shutter speed. When you dial in a negative exposure compensation, the camera needs to let less light in, so it either has to use a faster shutter speed or a smaller aperture. In both of these situations you can get results that you were not expecting. It is important to read your camera manual and understand what settings your camera changes when using exposure compensation.

Another method of getting the best exposure in direct sun is to use the spot-metering mode on your camera. Because the spot-metering mode only looks at a small area of the whole scene, it can be used to get an accurate meter reading in these extremely bright-light situations. The key is to make sure that the metering is done off a part of the scene that isn't too bright or too dark, so the wedding dress and the tuxedo are both bad choices. The better choice would be the face of the subject. Many of the new cameras have tied the spot-metering area to the focus point being used, so whatever you focus on is what the camera uses as a base for the meter reading.

A downside to photographing in direct sunlight is that everything can look a bit flat and lack character. It is not the light that defines the face, but the shadows. With very bright direct sunlight, there just aren't too many nice shadows, and those present tend to be very sharp because the light source is very small and hard. The sun might be a very large object giving out a huge amount of light, but because it is very far away, it becomes a small light source. The smaller the light source, the harder the light it provides. The evidence is in the shadows created by the light source — the shadows created by the sun have very distinct edges that don't have a lot of transition between the light and the dark, which is a key attribute of a hard light source. A

softer light source would create shadows that have a greater area of transition between the light and the dark and would look softer to the eye. Softer light is more desirable, especially when it comes to photographing people.

When the subject is lit with direct sunlight and the shadows are hard, there is no easy fix other than to move the subjects into the shade, which is often not an option. As you can see in Figure 5-3, as the sun strikes the bride's face, it leaves a very hard shadow created by her nose, and there is nothing that can be done about it.

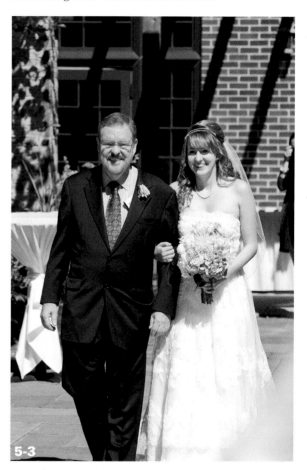

5-3

ABOUT THIS PHOTO *The bride being escorted down the aisle is walking in hard direct light, causing shadows to fall across her face. Taken at ISO 100, f/5.6, 1/500 second.*

Perhaps the biggest problem with direct sunlight is when it occurs during an outdoor ceremony, as that is the one time that you can't rearrange the subjects or move them to a shaded area. In a perfect wedding photography world, the photographer would be able to dictate where and when the ceremony would take place and would take into consideration the angle and direction of the sun. Because that isn't possible, you need to do the next best thing, which is to change your angles and try to minimize the sun's harsh effects.

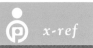

> **tip** Using a lens hood to shade the end of your lens is really important when shooting in direct sun, as it helps to negate any lens flare that can occur when the angle of the lens to the sun causes the light to skip across the front of the lens. Lens flare can be used creatively, but a little can go a long way.

SHADE

The shade can be your friend when you are shooting outdoor weddings. This includes the shade formed by trees or any other structure close to the wedding sight, especially if it is a cloudless day. While you can't control the actual ceremony site, you may have some input for the non-ceremony photographs. Ideally, look for a tree. A tree canopy softens the light from the sun and turns it into a closer, softer light, because shade is just another way to describe diffused light. Diffused light, as described in the previous section, has softer shadows and is more pleasing when shooting portraits. This is a much more flattering light and improves the photos dramatically. As you can see in Figure 5-4, the tree cover creates an even light across the bride and groom.

When you look at the light in the shade, there is a direction to the light that you need to take into account when setting up your shots. For example,

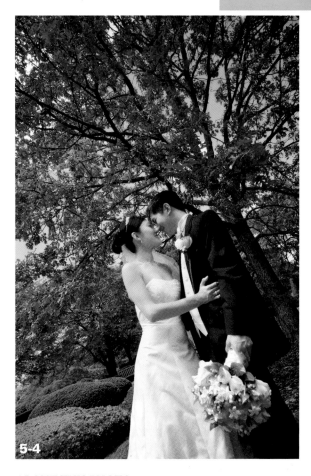

5-4

ABOUT THIS PHOTO *Placing the bride and groom under the tree changed the quality of light from a hard light to a softer, more pleasing light. There is still plenty of light available for the portrait. Taken at ISO 400, f/7.1, 1/320 second.*

if the light is coming from directly overhead, then there will be problems with deep shadows in the eye sockets and under the chin and nose. So, make sure you move the subjects around to adjust the light.

> **x-ref** For more on white balance and the color of light, see Chapter 6.

The real challenge can be to find a tree or area that has good shade and is big enough for the group you need to shoot, because it is important to have the same type of light on all the subjects. This keeps the tonal values between the bright and the dark parts close, making it much easier to get the correct exposure. Take the group in Figure 5-5, for example: By placing them all in the same light, no one has very bright areas or very dark areas on them. This natural lighting makes for a great group shot.

PART SUN, PART SHADE

The real challenge when shooting outdoors is dealing with scenes that are part full sunlight and part shade. This can get a little tricky, because when

there are areas that are brightly lit and areas of dark shadow in the same scene, the camera's sensor has a tough time recording the wide range of tones in the same exposure. The sensor in your camera is an amazing piece of technology, but it does have some limitations, and one of those is capturing a really wide range of tones in the same image. When the range of tones in your scene becomes wider than the range of tones the camera can capture, you need to either expose for the bright parts or expose for the dark parts, or add some light to the dark parts to make them closer in tone to the light parts.

There are three different approaches to dealing with scenes that have a range of tones that is wider than your sensor's capture ability. The first

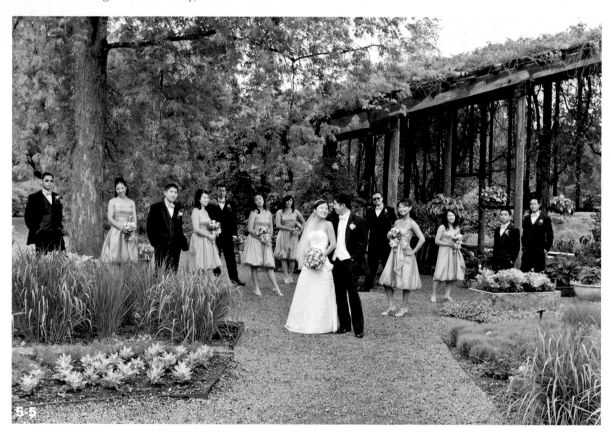

5-5

ABOUT THIS PHOTO *Having the same light fall on all the group members makes it easy to expose for a photo. Taken at ISO 400, f/6.4, 1/250 second.*

THE COLOR OF LIGHT There is a real difference in color between different types of light. This holds true for the different types of light used indoors, and it's true for the different light when shooting outdoors. Now the light at midday in the open and the light in the shade and even the light at sunset are all from the same source—the sun. While the source is the same, depending on the time of day and what the light travels through or bounces off of, the color can be very different. The way you deal with the different color light is to adjust the white balance on your camera to match the type of light being used so that the colors are rendered properly.

The good news is that in most cases, the automatic white balance setting works really well, and the newer the camera, the more likely the auto white balance will be accurate initially, without needing any adjustment. However, when you shoot in the shade, people can look a little cold, or in color terms, look a little blue. This is because the color of light in the shade has a blue cast compared to the color of the light in the open, which looks whiter. You can easily fix this by adjusting the white balance in post-production or by setting the white balance to shade (or the equivalent white balance setting if shade isn't a setting on your camera). Each camera is a little different, so check in the camera manual.

approach is to expose for the darker areas or shadows in your image; you usually lose the detail in the light parts, called the *highlights*. This isn't so bad if those bright areas are the sky or something unimportant, but if this detail is in the bride's dress or groom's shirt, it might be undesirable. One thing to consider is that the human eye tends to be drawn to the brightest area of an image first, so if you overexpose, or blow out, the highlights in part of your image, you had better have a really good reason, because the viewer will notice it first.

In Figure 5-6, the scene was exposed to show the details in the groom and his best man, and the lightest parts of the image are completely white.

The second approach is to expose for the highlights, but there is a good chance the dark areas or shadows in the photo will turn to solid black, and all detail there will be lost. This approach underexposes the image, and it can generally look too dark, but given the choice, this is the one I would pick, because it is easier to correct an underexposed image in post-processing than one with blown-out highlights. This is because many software-editing programs will allow you to recover details in the dark areas by lightening the image but have a hard time recovering details in the pure white of the severely overexposed areas. If you look at Figure 5-7, the details of the wedding dress still appear, but both the bride's and groom's hair have turned pure black in places, as has part of the mast and other shadow areas. The image was exposed for the highlights, and even in the bright sun, none of the wedding dress detail has been lost.

The third approach is the best in my opinion because it doesn't involve blowing out the highlights or darkening the shadows. This is where that trusty flash unit comes in handy, because you can add a little light to the scene — fill light.

ABOUT THIS PHOTO *At times it impossible to get away from shooting in the direct sun. This photo of the groom and his best man has areas that are overexposed especially in the top left, because the exposure was set to make sure the tuxedos were not too dark. Taken at ISO 320, f/4.5, 1/180 second.*

5.6

When you add fill light, you use the flash to add just a touch of light, which makes the dark parts of the image brighter, allowing you to expose for the highlights and still have detail in the dark parts. It takes some practice to master this method because you want to add enough light that the shadows have detail, but not so much light that the scene looks like it is lit by a flash. Think of it as adding light to the dark areas of the scene that reduces the range of tones in the image. There are some things to ask before adding a flash to the scene.

■ **Is there more light behind the subject than in front of it?** Because the idea of using a fill flash is to even out the light in the scene, it works best if there is more light behind the subject than in front of it.

■ **Are you close enough for the flash to have an effect?** The small, dedicated flash units have a limited range, and it would be impossible to use one to add light to a scene from very far away.

■ **Is the subject in shadow?** It is really tough to add light to a scene where there is already a lot of light, and flash works best if the subject is in shadow.

There are some things you need to consider when using fill flash:

■ **Shutter speed.** Many cameras need to have the shutter speed set to 1/250 second or slower for the flash to fire. This means that to get a proper exposure, you will have to use a smaller aperture, such as f/8.

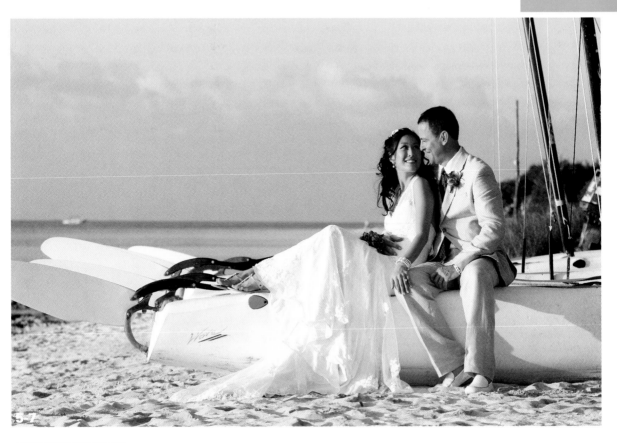

ABOUT THIS PHOTO *The bride and groom pose in the sun in Cozumel, Mexico. Taken at ISO 100, f/5.6, 1/250 second.*

■ **Adjust the flash output.** Many flash units allow you to adjust the power of the flash, which will help keep the photo looking natural. A good starting point is to reduce the power of the flash by 1 stop, and then adjust as needed. This is also known as flash compensation.

■ **Adjust the flash angle.** Most accessory flash units have an adjustable flash head that can be angled from 90-degrees to straight up, and many times from side to side as well. By adjusting the angle of the flash, you can adjust where the fill light illuminates, and a little change in the angle can make a big difference.

The key to using fill light is to practice and practice until the adjustments become second nature. Because each situation is different, the settings you use will be determined by the light present. However, as a starting point, I usually begin with the flash head angled at 45-degrees and with the flash power set to -1. It all depends on the amount of light in the background compared to the amount of light striking your subject. The bigger the difference, the more flash power you will need to use.

One thing that is really useful is to add a diffuser over the flash head on your flash, and I recommend using an OmniBounce diffuser or one of

the Gary Fong light modifiers, so that the light produced by the flash is softer and spread out more evenly. When you use a light modifier, you lose some of the flash power, so you might have to also adjust the power. The good news is that when you use a proprietary flash, for example a Canon Speedlite with a Canon dSLR or a Nikon Speedlight with a Nikon dSLR, the camera will calculate fill flash for you.

In Figure 5-8, the couple is posed with the sun in the background, yet they are lit with the flash. The flash was needed otherwise the backlighting from the sunset would have turned the couple into a silhouette. The exposure settings were used to render the sky darker, to give it a more dramatic punch. Had the exposure been set for the couple, the image would have looked like Figure 5-9.

5-8

ABOUT THESE PHOTOS *The images shown in Figures 5-8 and 5-9 were taken at the same time but, by purposely underexposing the sky in Figure 5-8 and lighting the couple with a flash, the sky and ocean are more dramatic than the shot in Figure 5-9.*

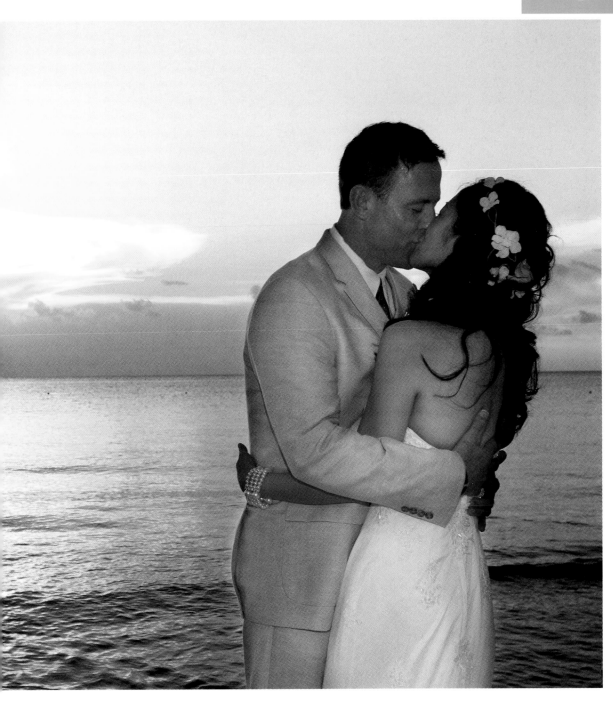

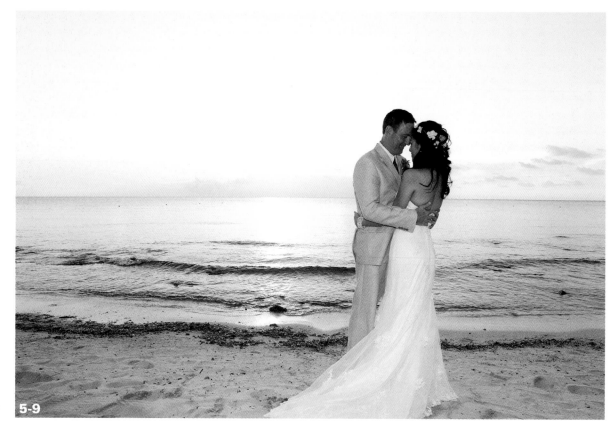

5-9

If you purposely underexpose the scene to make the sky more dramatic and don't use a fill light, you will get a silhouette. This is a very popular technique, and you can use it to great effect if the timing and light are right. To get a photograph like Figure 5-10, here is what I recommend:

1. **Position your subjects so that the light source is directly behind them.** Make sure that the subjects are easily identifiable by their edges because they will be nearly or completely black in the final image.

2. **Meter on the background.** Set the camera to auto mode and use your camera to take a meter reading for the background. I like to use the spot meter to take a reading of the sky behind the subject. Take a note of the shutter speed and aperture settings.

3. **Underexpose the image.** Enter the settings from Step 2 into the camera while in manual mode and take a photo. Because the meter reading was taken of a brighter area, the settings will underexpose the subjects.

4. **Check your image and make any adjustments.** Use the LCD screen to see if the image worked and adjust the exposure accordingly, usually to underexpose it a little more.

5. **Finalize the image in post-production.** You can further enhance these images with software actions during post-production.

ABOUT THIS PHOTO *Exposing for the background created this silhouette of the wedding couple. Taken at ISO 100, f/5.6, 1/640 second.*

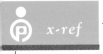

For more information on post-production and actions, see Chapter 11.

SUNSET AND LATER

One of the best times to take photographs is at sunset and for a short while after. Many photographers refer to this as the golden hour for the quality of the light present. This light is really soft because of the angle of the light as the sun drops below the horizon and is also very warm, because the light travels through the atmosphere at an angle, which just makes everything look better. When shooting people in this light, you need to carefully position the faces so that the subjects face the light and there are no deep shadows in the eye sockets and, if posing more than one individual, you also need to make sure that the light reaches everyone and isn't blocked by anyone's head.

The downside to this golden hour light is that it is actually very little light, meaning that the ISO needs to be increased or the aperture needs to be opened wide so that you can use shutter speeds that will give you sharp images. This type of light can be a little flat without much contrast. When the light is too flat, there is no direction to the light source and the subjects' features look flat, since there is no life in the eyes.

RAW VERSUS JPEG Your camera can record your photos in a variety of formats, including RAW and JPEG. It is important to understand the difference between the two and the advantages to shooting using the RAW file type, especially when in tough lighting conditions. The RAW file type records all the information from the camera's sensor without any adjustments, very much like a digital negative. This means that all the information that was present is recorded, and none of it is discarded. This creates a rather large file, but having all that information makes it much easier to adjust the image in post-processing. The downside to this is that the file can't be used in the native RAW format and needs to be processed with a software program to get the file into a usable format. This is either a program from the camera manufacturer or a third-party program that reads and translates the RAW files like Lightroom, Aperture, or the Adobe Camera RAW module of Photoshop. The JPEG format, on the other hand, is usable right out of the camera, but the tradeoff is that the image is processed in the camera and the image is compressed, which means that information is discarded. If the image needs to be edited in post-production, it can be, but the amount of data the software has to work with is much less. I recommend shooting in RAW mode for everything, but especially if the lighting is a challenge.

One way to add a little pop to images of people taken at this time of day is to use a little fill flash as described earlier. This will add a little spark to the subject's eyes, making for a better portrait.

Another control that can help as the light goes down is the auto ISO setting found on many digital cameras. This setting allows the camera to adjust the ISO automatically while leaving the shutter speed and aperture setting alone. This is great for those images you need to take as the last light of the day fades away. You have the shutter speed set fast enough for sharp images and the depth of field adjusted where you want it, so all that changes is that the ISO rises as the light levels drop. Keep in mind that this can produce digital noise at the higher ISO settings like 1600 or 3200.

PLAN AHEAD

When you shoot outdoors, the light is constantly changing. That means that scenes that are perfectly lit at 3 p.m. are radically different at 5 p.m.

and could be completely dark at 8 p.m. This is important to consider when scouting for locations before the wedding. If you can't visit the location at the same time of day you will be shooting, you need to be able to visualize where the sun will be at the approximate time the photos will be taken. This information can be really useful when working on the photography schedule and shot list. If you know that you will have great light in the afternoon, and have some time available to shoot then, schedule the portraits for that time or at least discuss it with the clients. Many times they will appreciate the concern you have and will work with you to get the best photographs and memories of the day.

There is also a really big difference in the light outside during the day and after the sun has set.

For example, in Figures 5-11 and 5-12, which were taken about seven hours apart, the building remains the same but the lighting changes dramatically. Technology can really make your life easier, especially if you use a smart phone, such

5-11

5-12

ABOUT THESE PHOTOS *This beautiful wedding site is the Villa Grazioli in Grottaferrata, Italy, and the building used to be home to the former cardinal of Rome. Now it is used as a hotel and a beautiful backdrop for a wedding. The same scene can look vastly different depending on the time of day and the lighting. Figure 5-12 was taken at ISO 100, f/5.6 and 1/800 of a second while Figure 5-13 was taken at ISO 3200, f/2.8 and 1/30 of a second.*

as an iPhone. There are apps that tell you the sunrise and sunset times, which will help you predict what the lighting will be like during the ceremony.

tip It is important to pack the right gear for an outdoor shoot as well, and while it seems counterintuitive, one of the most important pieces is the flash unit used for fill flash.

The nice part about shooting a wedding is that because you know approximately what and when things are going to happen, you can plan ahead.

If the wedding is going to take place in the late afternoon or the early evening, you can look up the exact time the sun sets and work a quick portrait into the mix, as I did in Figure 5-13. The best time for these shots is after the sun has actually set, and the light takes on a deep red and transitions into a deep blue.

While shooting outdoors might seem easier than having to deal with a dark interior, there are plenty of other challenges. Make sure you pay attention and plan ahead; the light won't wait for you.

5-13

ABOUT THIS PHOTO *The couple is lit by the setting sun that just recently passed below the horizon. Taken at ISO 5000, f/1.4, 1/1250 second.*

Assignment

Shoot with Available Light

The assignment here is to shoot during the day using the available light. This assignment might seem easy at first look, but you really need to think about the light in each photo you take. Here are some things to help you along:

- **Shoot in RAW.** Using the RAW file type gives you greater latitude in post-production editing, and it is especially useful when you are making corrections to the exposure and white balance.

- **Look for the shade.** The light in shaded areas is much softer and more pleasant to the eye. There are no harsh shadows and bright spots. This is also true on cloudy days when the clouds diffuse the light. This makes cloudy days great for taking photos of people.

- **Watch the exposure.** Decide whether you are going to expose for the bright parts or the dark parts of your image and constantly adjust as the light changes.

- **Watch for highlight warnings.** Check your camera and set the LCD to show the highlight clipping warning so that you know when parts of your image have turned completely detail-free white.

Take several shots making adjustments as you do, and post your favorite shot to the Web site to share.

Here, you can see that the bright sun was diffused beautifully by the umbrella that the bridesmaid was carrying. This created a much more even light and helped reduce the tonal range present in the image. It was taken at ISO 100, f/4, and 1/320 of a second.

Remember to visit www.pwassignments.com after you complete the assignment and share your favorite photo! It's a community of enthusiastic photographers and a great place to view what other readers have created. You can also post comments and read encouraging suggestions and feedback.

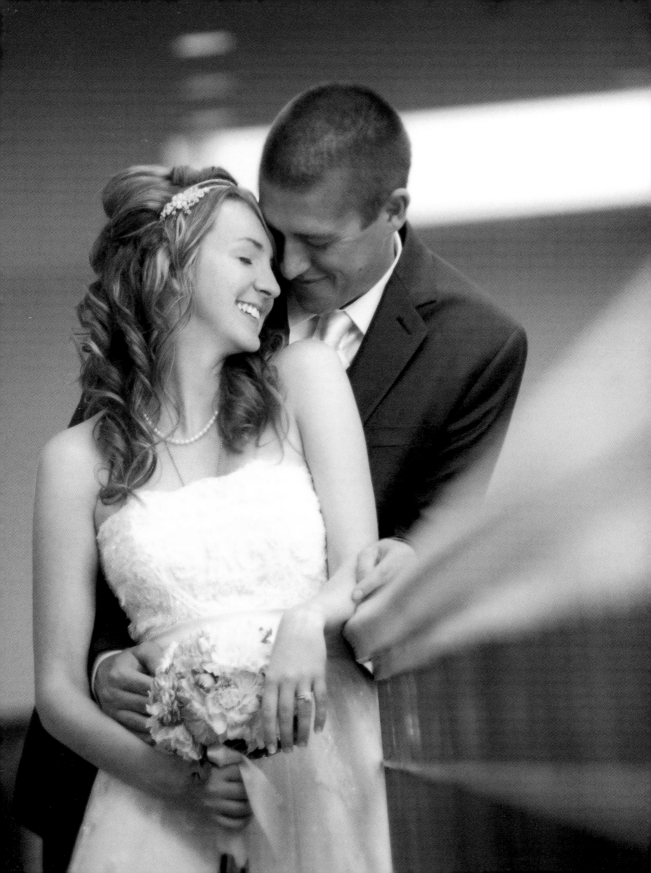

At some time during the wedding you will have to photograph indoors; even if the ceremony and reception are outdoors, the bride and groom have to get ready somewhere, usually indoors. When you think of shooting inside, the first thing that comes to mind is that there will likely be low light. While this is certainly true in a lot of cases and you need to address it, there are plenty of locations inside that have great light, usually streaming in through a window or door, as shown in Figure 6-1. When you are shooting indoors, there are many different things to consider: what lens to use, how to deal with ISO and noise, the color of light and the white balance, especially when it comes to mixed lighting, and, of course, using the flash.

EXPOSURE CONSIDERATIONS

Shooting indoors challenges you with a wide variety of lighting situations. Exposure is a balancing act between the shutter speed, aperture, and ISO. Each situation requires a different approach.

WINDOW LIGHT

Ask wedding photographers what their favorite light is and many will tell you that it is the diffused sunlight streaming through a window, wrapping around the bride or groom. It really is a very flattering light and when it is present, you need to take advantage of it.

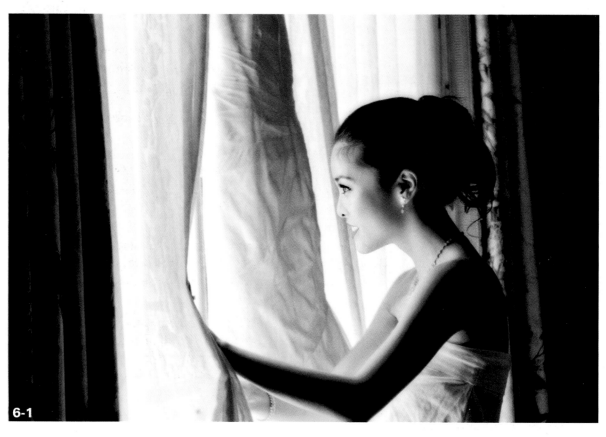

6-1

ABOUT THIS PHOTO *The light coming through the window illuminates the bride as she checks on the wedding ceremony site. Taken at ISO 1250, f/6.3, 1/320 second.*

The best part about window light is that it is simple to expose for and the results are unbeatable. Set the metering mode to spot metering and aim it toward the face of the subject. This way you will not have any really bright spots closer to the window and any dark shadows in other parts of the scene affect your meter reading. Then just take the photo. This works just as well for the groom as it does for the bride. Take Figure 6-2, for example: The light coming in from the window illuminates the groom as he patiently waits for the wedding to begin.

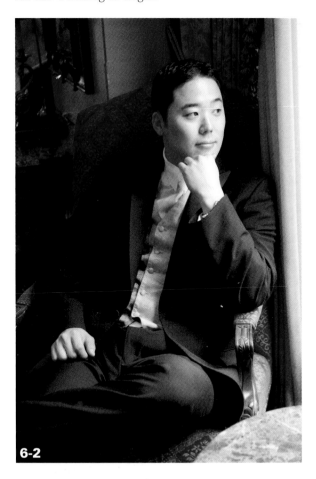

6-2

ABOUT THIS PHOTO *Placing the groom close to the window allowed me to use the flattering window light for this portrait. Taken at ISO 800, f/2.8, 1/30 second.*

There is another way you can use the light coming through the window, especially when you are shooting the wedding dress. The idea is to hang the dress in the window (see Figure 6-3) and let the light shine through so that the detail is illuminated. To properly expose this type of shot, you need to overexpose the scene slightly, and the easiest way to do this is to use exposure compensation. Just follow these steps to get the perfect exposure:

1. **Place the dress in the window.**

2. **Set your camera to spot-metering mode.**

3. **Set your camera to Auto mode.**

4. **Focus on the gray area of the dress, where the light doesn't show all the way through the material.**

5. **Press the shutter release button down halfway to activate the built-in light meter.**

6. **Make a note of the settings.**

7. **Dial in + 1/3 exposure compensation.**

8. **Take a photo.**

9. **Check the photo on the camera's LCD.** The window should be completely white, while the dress needs to be bright but not pure white.

10. **Adjust the exposure compensation.** If the image is still too dark, then increase the exposure compensation and shoot again.

Keep an eye out for the light coming through any nearby windows. Because natural light changes all the time, a window with nice soft light might not last long. Take advantage of it when you can.

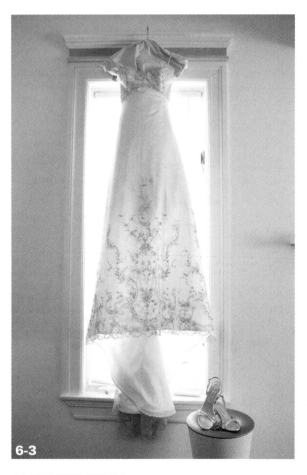

ABOUT THIS PHOTO *The wedding dress beautifully illuminated in the window. Taken at ISO 800, f/3.5, 1/160 second.*

ABOUT THIS PHOTO *The beautiful arches and stained glass windows look great but there really isn't very much light in the room, which called for these settings for a proper exposure. Taken at ISO 2500, f/2.8, 1/100 second.*

LOW LIGHT

The biggest problem when shooting inside can be the lack of available light. It is sad, but true that even with great stained glass windows and beautiful details, as shown in Figure 6-4, many churches and houses of worship are really quite dark and need high ISOs and wide apertures to get enough light to reach the sensor to make a proper exposure. This holds true for many indoor wedding locations and, while our eyes adjust to the low light rather quickly, the camera doesn't. When it comes to dealing with low-light situations, there are a few practical solutions: Use a lens with a

wide aperture to allow as much light as possible to reach the sensor, increase the ISO so that proper exposure can be achieved in really low light, or use a flash to add light if possible.

LENS CHOICES FOR LOW LIGHT

When photographing weddings, it is important to have the right lens or lenses for the job. To me, the most important factor when choosing lenses is the speed of the lens — the faster the better. Fast lenses are those with maximum apertures of f/2.8 or greater (f/2.8, f/2, f/1.8, f/1.4 and f/1.2).

These allow you to shoot in low-light situations and give you greater control over the depth of field than slower lenses. The maximum aperture available is wholly dependent on the lens you use, because the aperture is the opening in the actual lens.

When it is really dark, one of the best tools at your disposal is a good prime lens with a very wide maximum aperture of f/1.8 or f/1.4, and while there are lenses that open up to f/1.2, they can be very expensive. The good news is that you can purchase a 50mm f/1.8 lens for roughly $100 and, combined with the higher ISO ability of today's cameras, it is fast enough to be used in all but the very darkest of situations.

If you are planning on making wedding photography your career and find yourself shooting in very dark locations often, then it will pay to invest in some very fast glass. Not only was the photo in Figure 6-5 taken at a high ISO, in this case ISO 1250, it was so dark that an aperture of f/1.2 was needed along with a relatively slow shutter speed of 1/60 second.

A word of warning about buying some of the older prime lenses. Some don't have autofocus capabilities on the newer camera bodies. This is because camera manufacturers have started to make the camera bodies lighter, smaller, and cheaper by removing the autofocus motor. Newer lenses have autofocus motors built right into the

6-5

ABOUT THIS PHOTO *The couple enjoys a dance, and even with the really low light, a wide aperture and high ISO was needed to get a proper exposure. Taken at ISO 1250, f/1.2, 1/60 second.*

lens, which does make them more expensive. Make sure you check the lens compatibility before purchasing.

Buying a single prime lens with one focal length seems like a big expenditure; however, there are other lens options, such as fast zoom lenses. These lenses are often more expensive, but they are also more useful, because they provide a maximum aperture of f/2.8 at all focal lengths. These lenses are great in low light and give you the ability to change the composition without having to move. Examples of these lenses include the Canon 16-35mm f/2.8, the 24-70mm f/2.8, and the 70-200mm f/2.8 lenses (other manufacturers make comparable lenses). These three lenses cover a huge range of focal lengths from 16mm all the way to 200mm, and the aperture can be wide open at f/2.8 the whole time. I used a 70-200mm f/2.8 zoom lens to get in close and capture the groom in Figure 6-6. I could have used a prime lens, but I wouldn't have been able to adjust the composition in the same way.

> **tip** Many third-party lens manufacturers make lenses that are top quality but can cost less than the Canon or Nikon equivalents. Sigma and Tamron, for example, both make fast glass compatible with all the major camera manufacturers.

ISO AND NOISE

If there is one place that camera technology has really improved in recent years, it is in how cameras can use high ISO settings without significant digital noise. To change the ISO when shooting with film, you only had to change the film, but when it comes to digital cameras, you can't actually change the sensor that records the light. In dSLRs, the ISO is adjusted when the computer in the camera amplifies the signal from the sensor.

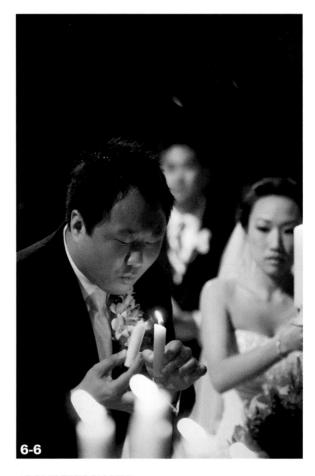

6-6

ABOUT THIS PHOTO *The groom is lit by the candle, which called for a wide aperture and high ISO. Taken at ISO 2500, f/2.8, 1/125 second.*

The more the signal is amplified, the more sensitive to light the sensor becomes, and the higher the ISO. The amount that the signal is amplified is calculated to match the characteristics of film so that when you shoot at ISO 400 on one camera, it matches ISO 400 on another camera and the ISO 400 of film. This is important, because as the signal from the sensor is amplified, digital noise is introduced, and the more the signal is amplified, the more visible the noise will be.

Digital noise shows up in your images as unwanted spots of color, and is especially noticeable in darker areas and areas with smooth tones. Using ISO 8000, as shown in Figure 6-7, results in digital noise, particularly in the dark areas of the tuxedo jacket.

Following are things that can increase the digital noise in your images:

■ **ISO.** The main cause of digital noise is ISO: The higher the ISO, the more noise you will have in your images.

■ **Exposure time.** The longer the shutter is open, the more digital noise you will have, especially when the exposure is longer than a few seconds.

■ **The relation of sensor size to megapixels.** The more megapixels there are crammed onto a sensor, the greater chance there is of noise being introduced. This is one reason that the full-frame sensors, which have more space on the sensors, can produce less noise at higher ISOs than cameras with the same megapixels on cropped sensors.

When you are shooting in a dark church or hall, many times you don't have an option and will need to shoot at high, and sometimes very high, ISOs. This means that you will need to minimize the noise as much as possible. The first step is to know the limitations of your camera and at what point the noise is just too much. Many of the newer cameras have a lot less noise at the high ISOs and give you the ability to shoot at ISOs that are much higher than film ever was. Using film with ISO 1600 would result in a very grainy photo, and using ISO 1600 would have been unheard of with digital cameras when they first came out. Now using the newer cameras, a photo taken at ISO 1600, like the one in Figure 6-8, is not a problem.

There are a few things you can do to reduce the noise in your images when taking them. The first is to slightly overexpose the image, because noise usually shows up in the dark areas of the image. Making these areas a little lighter will really help. The second is to apply noise reduction either in the camera or with software in post-production. I find that using the software choices available in post-production, especially the noise reduction available in Adobe Photoshop Lightroom 3 and Adobe Camera Raw 6 and above, is the best way

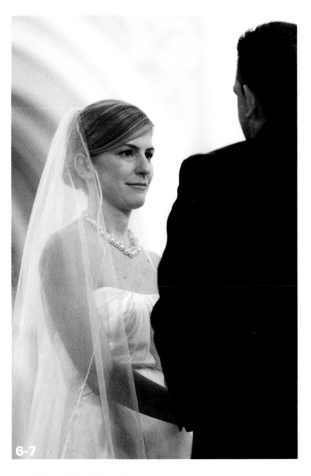

6-7

ABOUT THIS PHOTO *The low light in the church called for a high ISO, creating a noisy image. Taken at ISO 8000, f/2.8, 1/160 second.*

ABOUT THIS PHOTO *There is very little noise in this image of the ring exchange. Taken at ISO 1600, f/5, 1/200 second.*

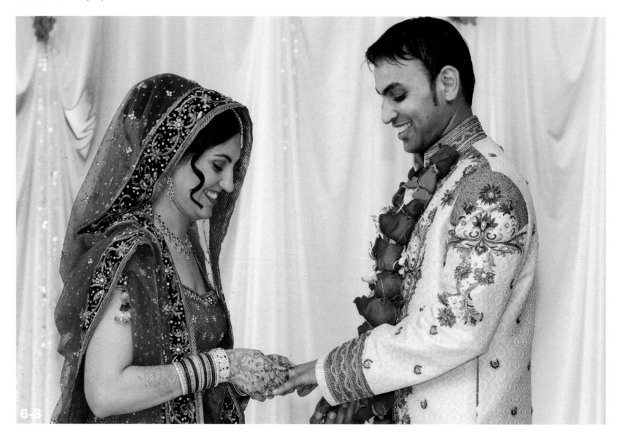

6-8

to clean up an image. The only downside to noise reduction is that it can cause a slight blurring of the image as it tries to even out the tones and get rid of the unwanted color spots. You need to experiment to see what works best for you, and read your camera manual to find out if your camera has built-in noise reduction.

note Most built-in noise reduction comes with a price: It takes longer for each image to be saved, uses more battery power, and can cause slight to moderate blurring in the image. Test your camera's noise reduction capability before an actual wedding.

The third thing you can do is to turn the image into a black-and-white image, as shown in Figure 6-9. This makes the noise look more like traditional film grain, and many clients actually like the look.

The goal is to use a high enough ISO that you can use a shutter speed that freezes the action and gives you a sharp image. So it pays to time the shots right and wait for those moments with little action or movement where you can use a slower shutter speed and still get a sharp photograph which allows you to also use a lower ISO.

110

6-9

ABOUT THIS PHOTO *A very tired guest. Taken at ISO 10000, f/2.8, 1/1/50 of a second.*

WHITE BALANCE AND ARTIFICIAL LIGHTING

When you photograph inside, there are numerous light sources available, from the sunlight streaming in through the windows to the incandescent and fluorescent bulbs that seem to be everywhere. To your eye, the light can all look very much the same and moving from one type to another doesn't make much of a difference. To the sensor in your camera, however, the changes are very noticeable. You compensate for the differences with the white balance setting on your camera. However, to fully understand why you need to make adjustments, you need to understand the color and temperature of the light and how to work with the artificial lights so that you can make the best adjustments.

COLOR OF LIGHT

Different types of light have different colorcasts that affect your images. These colorcasts can also change the mood in your image. For example, the more red or orange light in your image, the warmer the photo looks, while the more blue light in the image, the colder the image will look. When the color of the light makes the subjects in your image look green, then there is a real problem. I know you are thinking that you wouldn't

photograph under a green light, but the camera's sensor sees light very differently than you do, and it records the light as it sees it, not as you see it. Luckily, there is a way to deal with these different colors of light, and that starts with defining what the actual color of each type of light is. This is done using the temperature of the light on the Kelvin scale.

COLOR TEMPERATURE

The color temperature is a way to describe the color of light that can then be used to make sure that it is rendered properly by your camera. The Kelvin scale is based on the color produced by a theoretical black body radiator that runs from the very red low temperature (1,900K) to the very blue (16,000K). This makes sense when you think about something being white-hot as hotter than red-hot. If you look at a flame, the hottest part isn't the red and orange at the edges, but the blue and white areas at the center. Once you understand the various color temperatures of light, you can set your camera to take it into account and render the scene naturally no matter what the light source. This is where the white balance setting on your camera comes into play.

WHITE BALANCE

The white balance setting in your camera tells the sensor what color the light in the scene is and helps to render the colors accurately. After all, it is important for the bride's dress to look white, not slightly orange or blue. Because each type of light can have a different color to it, your camera can easily be fooled. The human brain and eyes see a white piece of paper as white whether it is outside or in a room with artificial light, but your camera can't make this distinction. The white balance setting on your camera allows you to

adjust the way the camera sees colors so that they are rendered correctly. After all, it is essential that the bride's white dress actually looks white in the photographs.

In Chapter 5, I discussed the importance of making sure you set the correct white balance when it comes to the difference between shooting in direct sunlight and in the shade. The difference in those light sources is mild compared to what can happen inside where different types of light bulbs are used. The good news is that you don't have to memorize the Kelvin scale or where the different types of light fall on the scale, because the camera manufacturers include preset white balance settings for the common type of lights, including Daylight, Cloudy, Shade, Incandescent, Fluorescent, Flash, and a custom white balance option. Check your camera manual for the white balance presets and how to set them; usually it is as easy as choosing a menu option or pressing a dedicated WB (white balance) button. Picking the correct white balance can make all the difference in getting the right colors in your images. Take Figures 6-10 and 6-11 for example, where the wrong white balance can ruin the photo. The first image was taken with the correct color balance, rendering the colors true, while the same image with the incorrect white balance renders the image with massive color problems.

For the white balance setting to work, the camera adds red to the photo when the light is blue and adds blue to the photo when the light is red. This way the colors will look natural, not too red or blue. Each camera manufacturer, and even each camera model, might use slightly different numbers for the actual color temperature, and you can find out what your camera uses in the camera manual. Here are the most common white balance settings and what they do:

ABOUT THESE PHOTOS *The same image processed with the correct white balance (as in Figure 6-10) is a lot different from when the wrong white balance is used (as in Figure 6-11). Both images were taken at ISO 1600, f/4, 1/300 of a second.*

6-10

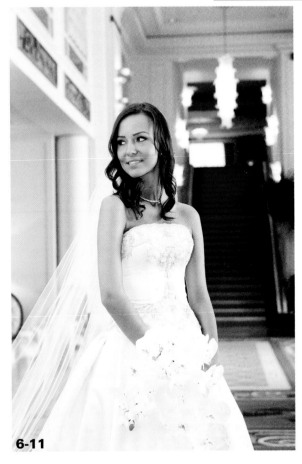

6-11

■ **Auto white balance.** Most cameras have an auto white balance setting where the cameras set the white balance for every shot. As this is a best guess by the camera and not an exact reading of the color temperature, it can be less accurate than using an actual color temperature setting, but I have found that as technology improves, so does the auto white balance setting, producing good results most of the time. The downside to using the auto white balance is that the camera adjusts the white balance constantly, so each photo has a slightly different white balance, meaning that there can be slight variations in the colors from image to image.

■ **Daylight.** The camera sets the color temperature to 5000K – 5500K, which gives an accurate color for direct sun in the middle of the day. Even though this is the correct temperature for that kind of light, it can still look a little blue or cold.

■ **Cloudy.** The Cloudy setting assumes that the direct sun is being diffused by clouds and makes the color a little warmer. The camera sets the color temperature to 6000K – 7500K and adds a little more red to balance out the slightly bluer light. This is a good choice when photographing outdoors, as it makes people look slightly warmer even when used in direct sunlight.

■ **Flash.** The Flash setting and the Cloudy setting are similar, and it can be tough to tell them apart. The Flash setting is meant to match the color of the light from an electronic flash, usually around 6000K, which tends to be a little cooler, so the white balance setting adds back in some of the warmth to get a natural look.

■ **Shade.** The color temperature of the light in the shade is 7000K – 8500K. The Shade white balance setting in your camera really starts to add red to the image to counteract the blue light present in the shade. This setting also works really well for very cloudy and overcast days.

■ **Tungsten or incandescent.** This setting is used when shooting indoors under the very warm tungsten or incandescent bulbs. These types of bulbs have a color temperature of 2000K – 3000K, which is very red. The camera adds a lot of blue to the image to counteract the very red light in order to end up with a true representation of the color. Many times this setting can actually look a little too blue, and a better choice is the fluorescent white balance setting,

■ **Fluorescent.** Fluorescent bulbs are different from other types of bulbs because of the way they work. They do not have an element that is heated up to produce light but instead use electricity to excite the chemical phosphors that coat the inside of a gas-filled tube. Each different type of phosphor creates a different color of light, and the bulb manufacturers use a variety of phosphors to mimic a nice white light. These lights can have a wide variety of color temperatures from 3200K – 7500K. The camera sensors have a really hard time with this type of light, and many times the subject photographed under fluorescents can have a sickly green cast. Another problem is that small fluctuations in the electric flow to the bulb create shifts in the color that you might not see with your eye but the sensor will pick up every time. The fluorescent white balance tries to counteract this and can do a satisfactory job, but using a custom white balance in these circumstances is a better solution.

■ **Custom white balance.** Some lighting situations are tougher than others (more on that in the next section), and the best solution to this is the custom white balance. This is where you can set the white balance based on the light in the scene and is covered in more detail in the following section.

> **tip** One of the biggest advantages to using the RAW file type when you're taking pictures is you can easily adjust the white balance using software in post-production. This works best if the light illuminating the scene is only one type of light.

MIXED LIGHTING CONDITIONS

Shooting indoors can mean a mix of different types of lighting, where incandescent bulbs and fluorescent bulbs are used in the same location, or there is natural sunlight illuminating part of the scene and incandescent or fluorescent bulbs illuminating parts of the scene. Because these lights all have different colorcasts, it can be a real headache getting the colors to render properly.

If the subject is predominantly lit by one light with just a smattering of other lights in the scene, then the best bet is to determine what the main light source is and set the camera to render that correctly, as shown in Figure 6-12. For example, if I had set the white balance to render the sunlight correctly, then the interior would have been too orange.

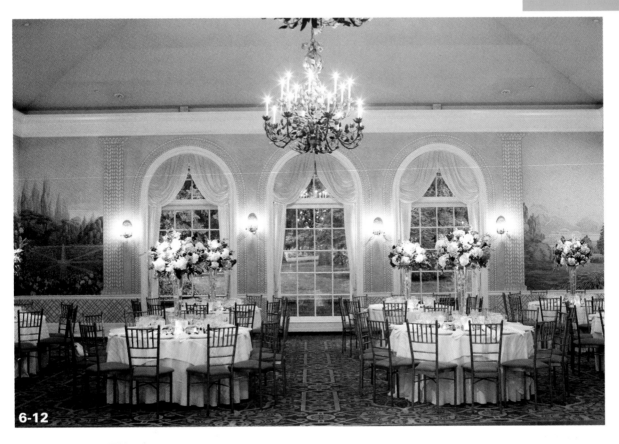

6-12

ABOUT THIS PHOTO *This room was lit with a combination of room lights and sunlight from the large windows. I used a custom white balance that correctly rendered the inside lighting to be white, which caused the sunlight to take on a blue cast. Taken at ISO 2500, f/2.8, 1/60 second.*

When it is difficult or impossible to tell what the main light is or the mix of lighting makes it impractical to use one of the preset white balance settings, then a custom white balance will help. To learn how to set up the custom white balance for your camera, you will need to read the camera manual, but the idea is the same no matter what camera you are using. Start with a white item that can be placed in the lighting you want to set the white balance for. This can be a piece of paper or a piece of white material. I carry a piece of white cloth in my camera bag for these types of situations. You place the white object in the lighting and take a reference photo of it, and then

you tell the white balance that the object is white, and the camera adjust, the colors to match. This works well, but you do need to remember to change the white balance when the lights change.

Many times it is possible to just move the subjects so that they are illuminated by one type of light. However, if that isn't possible, then look to see if you can turn off one of the light sources. When you do this, you will have to increase the ISO, reduce the shutter speed, or use a wider aperture because there is less light. It's also possible to use a flash to add a little light back into the scene. When using a flash in mixed lighting situations,

adding a gel over the flash head will make it possible for the light from the flash to match the existing light (there is more on using a flash in the next section).

If the mix of lighting is really tough, it is possible to adjust the image in post-production to adjust for the different colors of light. The key to doing this is to process the same image multiple times for each of the different light sources. You can then build a composite image, making sure that the entire image looks correct. This method can take a while to get correct and involves quite a bit of image-editing know-how, which is why it is a last resort. To make it easier to adjust the white balance in postproduction, I recommend shooting using RAW, because this has the most information and allows for the easiest postproduction white balance adjustments.

WHEN TO USE THE FLASH

It is true that using a flash during the ceremony is usually frowned upon, but there are plenty of times you can use your flash with great success, especially before and after the ceremony and during the reception. There are some general things to keep in mind when using a flash:

- **Flash sync speed.** When using a flash with your camera, there is a limit to how high of a shutter speed you can use. This is because the shutter inside the camera needs to be open long enough to record the flash. The fastest sync speed is determined by your camera and flash combination, so check with the camera and flash manuals to find out the top sync speed for your camera and flash combination. The usual top sync speed is 1/200 or 1/250 second, but you can use any shutter speed up to and including the top sync speed.

- **High speed sync.** Some cameras allow you to use a flash at much higher shutter speeds than the 1/200 second or 1/250 second sync speeds. It completely depends on the camera and flash. Being able to use a flash at higher shutter speeds allows easier fill flash usage and gives you a wider range of settings to use.

- **Shutter speed.** The shutter speed controls how much of the ambient light is present in the image. Because a longer shutter speed allows more ambient light to reach the sensor, when you want to capture parts of the room and backgrounds at weddings, you can. I like to shoot indoors generally with a flash at 1/30 second or even less. The subject appears sharp, because the very short flash duration freezes the subject in place. For example, for the bride waiting to throw her bouquet in Figure 6-13, I used a shutter speed of 1/20 second, and the women waiting in the background are lit by the ambient light. When using the flash, there are actually two exposures being captured at the same time. The first is the ambient exposure, controlled by the shutter speed, and the second is the flash exposure, controlled by the power of the flash and aperture.

- **Aperture.** The aperture controls the exposure by determining how much of the light from the flash reaches the sensor: The wider the aperture, the more the flash illuminates the scene. The key is to get a nice balance between the shutter speed (ambient light) and the aperture (flash light).

 x-ref For more on exposure basics see Chapter 3.

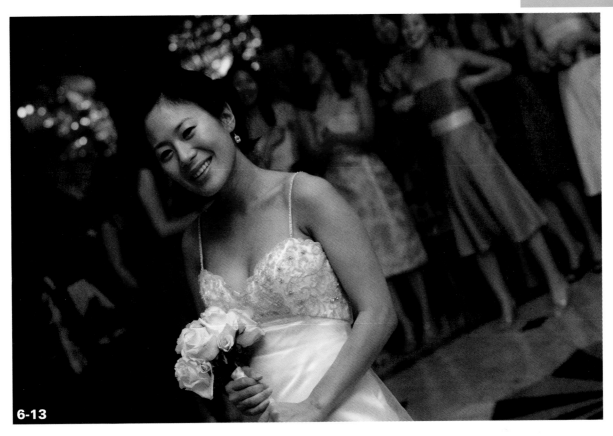

6-13

ABOUT THIS PHOTO *The bride is illuminated by the flash, but the women waiting for her to throw the bouquet are lit by the ambient light that was picked up because the shutter was left open long enough to let the light reach the sensor. Taken at ISO 5000, f/4.5, 1/20 second.*

■ **Rear-curtain sync.** Most cameras allow you to decide when the flash fires: at the beginning of the exposure or at the end. When you fire the flash at the beginning of the exposure and use a longer shutter speed, any movement happens after you have frozen the subject with the flash (front-curtain sync). When you fire the flash at the end of the exposure (rear-curtain sync), the subjects are frozen at the end of any movement caused by the long shutter speed.

■ **Off-camera flash.** You can do a lot to diffuse the light from an on-camera flash but if you can get the light off your flash, you will instantly see better results. A flash on a light stand set off to the side and a little higher than your camera will result in a better shot. Many manufacturers have built-in controls that allow you to use the built-in flash or dedicated flash unit on the camera to trigger an off-camera flash. There are also flash triggers from companies like Pocket Wizard and radio-popper that allow for off-camera flash triggering from the camera. The placement of the off-camera flash depends on where it can do the most good, but I like to use it placed a little overhead and off at an angle to the subject.

■ **Gels.** The light from your flash(es) is set to be as close to daylight as possible, which works well when you use flash with daylight or all by itself. However, when you are using a flash with the existing fluorescent light in a room, you need to make the color of the light from the flash match. You can do this with gels, which are small pieces of colored material that go over the flash head and change the color of the light. By using gels, you can balance the color of the ambient light with the light from your flash, making it seem like it was all from the same light source.

Keep your flash on the camera and turn it on when wanted or needed. This will save you time, and you are less likely to miss any shots because you weren't ready. Even when the flash is not allowed during the ceremony, it is usually allowed during the processional, as shown in Figure 6-14. If my flash wasn't on the camera, I wouldn't have been able to get this shot because even at ISO 2500 and 1/4 of a second shutter speed, it was still too dark to get a proper exposure.

One last thing to keep in mind when using a flash is the recycle time. The flash needs time to build up a charge between flashes. That means that you need to wait a few seconds between shots. An external battery pack will help the flash recycle faster, but it is up to you to make sure that the flash fired. When in doubt, check the LCD on the back of the camera to make sure everything is working. Some flashes can overheat if you use

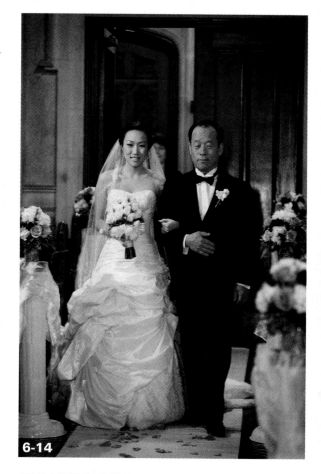

6-14

ABOUT THIS PHOTO *The bride being escorted down the aisle by her father. Taken at ISO 2500, f/2.8, 1/40 second with rear-curtain sync.*

them too much in a short period of time. If your flash does this, either have another flash ready to go or make sure you time your shots so the flash has plenty of time to cool down.

Assignment

Using Front and Rear Sync Flash Modes

This assignment is to capture the same scene using front curtain sync and rear curtain sync. It is up to you to decide which method conveys the scene you photograph best and post that image to the Web site.

Start with a longer shutter speed, usually 1/15 of a second or longer, and choose a scene that has movement in it. When the flash fires, the movement is frozen, so the big difference between front and rear sync is when the movement is frozen, either at the beginning of the scene or the end of the scene. Each gives the image a different feel. When the flash fires at the beginning of the scene, the subject is frozen and any movement after the flash but before the shutter closes looks like a blur moving away from the subject. When the flash fires at the end of the scene, the movement is captured before the flash, creating a blur that moves toward the subject. If the subject is moving randomly, say a spinning bride, it doesn't matter where the blur appears, so using rear curtain sync has no advantage.

A great time to use this technique is during the reception when photographing the dancing because it will add a sense of movement to the scene as I did for the assignment figure. For this couple dancing, I used a slower shutter speed, all the way down to 1/6 of a second and an ISO of 800 because the room was quite dark. Then I set the flash to fire in rear curtain sync mode and froze the couple at the end of the exposure.

 Remember to visit www.pwassignments.com after you complete the assignment and share your favorite photo! It's a community of enthusiastic photographers and a great place to view what other readers have created. You can also post comments and read encouraging suggestions and feedback.

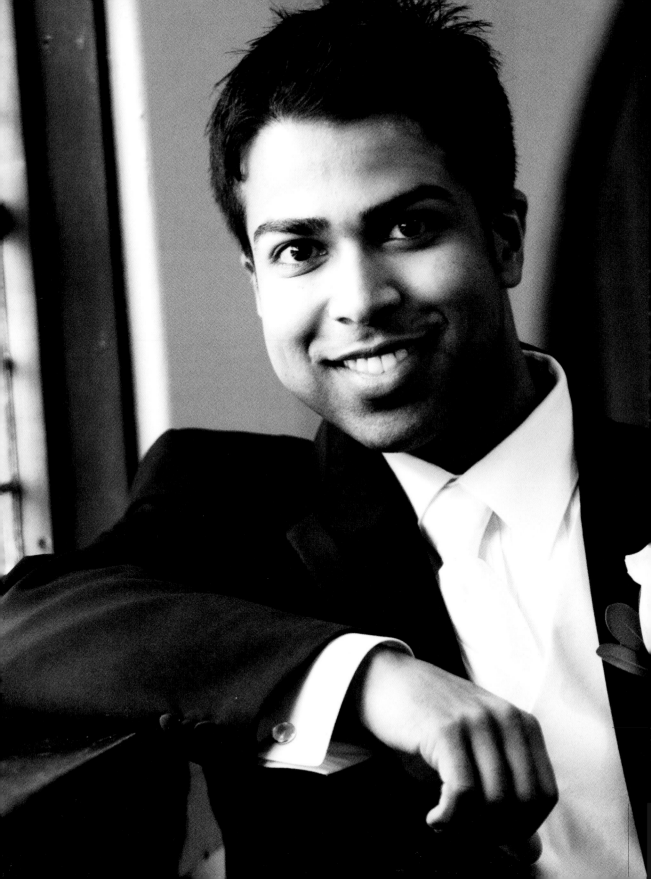

THE BRIDE AND GROOM

Photographing the bride and the groom is your main focus as a wedding photographer, and while the ceremony and reception are important, the portraits are where you can really shine. The basics are pretty simple: Set up a time and place, pose the couple, and take the portraits. The key is that the time you spend getting the portraits needs to be quality time. You want to make sure the location the portraits are to be taken is near the ceremony or reception location so that you don't waste the bride's and groom's or the wedding party's time. And you need to have a portrait plan. Ideally, you want to plan when the portraits will take place — before the ceremony, before the reception, or a combination of both times. You will also want to pick a location with good light and a background that adds to the image rather than distracts from it. At times, the area can have another meaning, as is the case in Figure 7-1, where the Beverly Hills sign adds some fun to the photograph while at the same time leaving no doubt where the wedding took place.

WHEN TO TAKE THE PORTAITS

To do the best job with the bride and groom portraits, you will need to spend a little time and not rush through the portraits. This means you should schedule the time beforehand and make sure it is included in the wedding schedule. You can take individual portraits of the bride and individual portraits of the groom as they get ready for the ceremony, as well as after it. However, this can be tough logistically, and it is one of the main reasons to work with a second photographer at weddings. When the bride and groom are getting ready at the same time but in different locations, it can be difficult for one photographer to cover everything, so while you are shooting the individual

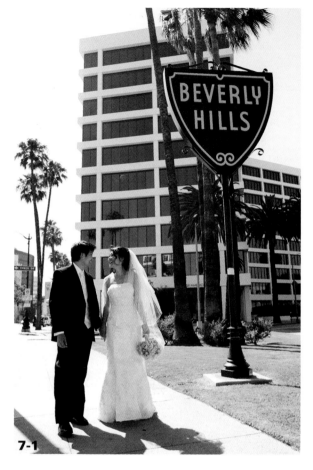

7-1

ABOUT THIS PHOTO *The Beverly Hills sign adds a location to the portrait of the bride and groom. Taken at ISO 200, f/3.5, 1/1000 second.*

portraits of the bride, the second photographer can shoot the individual portraits of the groom. You can also shoot the portraits of the bride and groom together before the ceremony if the bride and groom agree to it.

There are some really good reasons to do the bride and groom portraits prior to the ceremony:

■ Everyone looks his or her best. Because these shots are taken before the ceremony but after the makeup and hair are done, everyone looks fresh and photo-ready.

- You can schedule some extra time. If you know how long these shots will take, you can start preparing earlier and have some time set aside for the portraits here.

- The light can be better. Many weddings start in the late afternoon or early evening, and the light starts to diminish pretty quickly. When you shoot in the early afternoon, you can get brighter light, which is especially helpful for shots indoors where your main light source might be the available light coming through the windows or doors.

- There are fewer distractions. Because there are fewer guests and people around, there are fewer distractions for the bride and groom. This allows them to focus on the photos rather than on mingling with their guests.

Many times the bride and groom will still want to capture that first look as the groom sees his bride for the first time in the wedding dress. You can set up for a first look photo. As shown in Figures 7-2 through 7-4, it is possible to set up a great shot where you capture the moment the bride and the groom first see each other.

7-2

7-3

ABOUT THESE PHOTOS *The first look between the bride and her groom on the wedding day can be set up as a sequence with great results. All images taken at ISO 100, f/5.6, 1/250 second.*

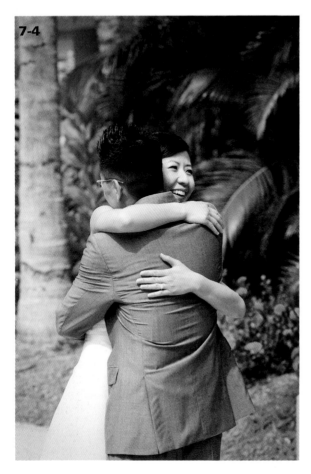

7-4

There are still some couples that believe the bride and groom shouldn't see each other until the actual ceremony, when the bride walks down the aisle. In this case, you will have to take the portraits of the bride and groom together after the ceremony, before the reception. Make sure you discuss these options with the couple before the wedding so that they understand how much time is needed for you to get all the photos they want. And there are advantages to taking the portraits of the bride and groom together after the ceremony: The couple is going to be more relaxed, everyone is dressed and ready to go at the same time (before-ceremony shots may find you waiting on some members of the wedding party), and chances are that the mood is a lot lighter. The most important thing is that you listen to the clients' wishes and don't pressure them into something that they will regret. Many times, traditional values dictate that the bride doesn't see the groom until the wedding ceremony, and you need to respect that.

The key to deciding when to take the portraits is to discuss the various options with the clients. Make sure to go over the pros and cons of each option with the couple, and that no matter what time you use for the portraits, you are on the same page as the bride and groom.

THE BRIDE

The bride is at the center of the wedding, and nothing of importance happens without her being present. Your coverage of the bride usually begins when she arrives at the wedding location or the pre-ceremony staging area so that you can capture her getting ready for her day, and continues until she and her new husband are whisked away at the end of the reception. That isn't to say that the groom should be ignored, but if there is one main subject at a wedding, it is the bride. Chances are that you will spend more time photographing the bride at the wedding than anyone else.

GETTING READY

Photographing the bride while she is getting ready is easier if you have developed a rapport with her before the big day. All the time you spent discussing what the couple wants from a wedding photographer, the schedule of events, and the people in the wedding will begin to pay off.

The area where the bride gets ready can range from a large, brightly lit room to a small room in need of some lighting help, but the one thing that usually holds true is that it can seem very chaotic. The bride and her bridesmaids, all in various stages of preparation with bags and boxes, and makeup and hair products, and clothes everywhere, can make for a busy, crowded image.

The following tips will help you get the best shots in what can be a very crowded, difficult situation.

■ **Look for the best angles.** Look for the angles that will keep the attention on your subjects and not highlight the background. If needed, move some of the furniture and clear the art

off the walls; and then carefully pick the right angle. Just remember to put the items back where they belong when you are done.

■ **Use a shallow depth of field.** Shooting with a shallow depth of field allows the camera to use as much of the available light as possible and create a nice blurred background, keeping the attention on the bride. If you are shooting the entire room, make sure that the focus point is on the main subject, because with a shallow depth of field, items in the foreground and background will be out of focus. Using a shallow depth of field, as shown in Figure 7-5, makes the background pleasantly out of focus.

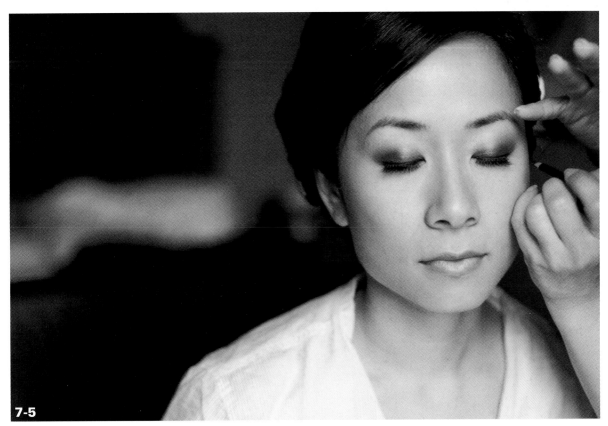

7-5

ABOUT THIS PHOTO *With an aperture of f/2.2, the shallow depth of field causes the background to be out of focus and focuses the attention on the subject. Taken at ISO 400, f/2.2, 1/250 second.*

■ **Use a wide-angle lens carefully.** Wide-angle lenses are great for capturing the scene inside and can even make a smaller room look big. On the downside, the distortion on the edges of the frame can make anything appearing there look odd, so try to keep the people in the middle of the frame. This is particularly true when you use a fisheye lens, where the distortion on the edges is extreme.

■ **Use the available light.** If the room has windows, the light coming in often helps with the photos. However, if the light is very bright, it can cause exposure problems in the room because the difference between the very bright light and any shadows in the room makes the tonal range difficult to capture. If that is the case, try to diffuse the light. A diffuser works, but you can also use a thin white tablecloth or sheet. Just make sure the material is white, because the light will pick up any color present in the material, and you will end up with a similar colorcast in your image. For example, a light green or blue material will turn your whole scene a light blue or green.

■ **Use a flash if needed.** There are two good reasons to use a flash: The first is to add light to the scene because it's too dark, and the second is to balance the light coming through the window. When using a flash in the small room, aim the flash at the ceiling to bounce the light into the room, creating a larger, softer, and more flattering light.

■ **Talk to your subjects.** Candid shots are great, but it is important to get the images you need for your client; this means letting the bride and the bridesmaids know what you are up to. It will also help you build your rapport with the bride. A little direction from you can help you create better shots.

■ **Look for the emotions.** A wedding is a very emotional time for the bride and everyone else involved. During the time the bride and groom are getting ready, you can capture the emotions that come to the surface before the ceremony. Again, the rapport you have built with your clients comes into play. The more comfortable they are around you and your camera, the easier it will be for them to allow the real emotions to come through.

■ **Hair and makeup.** Taking photos during the hair and makeup means working around a group of people. Make sure you introduce yourself to everyone and know that you are being watched by the bridesmaids, family, and hair and makeup artists, so being professional is really important. As shown in Figure 7-6, a simple photograph of the bride getting some makeup touch ups can really set the scene.

■ **Get in close and fill the frame.** Use a longer focal length to get in close to the subject and fill the frame while staying out of the way. If the light is too low, a 35mm, 50mm, or 85mm prime lens with a maximum aperture of f/1.4 or f/1.8 can really save the day.

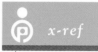

x-ref For tips on shooting the bridesmaids with the bride, see Chapter 8.

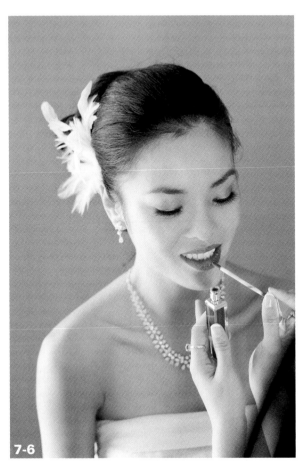

7-6

ABOUT THIS PHOTO *The bride getting a quick makeup touch up makes for a great photo. Taken at ISO 800, f/2.5, 1/200 second.*

THE RINGS

The wedding rings are the symbol of the marriage of two people, and a lot of time, energy, and money went into their purchase; therefore, while they can be photographed on the bride's and groom's hands after the ceremony, taking photographs of just the rings before the ceremony is a great idea. The first thing to know is who has the

rings before the ceremony and to make sure that you have access to both of the rings at the same time. If the rings are being held separately, then you will need to make some time during the reception to get the rings from the bride and groom and set up a quick shot. If you explain what it is you need, the couple will be happy to help.

Photographing the rings is more about product photography than it is about people photography, so it takes a little planning, and the exposure settings are important. The rings need to be clean and free of fingerprints and smudges, which you can do with a lens-cleaning cloth, but this makes the rings even more reflective, so it is critical that you make sure nothing unwanted is being reflected back toward the lens. There are times when a reflection is unavoidable, especially if you need to show a special feature, like the inscription as shown in Figure 7-7. The angle of the rings created a reflection that can be seen in the bottom ring, but the careful composition made it possible to see the inscription inside the ring.

Another important factor is the aperture you use, because the depth of field is impacted by the distance of the lens to the subject. The closer the lens is to the subject, the shallower the depth of field, and when you are shooting the rings, you are going to be really close to get the details. This means that you will have to carefully watch the depth of field so that both rings are in focus. As you use smaller and smaller apertures, the shutter speed needs to decrease to get the same exposure; otherwise, you need to add light with a flash or move the rings into a more natural light setting. You can also increase the ISO so that a faster shutter speed and a deeper depth of field are both possible.

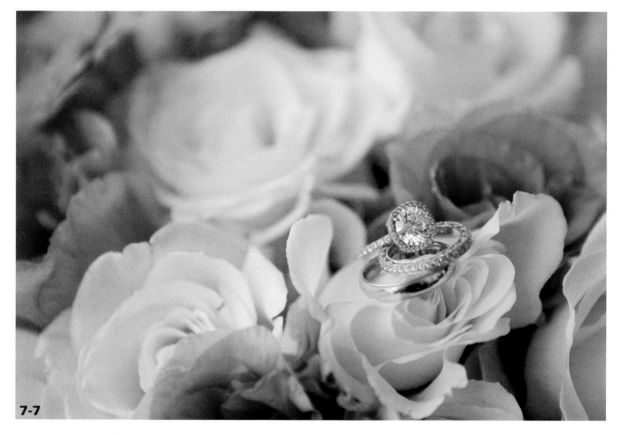

7-7

ABOUT THIS PHOTO *Notice how while there is a slight reflection on the bottom ring, you can see the inscription inside the ring. Taken at ISO 1000, f/2.8, 1/200 second.*

Set the rings in the scene carefully so that they are the focus of the shot, but in surroundings that can help to give the photo a time and place. Either placing the rings on the ring pillow (or a special tray) being held by the ring bearer, as shown in Figure 7-8, or placing them on the wedding invitation can create a strong photo. Use your imagination and look around the location for items you can use to highlight the rings.

THE DRESS

It takes a lot of time and energy for the bride to pick out the perfect wedding dress. It is likely the most important item of clothing she will only wear only once and for a very short period of time, but it will be in many photos, videos, and memories, and it needs to be photographed.

Photographing the dress calls for a good light and a very accurate exposure to show the dress in the best possible way. But before you can do any of

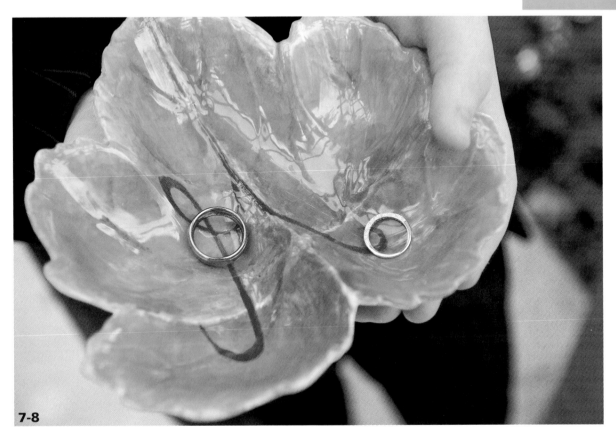

7-8

ABOUT THIS PHOTO *Instead of a ring pillow, this custom ring carrier works really well, and the shot will mean more to the couple later. Taken at ISO 400, f/3.5, 1/125 second.*

that, you need to find a way to hang the dress and make it look its best, so bring along a sturdy wooden or satin hanger (see Figure 7-9).

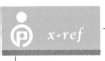

x-ref

For exposure help when dealing with the white wedding dress, see Chapter 3.

The next step is to find a spot where natural light offers even coverage for the dress, and because the built-in light meter will try to average the

scene to 18% gray, there is a good chance you will have to slightly overexpose the image. To do this accurately, follow these steps:

1. **Place the dress where you want to photograph it.**

2. **Set your camera to auto mode and press the shutter release button halfway down to see what shutter speed and aperture setting the camera suggests for the correct exposure.**

3. **Change the mode to manual mode and enter the settings from Step 2.**

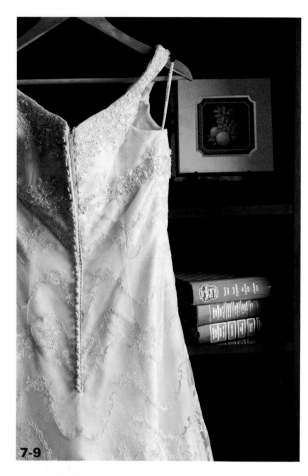

7-9

ABOUT THIS PHOTO *Displaying the dress can be a challenge, but it can be made easier when you have a good wooden hanger, as it can appear in the image without detracting from the image. Taken at ISO 500, f/4, 1/200 second.*

4. **Adjust the exposure by either reducing the shutter speed, opening up the aperture, or increasing the ISO.** Any of these methods overexposes the image.

5. **Take a photograph and check the LCD screen on the back of your camera.** It is very important to check the highlight clipping (known by the very scientific term *blinkies*), which instantly shows you areas that are too

bright. Every camera is a little different, so look in the user guide for how to show the highlight clipping on your camera.

6. **Adjust the exposure settings and take another photograph.**

7. **Once the exposure is set, it's time to adjust the composition and let your creativity come through.**

It is important to get these shots done early so that you don't hold up the bride from getting dressed and throw the timeline out of whack.

While the dress itself might be the main item of clothing that needs to be photographed, that doesn't mean it is the only thing. Consider the fine details of the dress, such as beading or lace, the jewelry, and anything else that helps to create a full story of the day.

Take the shoes, for example; they can really be something special, as shown in Figure 7-10. A macro lens is really useful for capturing these details because it allows you to get really close and fill the frame with the smallest of details. These lenses work great for shooting the rings, as well.

POSING THE BRIDE

The time has come to take the portraits of the bride. Pick up any wedding magazine or wedding book of any type and the chances are that the majority of the images will be of the bride, posed, poised, and looking stunning. Before posing the bride or raising the camera to your eye, take a moment and let the bride take a few deep breaths to get her calm and centered. These portraits of the bride can be taken before the ceremony or after, so make sure you discuss the option with the clients and schedule the time.

7-10

ABOUT THIS PHOTO *The bride's special shoes for the day. Taken at ISO 1000, f/4, 1/200 second.*

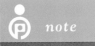 *note*

These posing tips can be applied to the groom as well.

The following tips can help you take better portraits:

- Focus on the eyes. The most important thing to do when taking portraits is to focus on the eyes. It doesn't matter if the rest of the image is fantastic; if the eyes are out of focus, then the shot will seem wrong. If the bride is standing at an angle and one eye is closer to the camera than the other, focus on the closer eye.

- **Watch the joints.** When composing a portrait, don't have the edge of the frame cut off the image at any of the subject's joints. This includes the wrists, elbows, ankles, knees, and even the waist.

- **Keep it simple.** There is no reason to create awkward poses where the bride looks uncomfortable because it just results in an awkward image. It doesn't matter if the images are outdoors or indoors; the same posing works as shown in Figures 7-11 and 7-12.

- **Watch the angle.** Turn the bride slightly so that she is not square to the camera. This is a great way to make the bride look a little slimmer, not that she needs it.

- **Have the bride sit or stand.** Sitting can help with a bride who slouches because the back of the chair will help her sit up straight, but be careful of this type of shot if the bride is slightly larger because it can make her look a little bigger. Pay close attention to the dress; many times wedding dresses look fuller when the bride is seated. This can make the bride look larger than she is and should be avoided.

- **Pick the best focal length.** The longer the focal length, the more flattering the subject will look. So try to pick a location that allows you a lot of working room so that you can use a longer lens (think 70-200mm).

Once you have the shots you need of the bride, it's time to think about getting shots of the groom and then some shots of the bride and groom together. You don't need to go wild with the images of the bride alone given this is a wedding and not a fashion shoot. Get a few great portraits with different poses and move on to the shots of the groom.

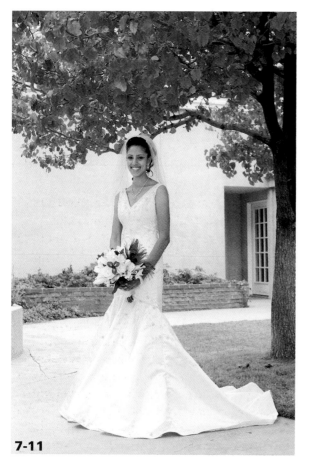

ABOUT THESE PHOTOS *It's important to get a variety of different poses with the bride. Figure 7-11 was shot outside on a sunny day using the shade from the tree. Taken at ISO 500, f/4, 1/1600 second. Figure 7-12 was shot indoors using the light coming through the windows. Taken at ISO 400, f/3.5, 1/800 second.*

THE GROOM

The bride might be the most important person at the wedding, but the groom is a very close second. Many times the groom and the bride get ready at the same time in different locations, making it very difficult to photograph both at the same time. One way to help with this is to have a second photographer work with you at the wedding. If you have a second shooter, he can be taking the photos of the groom getting ready or some portraits of the groom before the wedding, like in Figure 7-13, while you are off shooting the bride getting ready. If you are working as a second

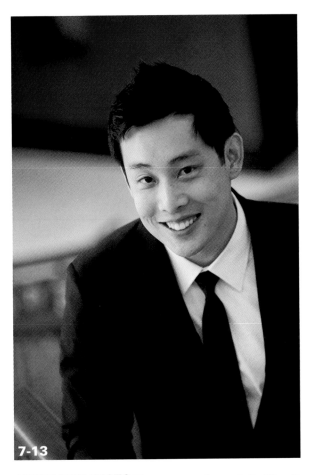

7-13

ABOUT THIS PHOTO *The groom poses for a portrait while wait-ing for the bride to join him for the joint portraits. Taken at ISO 1600, f/2.8, 1/125 second.*

shooter, there is a good chance you will be off shooting the groom getting ready while the main photographer is with the bride. If you are cover-ing the wedding alone, you will need to be smart with the timing and make sure you can get from the bride's staging area to the groom's staging area so that you can cover as much as possible.

GETTING READY

Some great moments can be had when the groom is getting ready. The camaraderie between the groom and his groomsmen is very different from that between the bride and the bridesmaids. Men tend to joke around more and use humor to mask their feelings about the big day and the serious-ness of getting married. This jovial attitude can be great for images and as the photographer, try to keep the mood light.

A groom can be just as nervous as his bride, espe-cially leading up to the ceremony, and that ner-vous energy can make for some great moments of him alone and with his groomsmen and family. As with the bride, images of the groom getting ready can help tell the story of the wedding. Capturing those moments showing the groom getting ready like in Figure 7-14 can actually be more difficult than photographing the bride, especially if it is the second shooter who is cover-ing the groom. The second shooter isn't likely to have the rapport that you have developed with the couple and must come in as a stranger. Make sure that you discuss a second shooter with the couple from the onset so that they know that you will be with the bride and not with the groom when the two are getting ready at the same time. The wedding day is not the time for them to be surprised with this information.

THE TUXEDO

The groom's tuxedo or suit might not be as glam-orous as the bride's dress, but it can still make for a great photograph and can help tell the story of

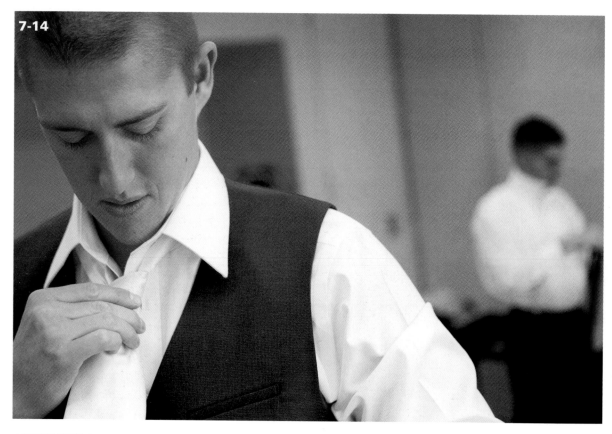

ABOUT THIS PHOTO *The groom getting ready for the big event. Taken at ISO 2500, f/2.8, 1/500 second.*

the wedding. Because the tux or suit is usually dark, just having it alone in the frame can be a little boring and can cause some exposure concerns. Instead, have the tux laid out with the shoes, or place the groom in the shot as I did in Figure 7-15. This adds a little more of the story to the image and also helps with the exposure. If you are shooting a photo with a mostly dark tuxedo, you want to underexpose the scene slightly to make sure the dark material stays dark. The built-in light meter will try to set the exposure too bright because it is working on trying to achieve an 18% gray average in the image.

These steps will help you get the proper exposure:

1. **Set the tuxedo or suit up where you want to photograph it.**

2. **Set your camera to aperture priority mode and pick an aperture that gives you the desired depth of field.**

3. **Take a photo and check the LCD screen.** The tuxedo should look a little light.

4. **Adjust the exposure by dialing in negative exposure compensation; start with a 1/2 stop.**

7-15

ABOUT THIS PHOTO *The groom with his tuxedo all ready to go, Taken at ISO 800, f/3.5, 1/60 second.*

5. **Take a photograph and check the LCD screen on the back of your camera.** The tuxedo should look darker and truer to the actual color. Check the histogram to see if there is any dark area clipping, which appears as a solid line on the dark side of the graph.

6. **Repeat steps 4 and 5 until you have the exposure you want.**

7. **Now that the exposure is set, it's time to adjust the composition.**

Some of my best shots have happened when I could set the bride and her dress up and then use the same composition for the groom and his tuxedo. These matching images really help tell the story of the couple getting ready for the big day.

When you are photographing the groom, in addition to capturing the tuxedo, there are many items that make great detail photos. They can run the gamut from a custom set of cuff links, a special watch, or another piece of jewelry to a different type of vest or article of clothing that the groom is wearing. If you are a second shooter and are covering the groom getting ready, this might be the first time you are meeting the groom, so talk to him and work on discovering his personality. Ask the groom if there are any special details he'd like captured, like the watch and keychain shown in Figure 7-16. Many times men get special items handed down from generation to generation, and some of the most common ones are cuff links, so be sure to ask about them specifically.

I know that it is rather clichéd to make jokes about women and their shoes, but men like their shoes as well, and sometimes it is the one place where a little personality shines through.

The best lens to use for these detail shots is one with a macro setting. This enables you to focus in really close and fill the frame with smaller objects. When you use a macro lens, it is important to closely control the depth of field. Given you are shooting very close to the items, the depth of field is very shallow, and even the slightest movement will change what is and isn't in focus. Check your work on the LCD screen on the back of the camera and zoom in to view the preview at 100% to make sure that the focus is sharp on the subject.

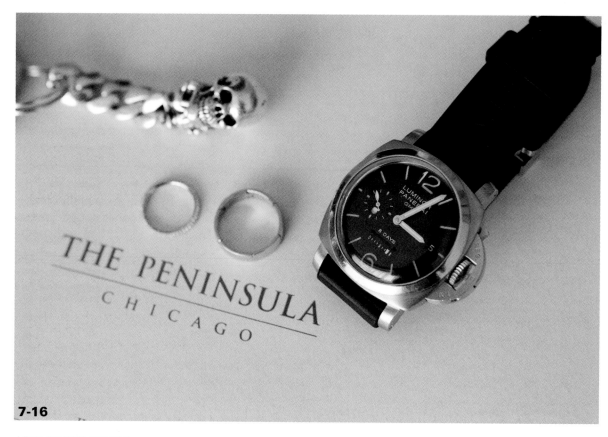

7-16

ABOUT THIS PHOTO *The watch, keychain, and wedding rings along with the location of the wedding make for a great photograph. Taken at ISO 800, f/3.5, 1/60 second.*

tip There are close-up filters available that will work for this type of shot. They cost less and are easier to carry around.

POSING THE GROOM

The job of the photographer, any portrait photographer, is to make the subject look as good as possible. Unless the groom is a professional model or actor, the odds are that he doesn't get his portrait taken much and it can be a nerve-racking experience, especially on his wedding day. So along with making the groom look good, you need to help him be calm and natural. Sometimes you get really lucky and your client is used to being in front of the camera; then it is just a matter of having him do what he does and photographing

him doing it. That was the case with Yul Kwon, shown in Figure 7-17, who was really comfortable in front of the camera from his time on television.

Your confidence and skills when it comes to posing the groom can help with getting a groom to look calm and natural in front of the camera. Here are some solutions to some of the most common problems:

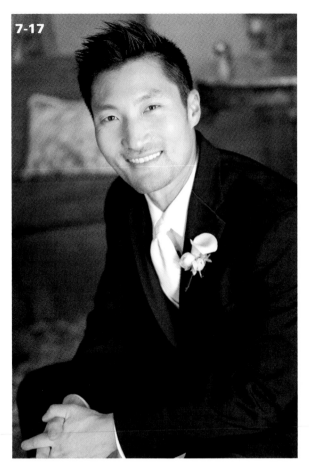

7-17

ABOUT THIS PHOTO *Yul Kwon, reality TV star, posing before his wedding. Taken at ISO 1000, f/2.5, 1/200 second.*

■ **Bald can be beautiful.** The real problem with thinning hair or baldness is that any light illuminating the head and face can reflect back at the camera, creating hot spots, or unwanted reflections. The easiest way to fix this is to change the angle of the camera to the subject and if possible diffuse the light as much as possible. If there is a makeup artist around helping the woman get ready, ask the groom if he'll consider applying a little makeup to reduce reflections. You might also talk about that option with the couple beforehand; some people will not be open to the idea, and it's best to know that before the wedding.

■ **Adjust his glasses.** Glasses reflect light but can be easily adjusted so that the reflection goes in a different direction. Just move the arms of the glasses up a little so that the actual angle of the glass points down and not back at the camera. If you are using a flash unit off the camera, try to change the height of the light a little as well to reduce the angle that the light bounces off the glasses. This will really help to eliminate the reflection in the glasses.

■ **Position the hands.** Hands can add character and interest to a portrait but can also really distract. Many people don't know what to do with their hands during a portrait shoot, so it is best if you just tell them what you want. You want to minimize the hands in your image by having them turned to the side and not flat toward the camera. Another way to minimize the hands is to keep the hands close to the body and busy doing a task, as shown in Figure 7-18.

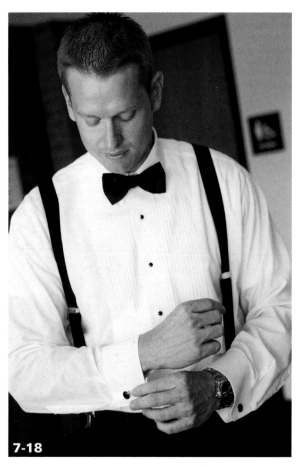

7-18

ABOUT THIS PHOTO *The groom posing naturally with his hands close to his body and busy working on the cuff links. Taken at ISO 400, f/3.5, 1/400 second.*

THE BRIDE AND GROOM TOGETHER

If there is one photo that is the most important of the day, it is the portrait of the bride and groom together. Have a location for the portraits at the ceremony site or reception site in mind if the portraits of the bride and groom together are going to

take place after the ceremony and before the reception. If the photos are going to be taken before the ceremony, scout locations that are close to where the bride and groom are getting ready and that are out of view of guests who might be arriving for the ceremony. This allows you to maximize the time photographing the couple rather than spending all the time allocated getting to the location. If you are shooting indoors and need to set up your lights, then do it before bringing the couple there or, at the very least, make sure you know where they are going to go, so you can set up the lighting quickly and there is no wasted time. The light, the red carpet, and the arches all made for an ideal location in Figure 7-19. I made sure the area was free of distractions and posed the couple in the flattering, diffused light coming across from the windows on the other side of the church.

POSING THE COUPLE

Whether your style is photojournalistic or traditional, you still have to pose your subjects. It is not an easy task, but by studying some of the basic poses, you can create a variety of different shots by making only slight alterations. The most important thing you can do is to get the bride and groom to relax. This comes from the rapport that you have built with them and their trust in you. Many times it is a good idea to shoot the joint portraits without any family or friends present. This is because the couple is most likely not used to being the center of attention and being in front of the camera as much as they are during their wedding day, and having other people around can be a distraction. It all depends on the

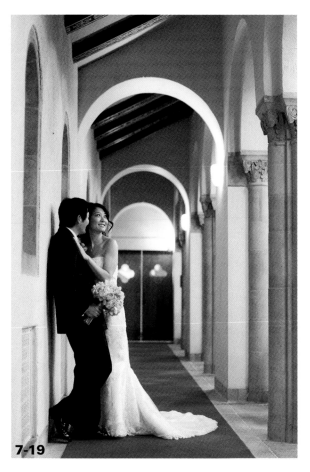

7-19

ABOUT THIS PHOTO *I had this location in mind for the bride and groom portraits from the moment I saw the light. This was taken before the ceremony at ISO 2500, f/2, 1/100 second.*

couple, but if you think it will help, have a close friend of the couple join you to help keep the mood light. Just try to keep the amount of people present to a minimum. You need to plan the poses that you want the bride and groom to do ahead of time and if necessary, keep a little notebook with examples of what you want. The following list offers some tips about posing:

■ **Traditional poses.** Some of the traditional poses include the 3/4-length shot of the bride and groom together, the couple looking at their rings, and a close-up of their hands with the rings visible. These poses are a great starting point for any wedding photographer and should be mastered, even if you want to shoot a more relaxed type of portrait as well. Consider these the building blocks of the wedding portrait because many clients still expect to see them in their wedding album. Also keep in mind that because you can't take a portrait of the couple's rings together until after the ceremony, you will have to set aside a few minutes to do that, even if the rest of the portraits are done before the ceremony.

■ **Relaxed poses.** These are more natural and break a lot of the rules of composition, but they can really be worth it. Take Figure 7-20 for example: The bride and groom are not looking at the camera, the pose isn't traditional, and the groom is even holding the bride's flowers, but the emotion is present and that's what makes it a great shot. Instead of a rigidly posed couple, the mood is more relaxed and informal.

■ **Compositional helpers.** There are some basic compositional guidelines that can really help make a portrait stronger. Use the Rule of Thirds when determining placement of your subjects. You can also use leading lines to draw the viewer's eye to the most important elements in the image. Figure 7-21 uses both the Rule of Thirds and the architecture and banisters as multiple leading lines drawing your eye into the image. Don't forget the basics when setting up your portraits.

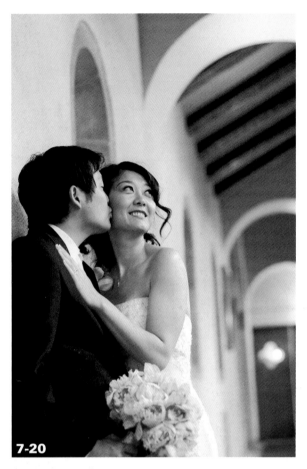

7-20

7-21

ABOUT THIS PHOTO *Getting closer together, the bride and groom share an intimate moment. Taken at ISO 2500, f/2.0, and 1/100 second.*

ABOUT THIS PHOTO *The couple is posed on the stairs with their heads roughly a third of the way down, and each of them is a third of the way into the frame. The leading lines from the architecture also help with the composition. Taken at ISO 1600, f/2.8, 1/250 second.*

 x-ref

For more information on composition, see Chapter 3.

■ **It's all about the emotion.** On the wedding day, there will be a myriad of emotions that can run the gamut from elation to fear. It is a big day. When you have the couple alone together for a few moments, the love for each other should start to come out.

■ **Keep the mood light.** Chances are the couple has been under a little stress that day, and this is most likely the first and could be the only time that they are not surrounded by people. Let them enjoy the moment.

■ **Talking is good.** Let them know what is working and always keep it positive. Also, let them talk to each other; this might be the first time they have had a moment alone, well, almost

alone. Silence is often considered golden but not in this case. You can also ask them to communicate love through body language, such as looking at each other, exchanging soft tender kisses, gently caressing each other's hands, hugging each other tightly, and so on.

■ **Keep the focus on the eyes.** This is true when photographing individual portraits, and it is true when shooting the couple. Make sure that the eyes are in focus; an out-of-focus eye will ruin a portrait quicker than anything else.

■ **Pay attention, close attention.** Sometimes, couples can feel a little intimidated being in front of the camera, and it is the smallest gesture that can mean the most. A little hand squeeze from the bride to her groom or brushing back a stray piece of hair can say volumes.

■ **Keep the camera to your eye.** If you are not looking through the viewfinder, then you will not be able to capture the moment when it happens. Chances are it will be before or right after you take a frame, so be ready to take another one immediately.

BACKGROUNDS

Portrait backgrounds can do one of two things: They can help the photograph by adding a sense of place, such as Figure 7-22, or they can distract, and take attention away from the couple.

Some good choices for backgrounds include the following:

■ **Areas that don't compete with the couple for your attention.** Some wedding locations are extremely beautiful, whether they are white sandy beaches or rolling vineyards, and while the beauty needs to be captured, don't let it swallow up the couple. In these cases, I

make sure to take some shots with the natural beauty as the main subject, then some with the couple as the main subject. The location for the wedding was chosen with a lot of care and planning.

■ **Areas that have symmetry.** Look for areas that have a symmetry that you can use in the portrait. The couple can be placed in the middle of the symmetry points or off to the side, creating a portrait that has more tension. Try it both ways and see what works for you.

7-22

ABOUT THIS PHOTO *There are times when the background can really add a sense of history and story to the wedding album. Taken at ISO 100, f/6.3, and 1/200 second.*

- **Areas with a staircase.** Staircases are a fantastic location for portraits. They allow for numerous levels and angles, and banisters make for great leading lines. There is a sense of elegance and old-world timelessness with portraits on a staircase, especially if the staircase is in an old or ornate building. If the stairs you have to work with are not that great looking, you can always move in a little closer and fill the frame with the couple to try to minimize the surroundings. The good news is that many times, wedding venues are really lovely buildings with a nice staircase somewhere, even if it is only a few stairs.

- **Areas with neutral colors.** Many times the background colors can draw attention away from the monochromatic black and white of the traditional wedding garb. Look for backgrounds that are neutral or at least complement the colors of the bride's flowers and groom's boutonnière. That doesn't mean all the shots should be boring and plain; just make sure that you choose a location with a subtle background for some of the photos.

- **Areas with even lighting.** It doesn't matter how perfect a location or background is if it has bad lighting. Look to see if there is even light present at the time when you will be photographing. For example, the east side of a building might have great light in the morning but be so deep in shadows during the wedding that it won't do. When photographing inside, see if it is possible to turn on or off the room lights, especially if there is light coming in through a window or door that is more flattering.

LIGHTING

Photographers talk about hard light and soft light and that soft light is better than hard light, especially for portraits. As I talked about in Chapter 5 and Chapter 6, the larger the light source, the softer and more flattering the light is, and this is important for wedding photographers because you want your clients to look their best. So when it comes to photographing the bride and groom, you want to make sure that the location you choose for the portraits has the best light available.

x-ref

Outdoor light is covered in Chapter 5, and indoor lighting is covered in Chapter 6.

When you are shooting outdoors, the best light can be in the shade. Look for areas where the hard direct light of the sun does not light the bride and groom but instead they are placed in the shade. This could be the side of a building or the overhanging tree. When shooting outdoors, you will hope that there are a few clouds in the sky, because nothing can soften direct sunlight quite like the clouds. They act like a huge natural diffuser and turn what is a small hard light into a bigger, softer light. You can also use the light to create elements in your image, such as in Figure 7-23, where the interplay between the light and shadow create leading lines for your eye to follow into the photo from the left side. Notice how even though there is obviously bright sun in the sky, by placing the couple in the shade, the light is very soft and diffused, creating a great portrait.

One last word about the light outside: It changes constantly, so the great light that was present in the early afternoon will have changed by the time the ceremony is over, and the light changes over the year so that the light that appears in March is different to the light appearing in October. When picking a location for the shots, picture how the light will be when you are taking the shots, not how it is when you are scouting the location.

When you are shooting indoors, the light comes either from the available light or from flashes brought in to illuminate the scene. You can also use many light-shaping tools, such as an umbrella or small soft light as well as the Gary Fong diffusers I use, covered in Chapter 2, to very effectively soften the light. The key to using these tools is to get them in as close as possible to your subjects so that the light is relatively large, providing the softest light possible.

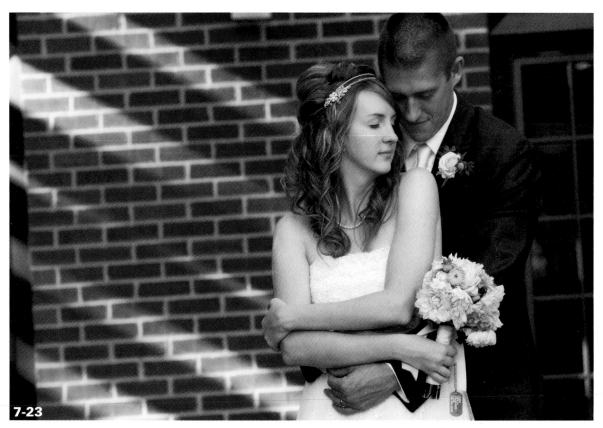

7-23

ABOUT THIS PHOTO *The light coming through the overhang creates a great pattern on the wall. Taken at ISO 1000, f/8, 1/160 second.*

Assignment

Show the Love

Weddings are joyous occasions that are all about celebrating the love between two people. It is critical to capture that love, especially when it comes to the portraits of the husband and wife. The good part about this is that you don't actually have to be at a wedding to practice this. Any happy couple can be your model for this. This assignment is to capture the love between a couple in a photograph, which is not as easy as you might think.

It's not just his arm around her, or the fact that they are gazing at each other, nor is it the smiles that grace their faces, but instead it is a combination of all those factors that make an example of the love that can be captured in an image.

Make sure that the lighting, location, and composition are all good; then just talk to the couple, and see which poses they are comfortable with and watch for those little signs that show the love. Once you capture a moment of shared bliss, post it to the Web site to share with other readers.

The couple in this photo are not paid models nor did they pose for a magazine shoot. They are just a young, newly married couple very much in love, and the pose conveys that. A look, a touch, a laugh—these all make the image have emotional impact. This was taken at ISO 1000, f/3.5, 1/500 second.

 Remember to visit www.pwassignments.com after you complete the assignment and share your favorite photo! It's a community of enthusiastic photographers and a great place to view what other readers have created. You can also post comments and read encouraging suggestions and feedback.

Taking the group portraits can be the most diffi-
cult task to tackle during the wedding day.
Shooting a good portrait of a single subject can be
tough, but when you start adding more people
into the shot, it can become chaotic. Some of the
most common problems that can arise when you
are trying to take group portraits include people
looking away or off in different directions, people
blinking during the photograph, people missing
from the group, and having to deal with different
emotions and personalities.

However, if you want to be a successful wedding
photographer, you will have to master the group
portraits, because no wedding album is complete
without them. There are many different group

portraits, from ones of the bride's family and the
groom's family to ones of the whole wedding
party, as shown in Figure 8-1. Each group config-
uration is a little different, but with some
planning, you can take them all so you get the
best results in the least amount of time, and the
clients and their family and friends can go on to
enjoy the wedding.

MAKING AND STICKING TO A SHOT LIST

It is important as a wedding photographer, espe-
cially if you are just starting out, to make sure you
have discussed a shot list with the clients. This is

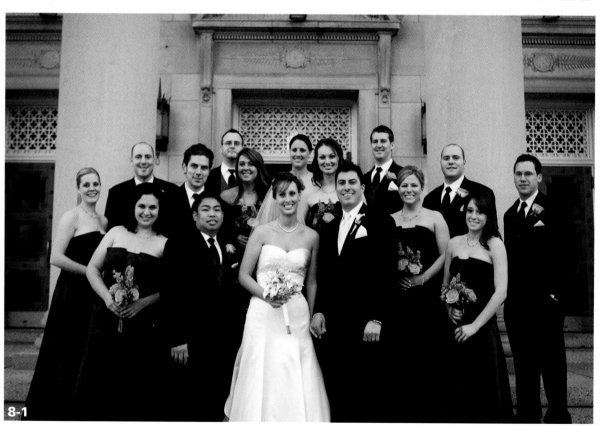

8-1

ABOUT THIS PHOTO *The whole wedding party poses for a group portrait. Taken at ISO 1000, f/3.5, 1/160 second.*

where the clients sit down with you and work out which groupings they want to make sure you capture during the wedding. It's important for the bride and groom to realize that every extra grouping that they want takes time. So, use the opportunity to discuss doing a large group shot, like the one in Figure 8-2. A large shot like this one can take the place of multiple other group shots. Make sure they understand that because these shots are taken between the ceremony and the reception, the time it takes to take all the detailed group shots could instead be spent at the reception mingling with their guests.

It is still important to make sure that if the couple have any special groupings that they want, you make a list and get the shots. This can include photos of favorite family members or special guests like the cousins who came in from out of town or a favorite childhood family friend of the bride or groom.

Here is a basic list of group shots to start with and to build on:

- Bride and groom plus bride's parents
- Bride and groom plus groom's parents

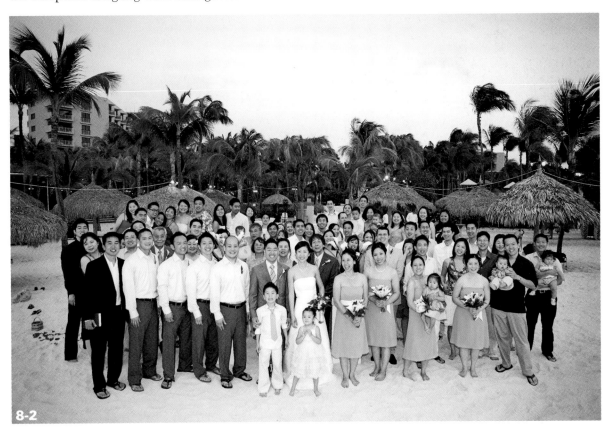

8-2

ABOUT THIS PHOTO *Getting one big group shot can really help to keep the shot list to a minimum. Taken at ISO 3200, f/3.5, 1/50 second.*

- Bride and groom plus both sets of parents

- Bride and groom plus both sets of parents and grandparents

- Bride and groom plus bride's parents, siblings, grandparents, aunts, uncles, nephews, and nieces

- Bride and groom plus groom's parents, siblings, grandparents, aunts, uncles, nephews, and nieces

- Bride and groom plus all family, immediate and extended

- Bride and groom plus bridesmaids

- Bride and groom plus groomsmen

- Bride and groom plus bridesmaids and groomsmen

Check with the clients about whether there are any special people that they want to get separate photos with. This could be a favorite aunt or uncle, a cousin or others members of the family, or a member of the wedding party who would usually just be included in the group shots, like the flower girls or ring bearers. However, suggest to the clients that they keep this number to a minimum because of the amount of time it will take to shoot them all. When it comes to shooting children, as shown in Figure 8-3, it is even more important to keep it really quick and fun.

8-3

ABOUT THIS PHOTO *The bride and groom along with the youngest members of the wedding party. Taken at ISO 400, f/4, 1/60 second.*

LOCATION

One of the most important considerations when it comes to taking group portraits is where to take them. As the wedding photographer, you need to have a location in mind for the group shots before the wedding even starts so that you can make sure that the people who need to be in the photos are told where to go.

When it comes to picking a location for the group portraits, keep the following in mind:

■ **Choose a location where the whole group can fit.** This makes it easier to position the group and makes it much easier for you as the photographer, because if the whole group can fit easily in the space, it is less likely that there will be distracting elements intruding on the scene, and the subjects will look more comfortable. Take Figure 8-4, for example: By choosing an open, uncluttered area outside, the wedding party fits easily.

■ **Choose a location where the light is even.** This makes your life much easier because the even light means you will have an easier time with the exposure and a lot less post-production work. An area that is half in deep shadow and half in bright light will not work well and you are better off looking elsewhere. If you are shooting inside, try to stay away from areas

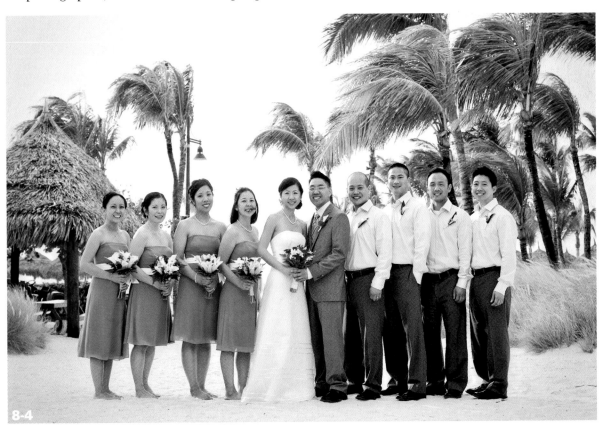

8-4

ABOUT THIS PHOTO *The entire wedding party can pose comfortably for a group portrait outdoors. Taken at ISO 100, f/5.6, and 1/160 second.*

where there are windows with bright light only on one side of the group; instead, try to position the group so the light is even.

■ **Choose a location that is close by.** The amount of time you have to shoot is precious, and it is best not to use it all up getting to the group portrait location. Try to find an area that is as short a distance as possible from where the subjects are to start with. For the wedding party images, there is usually a little more time if the photos are taken before the ceremony, and in this case, multiple locations can be used, as long as they are not too far apart.

■ **Choose a location that adds some context.** While plain backgrounds are great, look for something that can add context to the image, such as the front steps of the church or even in the church, as shown in Figure 8-5. Use the location to set the scene.

■ **Choose a location that's free of reflections.** A glass window behind the group can cause unwanted reflections of you or your flash and should be avoided. If it is unavoidable, then change your angle to reduce the reflection.

8-5

ABOUT THIS PHOTO *This photograph of the bride and groom along with the groom's family was shot in the church. Taken at ISO 1250, f/4, 1/60 second.*

There could be more than one location for the group portraits and in all likelihood there will be. You will need a setting for the bride and groom and the wedding party for photos before the ceremony and a location for the bigger family group shots after the ceremony. This could be because the preparation area could be too small for the whole family or it might just be too far away to get to after the ceremony. If possible, go to the wedding location before the wedding to get an idea of which places will make good portrait locations; it will also take some of the pressure off during the actual day. And it is important to make sure that any other photographers working with you know what the plans are for the couple and the subjects of the photos. Let the grooms-men and bridesmaids know where to go for the after-ceremony photos so they can help move things along in a timely manner.

FAMILY

Family plays an important part of any wedding, and the family photos are a chance to capture a special moment in time, that moment when a daughter or son is off to start a family of her or his own. There are two types of family group photos: those with the parents and those with the extended family. It is easier to take the photos with the parents before the ceremony and take those with the extended family after the ceremony and before the reception. This gives you a little more time for the parent photographs. Many of the location details will have to be discussed and planned with the clients before the wedding. If the ceremony and reception take place at different locations, you will need to decide at which location the photos will be taken. This could mean doing a little research and checking out both sites with the group portraits in mind.

There is one emotion that is constant with the parents of the bride and the parents of the groom at a wedding and that is pride. They are happy and joyful and very proud of their respective children. The photos of them with the bride and groom will be treasured along with their own wedding photos forever. The time to take the parent photos depends on whether the bride and groom are going to have joint photos before the ceremony or after. If they are going to have photos done before the ceremony, then plan some shots with the parents as well. If the bride and groom have chosen not to have any joint photographs before the ceremony, then you can shoot the bride with her parents and the groom with his before the ceremony, but take all the other family shots after. Knowing who needs to be photographed when makes things run more smoothly and avoids wasting time.

There are some standard shots to take for family portraits, and while you can try to make them interesting, your best bet is just to make sure that everyone is looking at you or at the bride and groom, the light is good, and the exposure is correct. In Figure 8-6, both sets of parents are present with the bride and groom. The location for this photo was just right, with the banisters of the bridge acting as anchor points on either side of the group.

Talk about family dynamics with your clients and find out if there are any family tensions that exist with divorced parents or among other family members that you need to be aware of. While it

ABOUT THIS PHOTO *The bride and groom with their respective parents posed before the ceremony. The wooden stairs and the railings make for a perfect framing element, keeping your eye in the frame and on the subjects. Taken at ISO 125, f/5.6, 1/250 second.*

would be nice to think that it never happens, divorce does happen and can create problems. Sometimes you might want to remind your clients that taking an extra photograph or two might make a bad situation better and doesn't cost them anything but a few moments of time. The less friction there is at the wedding, the better.

If the bride and groom have decided not to see each other before the ceremony and you need to shoot the bride with her family and the groom with his family separately before the ceremony, make sure everyone knows where to be and when.

There really isn't very much time, and to spend any of it waiting for someone to arrive will put undue pressure on the bride or groom and on you. Make sure that the people needed for the photos are notified before the wedding day so that they know where and when to arrive because these images are usually done before the guests arrive. Choose a location that is close to or at the site of the ceremony, as shown in Figure 8-7, and be ready to take the portraits as soon as the subjects arrive. If you are shooting indoors and using your flash, or flashes, make sure they are set up and ready to go before the bride and/or groom is on the scene.

8-7

ABOUT THIS PHOTO *The bride and her family taken before the ceremony. A Gary Fong lightsphere was used on a flash on the camera to add soft light to the scene at ISO 1250, f/4, 1/60 second.*

THE BRIDAL PARTY

The bridal party is comprised of the friends and family nearest and dearest to the couple, and the images of the bridal party are some of the most cherished from the wedding. The bridal party photos can be broken into three different groups: the bride's side of things, the groom's side of things, and everyone all together.

THE BRIDE AND HER BRIDESMAIDS

There are two main styles of images of the bride and her bridesmaids to capture: those that seem candid and relaxed and those that are a little more formal. The first type of shot usually happens when the bride is getting ready and is surrounded by the bridesmaids, and while you can take these shots as candid ones, a posed moment works really well.

The idea is to keep the bride the center of attention and have the bridesmaids around her in a relaxed configuration, as shown in Figure 8-8, where the bridesmaids are arranged around the bride in the room where they got ready for the wedding. By having some of the bridesmaids sit next to the bride while others stand behind and to the sides of her, the composition is balanced, and the eye is drawn into the image and focuses on the bride, who is and should be, the center of attention.

The other image to take with the bride and her bridesmaids is a more formal, posed shot, but it doesn't always have to be serious. Keeping the mood light and joyous will result in images that are playful and fun, as shown in Figure 8-9, and allow the group to be more relaxed in front of the camera. That doesn't mean all the photos should be irreverent; keep the personality of the couple in mind, and if you think that they would appreciate a more serious shot, then make sure you take one.

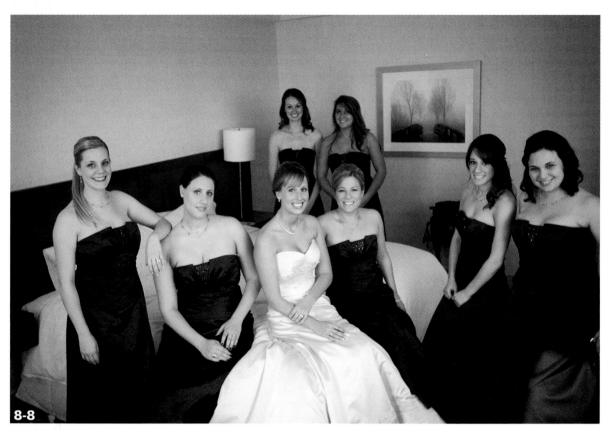

8-8

ABOUT THIS PHOTO *The bridesmaids surrounding the bride, as they get ready to leave the brides room. Taken at ISOO 800, f/2.8, 1/160 second.*

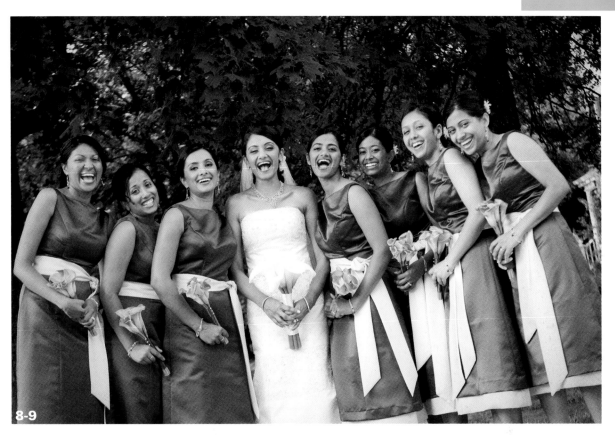

8-9

ABOUT THIS PHOTO *The bride and her bridesmaids taken at the bride's home before the wedding. Just asking the group to laugh out loud helped to capture this shot. Taken at ISO 400, f/4, 1/250 second.*

Additionally, capturing a group shot taken with the bridesmaids helping the bride get ready for the wedding is important. It can really show the bond between her and her retinue. While it is a good idea to watch what the bride and her attendants are doing naturally and try to capture that feeling, don't be afraid to do a little directing. If you place people where the light is the best, the photo will look the best. Many times capturing the moment that the bride is being helped into her dress or having a little touchup done to her makeup makes great moments. These are the types of images that the bride and her friends can look back on many years after the wedding and relive that moment. Take the moment captured in Figure 8-10: Not only is the bride being helped by her bridesmaids, but also the light coming in through the sheer curtains over the window is very soft and flattering, and the whole scene is uncluttered.

Women tend to be a little subtler than men when they demonstrate their emotions, so make sure you pay close attention to everything going on. A small gesture or look can speak volumes, and capturing it can really make for a wonderful image.

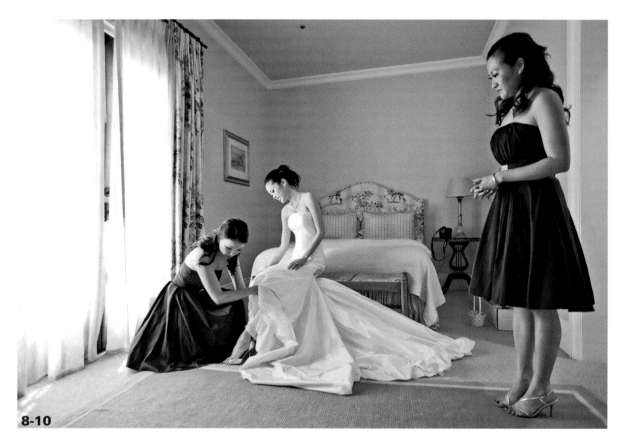

8-10

ABOUT THIS PHOTO *The bridesmaid helping the bride to put on her shoes. I loved the light in the room and had them hold this pose for the photograph. Taken at ISO 800, f/2.8, 1/80 second.*

THE GROOM AND HIS GROOMSMEN

Some special moments can be had with the groom and the groomsmen. Many times if a wedding has more than one photographer, it's the job of the second photographer to cover the groom getting ready, which includes taking group photos of the groom and his groomsmen. If you are the main photographer at a wedding, it is your responsibility to let the second shooter know what you want. Don't assume that your second photographer will instinctively know what shots you want, and keep in mind that the second photographer didn't meet with the clients — you did. Clear, concise directions and a shot list will help ensure that the second shooter returns with the images the bride and groom want. Many times the area the groom gets ready in isn't as big as the bride's room; if the groom and his men are getting ready at a location that makes it difficult to get everyone together for a full group shot before the ceremony, you will have to take it afterward.

Another option is to walk outside and look for an area big enough for all the guys to be posed, as shown in Figure 8-11.

The groom is usually ready long before the bride, which gives you some time to get a wider variety of photographs. Once the images of the groom and his groomsmen getting ready are taken, like the groom being helped with his tuxedo, look to find something that the groomsmen can do to bring out their personalities. There is nothing quite like playing a quick game of table tennis while waiting for the bride and her bridesmaids,

as shown in Figure 8-12. The table was there and the groomsmen were willing. It is a nice reminder of the time spent getting ready.

THE ENTIRE BRIDAL PARTY

You have two opportunities to take photos of the full bridal party: before the ceremony if the bride and groom agree to it or before the reception. Taking these portraits can be some of the most fun you will have all day. You are photographing

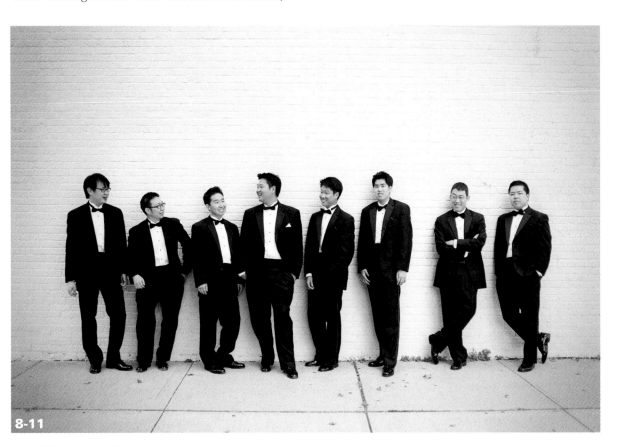

8-11

ABOUT THIS PHOTO *The groomsmen with the groom outside before the wedding photographed by David Burke. The relaxed pose was set up so that the attention of the groomsmen was on the groom. Taken at ISO 400, f/2.8, 1/1250 second.*

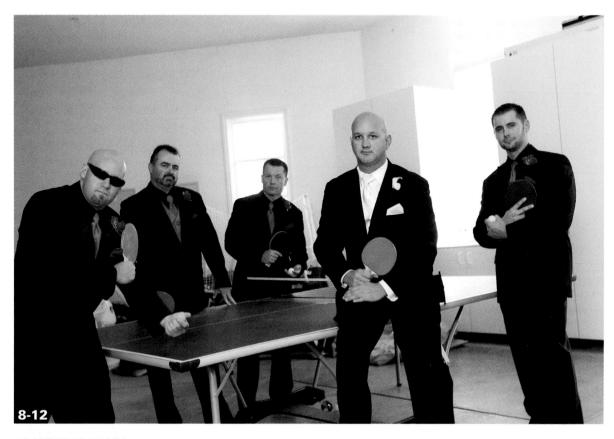

ABOUT THIS PHOTO *Playing a little table tennis before the wedding is a great way to relax. Taken at ISO 400, f/4, 1/100 second.*

the people who are closest to the bride and groom, and the photos of them will be some of the most viewed after the wedding is over.

It doesn't matter when you take the group shots of the bridal party; the setups are going to be the same. The only advantage to shooting before the ceremony is that the makeup will be fresh, and everyone will be looking their best. There is also more time to do some creative shots before the ceremony. Usually if the shoot is done after the ceremony, everyone is under a time crunch to make it to the reception quickly.

The best advice when it comes to group portraits is to keep them simple and easy. It is about getting the party relaxed and letting them enjoy this time. Have a set of poses that you already know will work compositionally based on the size of the wedding party, and let the wedding party have fun while they are doing them. While shooting the same set of standard poses may sound boring, you can still add some variation to the poses every time you shoot.

Have a location or two in mind and make sure that the whole bridal party knows where it is and is ready for the shoot. Once these photos are done, if there is some time left, you can get creative and try to come up with shots that you normally do not take. Let the wedding party know that you are experimenting and have fun with it. By now, the wedding party should have complete trust in your creativity and talent and will be willing to try anything to have some fun with the photos.

Some groupings to try when shooting the bridal party include:

■ Pose the groom with the bridesmaids

■ Pose the bride with the groomsmen

■ Pose with the groomsmen on one side and the bridesmaids on the other

■ Pose the wedding party as couples

Keep the proceedings light and let everyone have some fun. For example, take Figures 8-13 and 8-14, were the bride and groom posed first with the groomsmen and then with the bridesmaids.

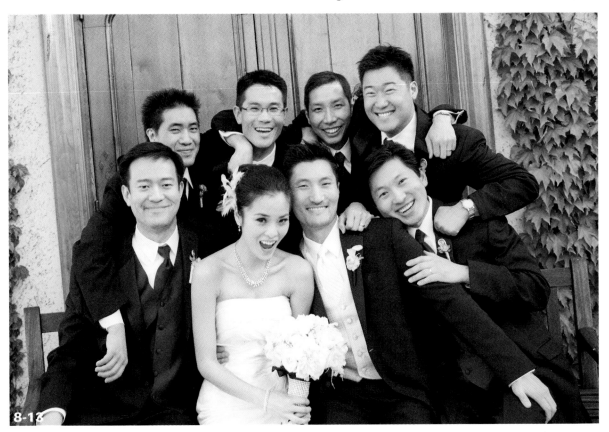

ABOUT THIS PHOTO *The bride and groom with the groomsmen. Keeping the bride and groom in the center of the composition and just building the image by placing the group around them keeps the bride and groom as the center of attention. Taken at ISO 800, f/5.6, 1/320 second.*

ABOUT THIS PHOTO *The bride and groom with the bridesmaids. Keeping the bride and groom in the center of the composition and just building the image by placing the group around them keeps the bride and groom as the center of attention. Taken at ISO 800, f/5.6, 1/320 second.*

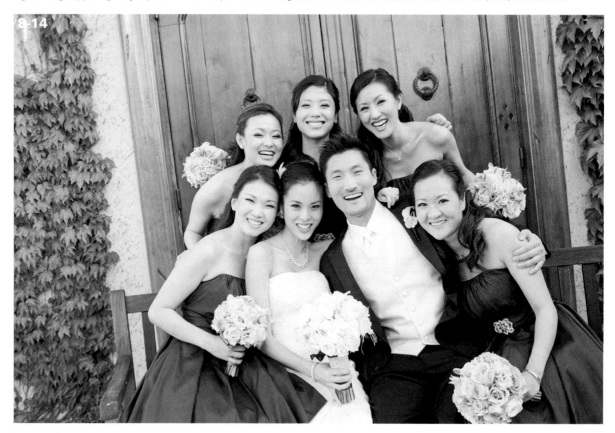

8-14

The two shots were taken at the same place and same time, and it is easy to see that everyone is having a really great time.

POSING TIPS FOR GROUPS

One of the toughest parts of getting a group to all look good in a photograph is to have them posed well. Just having everyone stand around in a clump is not very effective, and neither is just lining everyone up in a straight line because there is no visual impact and nothing to stop the viewer's eye from just going in and then immediately out of the photo.

As a wedding photographer, you will start to feel the pressure to take a lot of group shots in a small period of time, and this can hinder your creativity. The following tips can help you still get the creative images and not waste much time:

■ **Control the group.** As the photographer, your job is not only to take the photograph but also to keep the attention focused on you so that everyone is looking at the camera at the right time. At weddings this is even tougher to do because the bride and groom are getting a lot of the attention.

■ **Work quickly.** The longer it takes to get the shot, the more likely it is that you will lose the attention and focus of the group, especially if there are kids involved. Be ready to take the shot the minute the group is set up.

■ **Shoot in burst mode.** Set your camera to continuous advance and take a series of images that can really help with the blinkers in the crowd.

■ **Start with the biggest group.** If you start with the largest group and work your way down to the smallest group, then the guests that you are done photographing can leave and start to enjoy themselves at the reception. If you start with the smallest group and work your way to the largest group, then you will have a lot of unneeded and unwanted distractions going on. Start with the bride and groom in the middle and build the group around them, as was done in Figure 8-15, and then start to peel people away until you are left with just the bride and groom at the end.

■ **Put the bride and groom together.** Keep them together because it looks better, and they are now the center of attention as a couple. It also makes it easier for you to focus on them, and it is easier for the rest of the group to focus on them.

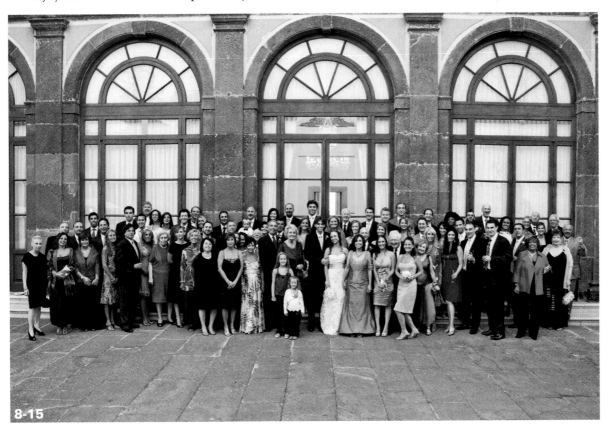

8-15

ABOUT THIS PHOTO *All of the wedding guests at this wedding in Italy gathered around the bride and groom. Taken at ISO 3200, f/3.5, 1/50 second.*

- **Look for the faces.** You need to be able to see the faces of your subjects, and they should all be able to see the camera. Check with the crowd to make sure that they can see you with both eyes; that way you should be able to see them and capture them in the image.

- **Stagger the rows.** When you start working with larger groups, it's best to stagger the rows a little so that the people in the back can see and be seen. What you want is for the people to be able to look out at the camera over the shoulders of the people in front of them.

- **Stagger the height.** If it is possible, it's best to stagger the heights of the rows so that there are two, three, or even more heights present. This is done really easily by posing the group on stairs, as shown in Figure 8-16. If there are no stairs, then you can always have the front row kneel, the middle row sit, and the back row stand. This enables everyone to see the camera, and you will be able to capture the shot with everyone's faces showing.

- **Watch the background.** Just because you have a big group doesn't mean that you can ignore the fundamentals, so make sure that

8-16

ABOUT THIS PHOTO *Stairs are a great way to stagger the people in the photo, and the different heights mean that everyone can be easily seen. Taken at ISO 100, f/5.6, 1/200 second.*

your background is helping, not hurting. A great background is one that can add a sense of location to the photo. The stairs in front of the church are ideal, because they not only help you stagger the group but also add a sense of location to the wedding. The downside is that they might not be big enough.

■ **Watch the light and watch the shadows.** The biggest concern when shooting groups is getting everyone well lit — you don't want the shadows from some people falling on others. This happens when the light strikes the group from the side and the people on the edges block the light from illuminating the people toward the middle. The two ways to avoid this are to place the group where there is even light falling from above or to place your external flashes in front and as high up as possible so that the light falls down on the group. One of the best types of light is the open shadow, as is shown in Figure 8-17, where the shadow from the arch keeps all the faces in the same light, while the sun acts like a hair light, giving the group just a bit of pop.

8-17

ABOUT THIS PHOTO *The group shot taken in shadow allows for a very even lighting on the faces of the subjects. Taken at ISO 400, f/5, 1/500 second.*

PLANNING ON THE BEST TIME TO TAKE THE GROUP PORTRAITS

There are really only two times to take the group portraits: before the ceremony begins and after the ceremony ends, but before the reception. By dividing the shots up and having a plan, you can maximize both these times. As I've mentioned before, you will need to discuss with the bride and groom whether they are open to seeing each other before the ceremony and getting some of the group portraits taken then along with their individual portraits at that time. If they aren't, you must plan accordingly to accommodate their wishes. Most importantly, discuss this with the clients so that they understand when and where the images will be taken. This will be important when creating the wedding day timeline.

x-ref

For more on photographing the bride and groom together before the ceremony, see Chapter 7.

The time of the day can play a big part in when to do a big group portrait. If you are shooting a wedding that takes place in the afternoon and is outdoors, it is possible to take advantage of the available light and shoot the group portraits without any need for a flash.

HOW MANY PHOTOS DO YOU ACTUALLY NEED?

This is a matter of personal preference, but many beginning wedding photographers tend to take too many group shots, trying to get every possible combination of people posing with the bride and groom. This typically takes a lot of time, and the payout usually isn't worth it. You might want to consider photographing larger groups, which results in fewer images but ones that are more likely to end up in the wedding album or as prints later on. That doesn't mean that you should completely ignore shooting small groups, but pick those groups carefully with the help of the bride and groom. If there is a special family member they want a photo with, then by all means schedule taking it, but keep your list of shots relatively small, and use the extra time to shoot the more important portraits of the bride and groom alone or with the wedding party. As I mentioned earlier in this chapter, a full group shot like Figure 8-18 can take the place of a lot of other photos and is much more likely to end up printed and displayed in the couple's home.

Discuss the group shots with the clients before the wedding because you will want to be on the same page as the clients when you deliver the final images.

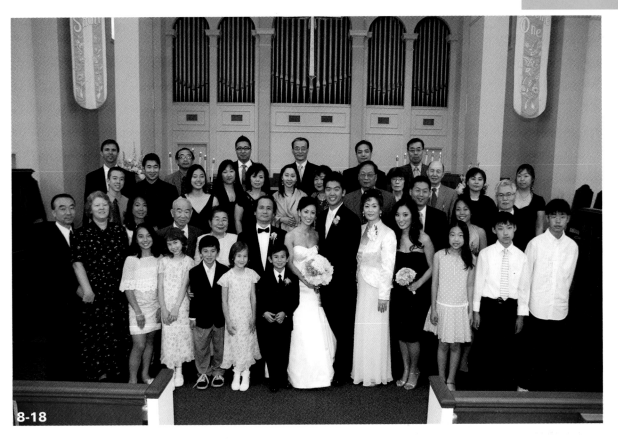

8-18

ABOUT THIS PHOTO *Getting everyone in a single great photo can significantly reduce the number of individual shots you might need. Taken at ISO 640, f/4.5, 1/60 second.*

Assignment

Pose a Group

Posing a single person can be a challenge; posing a group is even tougher. It is best to be prepared by practicing posing a group. For this assignment, practice posing a group of people and taking their group portrait. Since it's not a great idea to practice the poses at an actual wedding, my first suggestion is to get a group of friends together and work out a set of group poses. Then when you are shooting at a wedding, you will already know what will work.

For this shot, I made sure that the bride and groom were placed in the center and built the group around them. The bridesmaids and groomsmen were placed on either side at an angle that keeps the focus on the bride and groom. I loved having the kids in the images but it was very tough keeping their attention focused.

One way to make sure that everyone can see the camera and that the camera can see them is to stagger the heads as was done in this image. By making sure that each person is between the two in front of them, each face is visible. This group shot was taken at ISO 1250, f/4, 1/60 second.

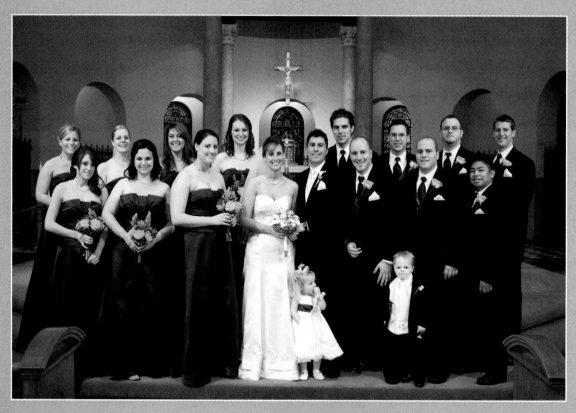

Remember to visit www.pwassignments.com after you complete the assignment and share your favorite photo! It's a community of enthusiastic photographers and a great place to view what other readers have created. You can also post comments and read encouraging suggestions and feedback.

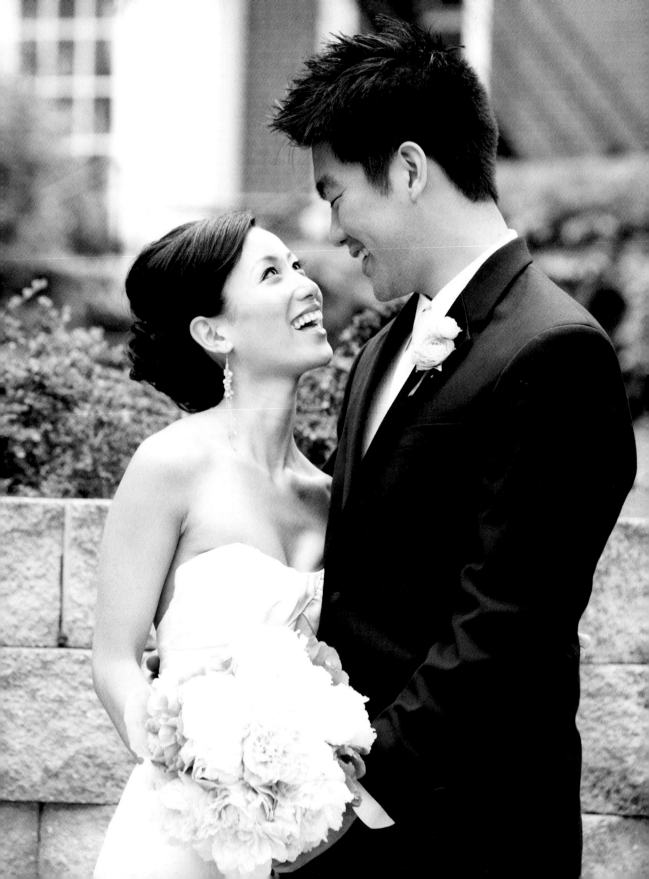

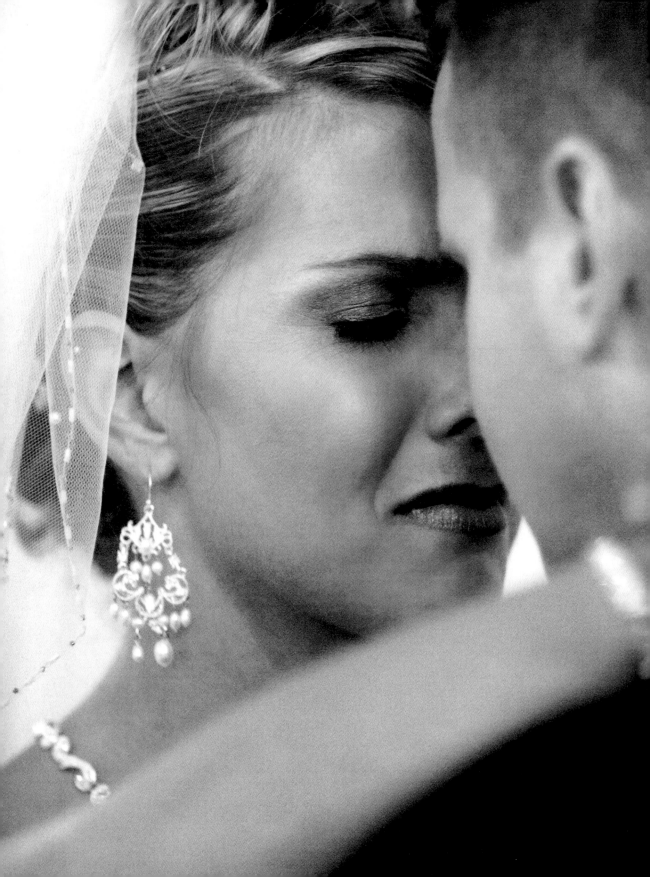

THE CEREMONY

The ceremony is what the whole wedding is about. All the preparation, all the work, all the planning, everything leads up to this moment. Your job as a wedding photographer is to make sure you capture the ceremony in its entirety. This includes setting the scene with exterior shots, like those shown in Figures 9-1 and 9-2, before everything starts, and shooting the processional, the bride being escorted down the aisle, the exchange of the vows and the rings, any special moments during the ceremony, and the couple walking back up the aisle together as man and wife. Capturing each of these moments begins with good preparation.

9-1

ABOUT THESE PHOTOS
Two very different wedding locations, Figure 9-1 was taken in the tropical outdoor setting in the Bahamas taken at ISO 100, f/7.1 and 1/500 second, while Figure 9-2 was shot in the interior of the Indiana Statehouse taken at ISO 800, f/5.6, and 1/125 second. Both were captured before the ceremony started.

KNOW THE SCHEDULE

It is difficult to get the shots you want when you don't know the schedule. This applies to the entire wedding but is particularly important when it comes to the ceremony given there are no second chances. When you shoot a toast, for example, you can move into a better position, such as into the middle of the room, and no one will mind very much, but during the service, that just isn't possible.

You need to know the order of the events so you can be in position to capture them. Go through the schedule and mentally plan for each of the moments that you must capture. I use this mental check list:

- **Which camera?** If I have more than one camera with me, which one will be best in a given situation? Does one camera handle low-light situations best or have more megapixels so it's easier for me to crop the image in post-production?

- **Which lens?** Will I need a longer focal length or a wider angle? Will that lens be on the proper camera body?

- **Flash or no flash?** For the times I can use the flash, will it be on the correct body? For example, as the couple leaves the ceremony, I like to use a 24-70mm f/2.8 lens with the flash in place for fill light. I need to have this combo ready at the end of the ceremony.

- **White balance?** Do I need to set the white balance for the room light, create a custom white balance setting, or will there be enough natural light coming in to use a daylight white balance?

9-2

PREPARATION

The wedding ceremony goes by quickly. This is especially true for the bride and groom, who will barely remember it, and it is true for the wedding photographer who needs to capture as much of it as possible. The better prepared you are to shoot the ceremony, the easier it will be to get the images you need.

■ **Which ISO?** How dark is the room and how high will the ISO have to be? For example, a reading during the ceremony that takes place in the shadows will need a much higher ISO than the vow exchange that takes place in the light. Taking the ISO question into consideration in Figure 9-3, I knew the church was fairly well lit and I could use ISO 800, which is fairly low for a church interior.

■ **What location has the best angle?** Do I need to switch sides in the church to capture the vows correctly, or can I shoot everything from one location?

■ **Where is the second shooter?** Will I appear in this photographer's shots? I don't want to be in the background.

■ **Where is the videographer?** Where is the videographer set up? I want to make sure I don't walk through his shot, or have him walk through mine.

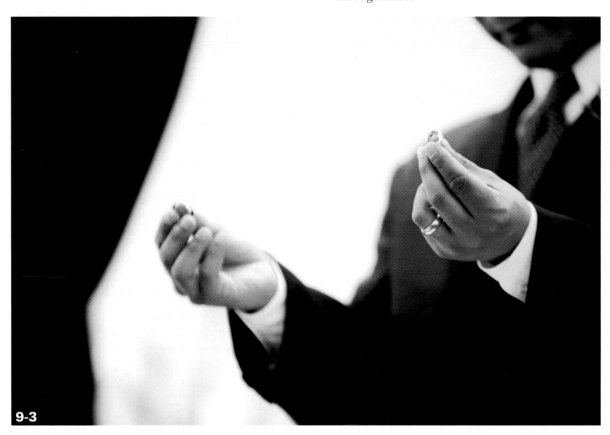

9-3

ABOUT THIS PHOTO *It is time for the rings to be exchanged. Taken at ISO 800, f/2.8, 1/125 second.*

All these considerations go into planning the ceremony shoot before the ceremony even begins. That way you can have your camera bag and gear ready to go and placed where you need them.

I try to make sure that I check out the ceremony site before the wedding day because that allows me time to make sure I have the right gear for the job. Another good time to check out the location is during the wedding rehearsal. If I am hired to take photos at the rehearsal as well, then I will check out the ceremony site before the rehearsal. If I am not hired to take photos at the rehearsal and I am not familiar with the venue, then I will still go so I can look over the the site before the wedding. Attending the rehearsal is a great option because it also allows you to see exactly where everyone will be during the actual ceremony. Because some of my business is as a destination-wedding photographer, there are times when I don't get to see the ceremony site until the day of the wedding. If this is the case, I make a plan to get to the ceremony site early to make sure I know where everything will take place.

KNOW THE RULES

As a wedding photographer, it is important to know the rules when it comes to the wedding ceremony location. When you shoot outdoor ceremonies, the atmosphere is usually relaxed, and the rules are often as well. However, when shooting indoors, especially in a church, temple, synagogue, or other house of worship, the rules can be much more strict.

Most places of worship have rules that restrict what a photographer can and can't do. These can include limiting where the photographer can and can't walk and limiting the use of a flash inside. The first thing to do is to find out what the rules are and then reassure the site's liaison that you will follow the rules. Chances are that the venue will still have someone watch you like a hawk, but by following the rules and respecting the wishes of the venue, they shouldn't interrupt you as you work. Think of how embarrassing it would be for the officiant to have to stop the wedding to chastise you for not following the rules. It would

tip

To build a good relationship with the venue's personnel, provide some images of the ceremony for them to use (with your clients' permission, of course), and be sure your copyright and contact information appears on the images.

not only be very embarrassing but would also probably ruin your chances of being hired by anyone attending the wedding, and stories like this spread in the wedding community.

The following are typical rules for photography in houses of worship, along with advice on how best to deal with them:

■ **Photographers are not allowed to use flash during the ceremony.** This is very common because it distracts the guests and the couple being married from the ceremony. To capture sharp images in a dark hall during the ceremony, use a high ISO and fast glass — that is,

lenses with a maximum aperture of f/2.8 or wider. In the past, the higher ISO settings produced a lot of digital noise that could appear in the image as little spots of color. In newer cameras, you can use much higher ISO settings with less noise, and software advances in noise reduction can also help you during post-production editing. It is not unusual to use ISO settings as high as 3200 (see Figure 9-4) and 6400 to capture the ceremony.

■ **Photographers must stay behind the last row of guests during the ceremony.** This is to stop the photographer from getting in the way of, and distracting, the guests. This means that to get in close for the special moments, you need to bring a longer lens like the 70-200mm f/2.8, which allows you to get closer without breaking the rules. If it is a really big church and you are stuck in the back because of the rules, a lens like the 400mm f/4 might be a good idea. You don't have to buy it just for one wedding; you can rent it, but make sure to take this expense into consideration when providing your clients with a quote. Another consideration is that with a long lens like the 400mm, you will need to use a tripod or monopod to keep the camera steady. Using this equipment might be against the rules, so make sure to confirm it is okay. In reality, chances are you will never have to use a 400mm lens for a wedding; this is an extreme case scenario. The principle is that you need to respect the rules of the church.

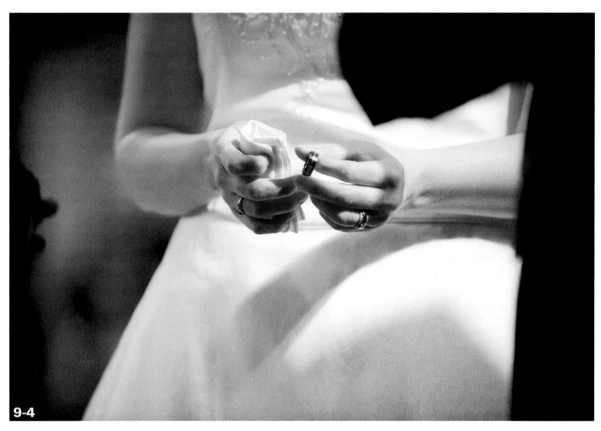

9-4

ABOUT THIS PHOTO *Using a high ISO allowed me to get a great shot of the bride as she is about to slide the ring onto the groom's finger. Taken at ISO 3200, f/2.8, and 1/400 of a second.*

- **Photographers need to stay on the side aisles.** Some venues will allow you to photograph from the side aisles during the ceremony but not allow you down the main aisle. This means that to get a straight-on shot during the ceremony, you have to shoot from the back of the room. The side angles can work great for getting shots of the bride and groom as they turn to face each other, but to get shots of both, you will have to plan on doing a lot of walking from one side of the venue to the other. In these circumstances, it is a good idea to consider using a second photographer to cover one side while you cover the other.

- **Photographers need to share the space with videographers.** This rule is common and easy to address: Simply become acquainted with the videographer, because you will essentially be working together all day. Make sure you respect each other and make an effort to stay out of each other's shots. You will find more on working with videographers later in this chapter.

- **Photographers can use a flash during the processional and recessional.** This is great news, because it means you can rely on the flash instead of the available light. When shooting the processional moment like the one shown in Figure 9-5, you will need to learn how to walk backward while photographing, without running over anyone or anything. It is also a good idea to let the videographer get his footage without your flash going off all the time.

- **Use the aisles and balcony if possible and available.** One thing to check is whether you are allowed to shoot from the side aisles, main aisle, and balcony (if the venue has one). This can give you a better angle than just standing at the back of the room and hoping for the best.

While these are the most common rules, it is important to check with the venue well in advance of the wedding so you are aware of all the venue's rules and there are no surprises. Now, not all venues have these strict rules; in fact, many wedding venues will give you a wide latitude, allowing you to shoot at your discretion.

KNOW YOUR ANGLES

Given you know in advance where everyone will be located during the ceremony, you can work out the best angles to make sure you have the whole thing covered. If you have a second photographer for the day, it is possible to position her off to the side of the venue so that she can capture nice reaction shots of the bride or groom and the parents and family sitting in the front row.

The real question becomes which side this photographer should set up on. Ideally, have her set up on the groom's side so that when the bride turns to the groom, her face will be directed toward the camera. Then position yourself so you are looking down the center aisle, or sit in a pew with a good view right down the middle. This enables you to face the back of the church where the bridal party will make their entrance and

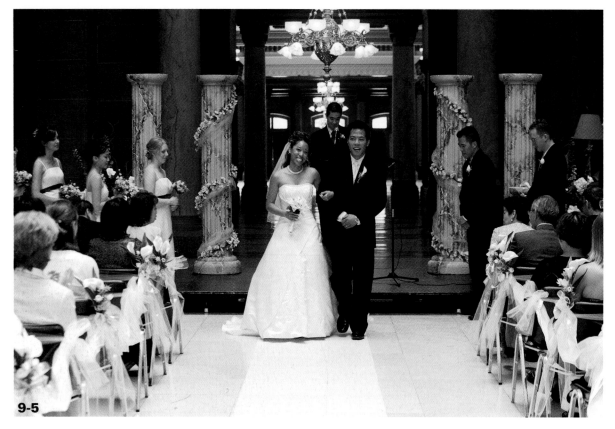

9-5

ABOUT THIS PHOTO *Walking backward is a skill you need in order to grab photos of the husband and wife walking down the aisle during the recessional. Taken at ISO 1000, f/4.5, and 1/180 of a second.*

allows you to capture each member of the wedding party, and most important, the bride and her escort.

There are times when the venue will allow you to shoot from the front of the venue during parts of the ceremony. The only way to know this is to ask beforehand. If this is allowed, take advantage of the unique angles. Being able to shoot from the front allowed me to get this shot of the bride and

groom lighting a unity candle (see Figure 9-6). If you have access to the front of the church during the ceremony and plan on taking any kind of photos like the one in Figure 9-6, it is important to know what settings you need. For example, I had already worked out what setting I needed to get this shot before the ceremony. So when this moment happened, I came in from the side, took one shot, and walked out without the couple even noticing.

9-6

ABOUT THIS PHOTO *A fisheye lens and a preplanned angle allowed me to capture a unique view when the bride and groom lit a unity candle during the ceremony. Taken at ISO 800, f/5.6, 1/100 second.*

Look for staircases and balconies at the rear or sides of the church for different views. Many times when the wedding ceremony is held outdoors, there will be a nearby structure that you can use to get a different angle on the proceedings. Just don't be caught out of position.

However, as you can see in Figure 9-7, sometimes there really is no place to go. Notice how little space there is at the altar, and how there is no place for a photographer not to be in the way. In this circumstance, I first checked with the coordinator and officiant to see whether it was all right to move around the rear of the ceremony site and did most of my shooting from the rear, using the 70-200mm lens. I did move closer to the front a few times, but by moving quickly and staying low, I did not disrupt the ceremony at all.

ABOUT THIS PHOTO *The ceremony site was a challenge to shoot because there was limited access at the altar as well as bright sun combined with deep shadow. Taken at ISO 100, f/8, 1/160 second.*

WATCH YOUR LIGHT

The light during a wedding can change — sometimes it's a little and sometimes it's a lot. Changing light is a bigger problem outdoors than it is indoors, as shown in Figure 9-8. The shadows will continue to change in direction as the sun moves across the sky. This can make it very tough to get an accurate exposure, because there is a big difference between the shaded areas and the sunny areas. Even worse is when the light changes directly on the bride or groom, because both are already tough to exposure for with the bright white dress and dark suit or tuxedo. Your best bet is to keep the metering mode set to spot metering and pay attention to how the exposure settings change as the light changes.

The light indoors can be just as tough as it is outdoors, but it usually doesn't change as drastically as the light outdoors. For example, in the church

9-8

ABOUT THIS PHOTO *The tree is casting a shadow that will change as the light changes during the ceremony. Areas in shade will suddenly be in bright sun, and areas in bright sun will be in shade. Taken at ISO 400, f/8.0, and 1/160 second.*

in Figure 9-9, you can see the light comes from three sources: the hanging lights, the stained glass windows, and the small skylights. While this might seem like a lot of light when you look at the photograph, the actual church was really dark, requiring a very high ISO, 12800 to be precise. This ISO can be adjusted as more light comes through the windows. (Figure 9-9 is also a great example of how a second shooter can really help with capturing the day.) I was positioned so

I could see the faces as the processional walked down the aisle while the second shooter was able to cover the rest of the room.

THE MUST-HAVE SHOTS

Sometimes, it seems like the ceremony is a continuous list of must-have shots, but it's not as complicated if you break it down into those images that no wedding album is complete with-

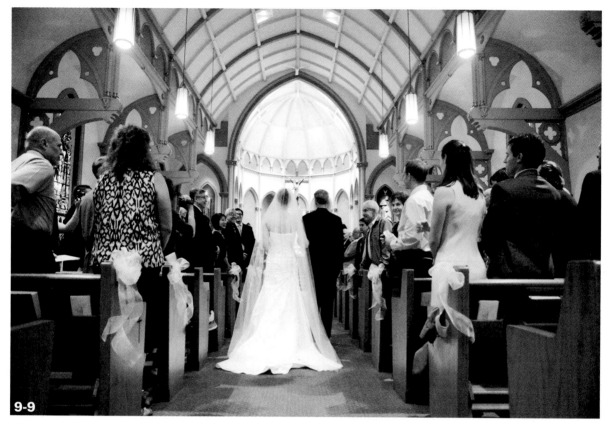

ABOUT THIS PHOTO *The bride being escorted down the aisle of a fairly dark church. Taken at ISO 12800, f/3.5, 1/100 second. Photo by Jenn Gaudreau.*

out. This includes the first look as the couple see each other for the first time at the beginning of the ceremony, the vows, and the ring exchange. There are plenty of other must-have photos, and they can run the gamut, depending on the traditions of the couple and their families.

THE FIRST LOOK

There is one shot that always makes me smile, and that is the look on the bride's face as she sees her husband-to-be standing at the altar waiting for her. That is followed closely by the look on the groom's face as he sees his bride coming down the aisle for the first time. Of course, it is impossible to capture both without a second photographer, so if you are shooting alone, go with the bride's face first, then if possible, turn and shoot the groom waiting for her. It will still be a good shot, even if it isn't the initial reaction. Sometimes you just get lucky and manage to get a shot of the groom just as he realizes that the best thing in the world is about to happen to him, as shown in Figure 9-10.

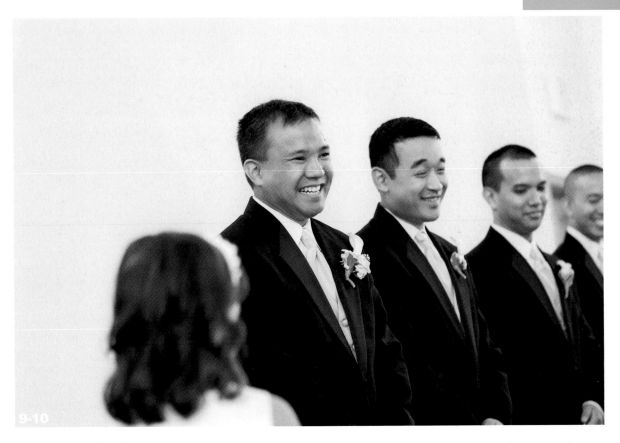

9-10

ABOUT THIS PHOTO *The smile says it all. Try to capture the wonderful reaction the groom has when he sees his wife-to-be walking down the aisle. Taken at ISO 800, f/2.8, 1/200 second.*

THE VOWS

One of the more tender moments happens when the couple read their vows, especially if they have written their own. The range of emotions and reactions can go from joy and laughter to tears in seconds as the couple profess their love and promises to love each other. If you are shooting solo, try to be positioned centrally so you can get both the bride and groom in the shot. A great lens to use here is the 70-200mm f/2.8, as I did in Figure 9-11. It allows you to get a wider view and a close-up view, depending on your proximity to the couple, without being disruptive or breaking any of the venue's rules.

THE RING EXCHANGE

The wedding rings are an instantly recognizable symbol of marriage. There is a time in every wedding ceremony when the bride and groom

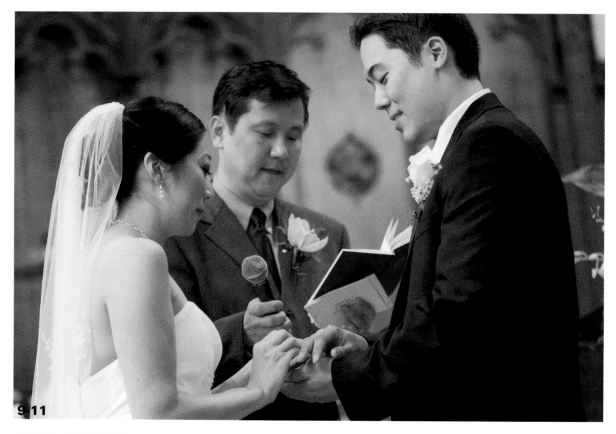

9-11

ABOUT THIS PHOTO *The bride and groom exchanging their vows is one of the more emotional moments of the ceremony. Taken at ISO 3200, f/2.8, 1/80 second.*

exchange rings, and it makes for a great photo. The problems photographically speaking are that the exchange happens quite fast, the couple's positioning can make it hard to see, and the distance from the camera to the couple can be quite far.

Many times your location depends on the rules of the venue, and it isn't possible or polite to move in really close just to get a photo of the ring exchange. I have found that either being in the center aisle shooting straight toward the couple or coming from one of the sides and composing the shot at an angle, as I did in Figure 9-12, works the best. Using a long lens, like the 70-200mm f/2.8 lens set to 200mm, enables you to get in quite tight and hopefully capture the moment as the groom or bride slips the ring onto his or her partner's finger.

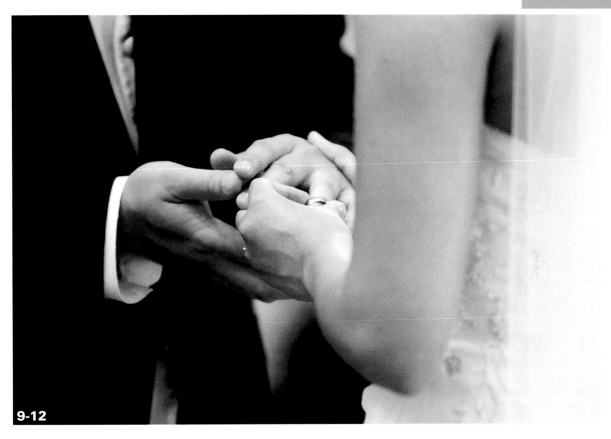

9-12

ABOUT THIS PHOTO *The bride slides the ring onto her groom's finger. Taken at ISO 800, f/2.8, 1/160 second.*

OTHER MUST-HAVE MOMENTS

When you are shooting a wedding ceremony, great photos can happen right from the start. Some of the most popular photos are those of the flower girls and ring bearers, especially if they are cute kids, and they are always cute kids. Take the pair in Figure 9-13: They are very serious on this big day as they start the processional down the aisle.

The rest of the processional is usually pretty standard until the bride appears with her escort. It is not imperative that you capture each bridesmaid walking down the aisle, but it is a nice touch if it is possible.

There can be a lot of cultural and traditional moments in a wedding ceremony, depending on the cultural and religious backgrounds of the

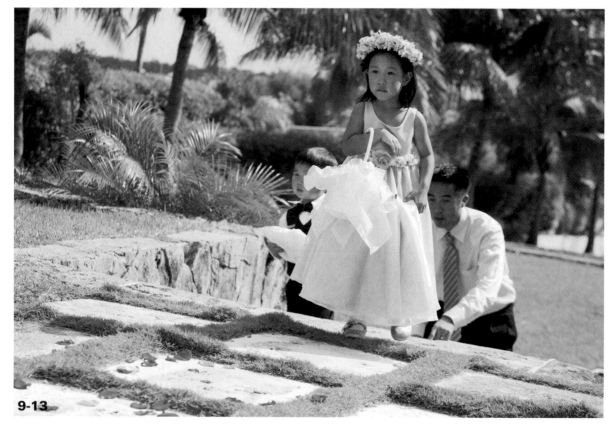

9-13

ABOUT THIS PHOTO *The young flower girl makes her way down the aisle, followed closely by her brother, the ring bearer, who is being urged on by their father. Taken at ISO 100, f/6.3, 1/500 second.*

couple and their families. This can be a source for some fantastic and interesting photo moments. For example, the bride washing the groom's feet, shown in Figure 9-14, certainly doesn't happen in every wedding. To be ready for these moments, make sure you discuss the details of the wedding with the couple.

Some weddings can actually last for days, like the traditional Indian wedding, which can be broken into three parts: the Garba, the Mendhi, and the

Ceremony. This affects your costs and pricing, so know what is going to happen from the onset. And Jewish weddings can have a very strict set of rules, so if you are hired to shoot one, it is a good idea to meet with the rabbi before the wedding and make sure you understand the rules and parts of the ceremony. Traditional Jewish weddings can be rather confusing if you don't speak Hebrew,

9-14

ABOUT THIS PHOTO *The bride washing her groom's feet is a Christian tradition symbolizing humility and serving one another. Taken at ISO 100, f/3.5, 1/250 second.*

and while everyone knows about the glass breaking at the end of the ceremony, there is a lot more to it than that.

Pay very close attention to the bride and groom, especially toward the end of the ceremony. There is a good chance you will see a sigh of relief and if you are lucky, a display of their joy or, as in the case of Figure 9-15, his joy.

The last moment of the ceremony is the first kiss, as in Figure 9-16, and while it might not have the passion a private kiss would have, it is one of the key moments of the wedding ceremony. Be ready to catch it, usually from the center aisle, where you will need to be positioned to capture the bride and groom walking back up the aisle after the ceremony. The first kiss is one of the must-have shots of the ceremony.

ABOUT THIS PHOTO
That first kiss of many as husband and wife. Taken at ISO 500, f/2.8, 1/800 second.

9-16

WORKING WITH A SECOND PHOTOGRAPHER

Shooting a wedding alone is possible, but it is so much easier when you are working with a second shooter or at least an assistant. The bigger the wedding, the more difficult it is to cover everything when working alone. The obvious advantage of a second shooter is that you get a lot more coverage of the day, and there is less chance of missing a photo opportunity. The disadvantage is that the second shooter is an extension of you and your business. The photographer represents you, and if the photographer's conduct is not up to your standards, it can impact your reputation.

When you are working with a second, or even third, photographer, it is important that you discuss the photographer's role and your expectations before the wedding. Any other photographers you work with need to know in detail what they are supposed to do at all times. One way to make sure that everyone is on the same page is to go over the schedule of the day and the shot list with all the photographers involved and make sure that they know where they need to be so they don't end up in the background of each other's shots.

If at all possible, try to work with the same group of photographers on a regular basis. I like to work with photographers I know and trust, which I am able to do now, and we have come to understand how each member of the group works and manage to stay out of each other's way. Also, many times these second or third photographers are wedding photographers who will use me as a second shooter when they are hired to be the primary photographer at a wedding.

Also, by working with photographers I know well, I feel that I can allow them the freedom to shoot the wedding as they see fit, as long as they get the shots I ask for. If I find a photographer who I like to work with, it is usually because his or her style of shooting complements my own. At the same time, it's important that the second shooter remain aware of my expectations. I will explain what I will be covering during the wedding ceremony and ask the second shooter to handle specific details; for example:

- During the processional, when the bride is walking down the aisle, I will focus on the bride's face and her reaction when she sees her husband-to-be for the first time, and ask the second shooter to concentrate on the groom. Because it is practically impossible to catch both reactions, the division of labor needs to be clear or you will end up with two shots of the bride and none of the groom.

- During the ceremony, I like to concentrate on the wedding party and will ask the second shooter to focus on the crowd and the wider shots of the church.

The real goal of the second (or third) photographer is to complement the primary shooter and cover what the primary shooter can't. This means that there not only has to be communication before the wedding to make sure everyone is on the same page, but also communication during the wedding so that all photographers are not

getting the same images. For example, if I am shooting with a telephoto lens and concentrating on the details, I want the second shooter to see that and start using a wide-angle lens to cover a different view of the same scene. In Figure 9-17, I shot the bride and groom with a wide-angle lens, while in Figure 9-18, the second shooter shot with a longer focal length, getting in close.

One last thing to keep in mind when you are working with a second photographer is to spell out the working arrangement with a contract that limits what can and can't be done with the images, what the payment for the day is, and any other details that you think are important. It is worth having an attorney draw up a second

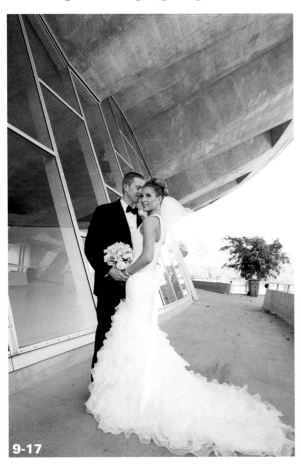

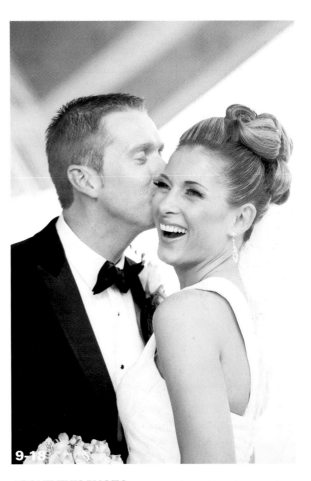

ABOUT THIS PHOTO *As I took this portrait of the bride and groom, the second shooter was using a different focal length to get a tighter shot. Taken at ISO 800, f/5.6, 1/640 second.*

ABOUT THIS PHOTO *A close-up of the bride and groom taken at the same time by the second shooter. ISO 500, f/5, 1/320 second. Taken by Oliver Peng.*

shooter contract for you to use. Having a contract might make things a bit awkward initially, but it can save you and the other photographer a lot of headaches if your expectations are written down and signed. This means that there can be no misunderstandings, and everyone will go into the wedding knowing what is expected of him or her. Just remember that if the second photographer does not do a good job, it reflects on you, so pick who you work with carefully.

WORKING WITH VIDEOGRAPHERS

Chances are that you are not the only one covering the big day for the clients; there is probably a videographer or video crew recording the day for posterity as well. I know that on the outset this might seem like a hindrance to you, but video is here to stay, and working well with a videographer or video crew will help you out in the future.

Some things to help you work together with the video crew successfully are as follows:

- **Discuss your objectives.** The main goal for both parties is to cover the day and record the story of the wedding, but using different media. It is possible to work together so that the clients get the best possible product. For example, during the reception, there will be speeches and toasts that are important for the videographer to record in full, while you just need a few photographs. Shoot without a flash so as not to disrupt the video, and try to stay out of the line of sight. On the plus side, the videographer might have an extra light turned on so that there is no need for a flash.

- **Discuss the sightlines.** Work out ahead of time where the videographer will be set up and whether the videographer will be moving or stationary. That way you both can stay out of each other's sightlines.

- **Work on mutual respect.** Act professionally and expect the videographer to do so as well. You both have a job to do.

- **Work together.** Offer to supply images to the videographer to be used in his presentation. This can be the start of a beautiful relationship between the two of you.

It is good to network with videographers who you work well with, given you are not in competition. They will recommend you and vice versa. As digital technology moves forward, there is a good chance that still photographers will start to incorporate video into their packages because professional dSLR cameras can now also shoot video. Knowing a good videographer will help when the clients want video as well.

Assignment

Tell the Story

The wedding is all about two people deciding to spend their lives together. As the wedding photographer, your job is use your images to tell the story of the wedding. The assignment is to pick one photo from the ceremony to tell the story of the day. I know this sounds like an impossible task, but you can do it. Once you choose that one photo, post it to the Web site. When narrowing down your choices, consider the following:

- **Emotions.** The whole wedding day can be a very emotional time for both the bride and groom (and their families as well). The ceremony can be the time where those emotions will be most present, and it is those emotions that you need to look for and capture. Being in the right place with the right angle is important, but watching the scene unfold and taking the photo at the right time is also important.

- **Gestures.** Many times a small gesture can mean a lot, such as the groom holding his bride's hand or a bride brushing back the groom's hair. Pay attention to these as they happen and be ready to take the shot.

- **Surroundings.** The ceremony location can help to tell the story of the day. Sometimes it is a good idea to shoot a little wider so that the location is part of the image.

The image here was taken at the end of the wedding ceremony and captured the look between the newly married couple. The smile, the hands on the hips, and the looks they are giving each other is a completely un-posed moment captured because I was in the right place at the right time watching the moment take place. This shot was taken at ISO 1000, f/3.5, and 1/180 of a second.

 Remember to visit www.pwassignments.com after you complete the assignment and share your favorite photo! It's a community of enthusiastic photographers and a great place to view what other readers have created. You can also post comments and read encouraging suggestions and feedback.

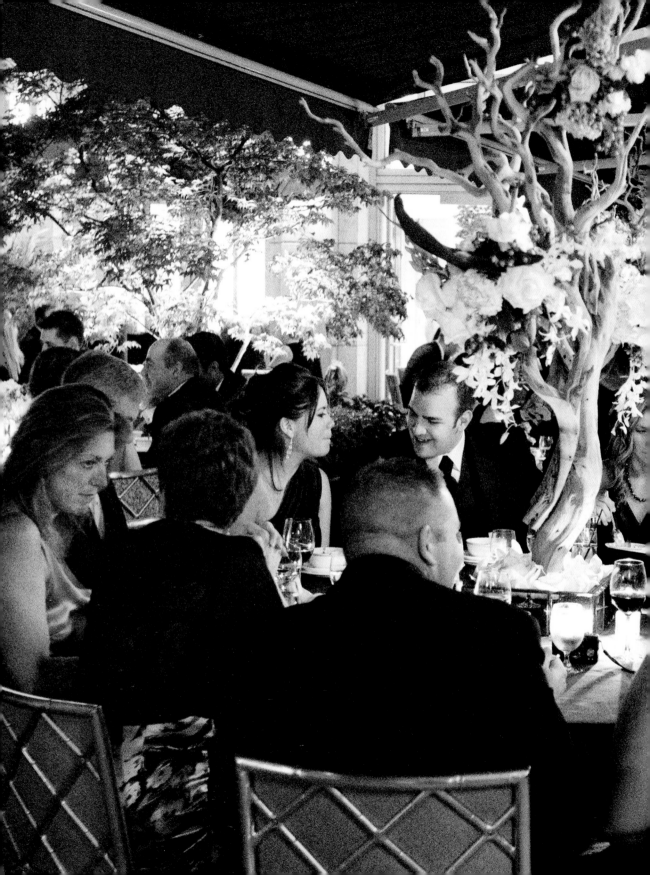

The ceremony is over, the portraits have been taken, and now comes the reception: the food, the drinks, the dancing, the celebrating, the time when the couple can relax and start to enjoy their life as newlyweds. While everyone else is enjoying the festivities, you are busier than ever. One important factor in making the reception photography go as smooth as possible is to have a detailed timeline so that you can be in place to capture the key moments. Work with the couple and the wedding planner or event coordinator so that you are kept in the loop on any and all changes to the plan. If you are expecting a garter and bouquet toss, but instead it's time for the cake cutting, you will be left scrambling to get into position. Oftentimes, the DJ is also involved in the schedule, so be sure to communicate with him as well so that you do not miss any important moments.

THE VENUE

The reception venue can vary greatly from wedding to wedding, but a few things are at every reception. And, you can be sure that a lot of time and energy went into picking the right centerpieces, the color scheme, the food, and the decorations. The best time for you to capture these details is before the guests arrive. The timing might be tough, especially if you still need to take portraits, but this is why many weddings have a cocktail or social hour before the main room is opened to the guests. It's best to be in the room right before the guests because that will be when it is the most complete. The candles will be lit, the place settings will be perfect, and the room will be ready for the guests to arrive.

You will need a wide-angle lens to photograph the room, and should use it from a variety of locations, including changing the height from which you take the photograph. Make sure that you cover the room from the middle, as shown in Figure 10-1, as well as from the right and left sides. While not all these images will end up in the couple's wedding book, some might just end up with the vendors, which is great networking for you (more on that a little later in this chapter). If there is a balcony or a staircase, try to get a top-down angle on the room, showing the whole layout in one shot.

Make sure you capture the centerpieces and a single table setting, and look for any of the small touches that the clients used to personalize the reception, like the details in the place settings, centerpieces, and cake, shown in Figures 10-2 through 10-4. Make sure you take a moment to photograph the wedding cake; it is the perfect time to get a shot of it without people in the way. It is also a great idea to ask the couple if there is anything special at their reception site that they would like you to capture. Now is the time to take care of those types of images; you won't have a good chance later.

One of the things to shoot during the reception is the food and drink. You can't do this before the reception because the food isn't out. As soon as the food is out, grab a few shots, and then get out of the way so as not to disrupt the flow of the wedding. You don't need a lot of photos, and many of these will not make it into the wedding album, but if they are not there, the clients will notice. One trick to keeping the focus on the food is to use a shallow depth of field, which blurs the background, keeping the food as the center of attention, as was done in Figure 10-5. Many times the bride and groom will be so caught up in the day that they won't even remember what they ate. I know it sounds hard to believe, but I've been told that many times over. On the plus side,

ABOUT THIS PHOTO *With a 24mm focal length, the whole room can be captured at once. Taken at ISO 1600, f/2.8, 1/100 second.*

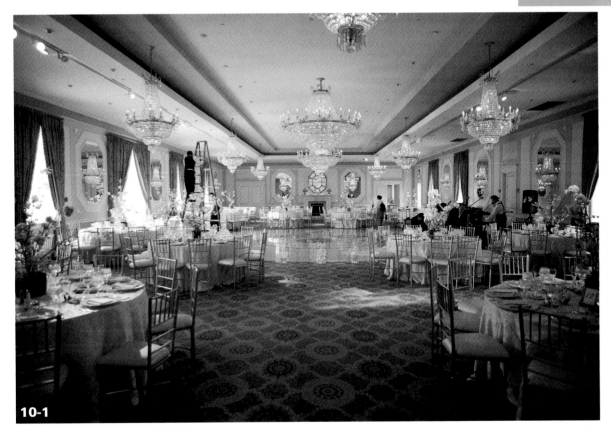

10-1

the vendors might really like a few professional shots of the food and food setup, which will help with marketing yourself.

THE GUESTS

There is one sure-fire way to make sure that you have photos of all the guests at the wedding and that is to photograph the tables when the guests are all sitting down. The challenging part is to do this without disrupting the flow of the wedding and the conversation at the tables, and timing is really important because no one wants photos of a table full of half-eaten food.

There are two methods to capturing the guests, and it is up to you to decide which works best for you and what you think the couple will like more.

The first method is to have one side of the table get up and walk around to the other side, creating a staggered group. This has the advantage that if you are working by yourself, you can use a flash on the camera fitted with a light modifier to illuminate the whole group. This works well but does have a downside; half the people at the table have to get up and move, which can be disruptive. This works really well if the tables are round but can be used even if the tables are square. When the tables are square, position yourself at a

10-2

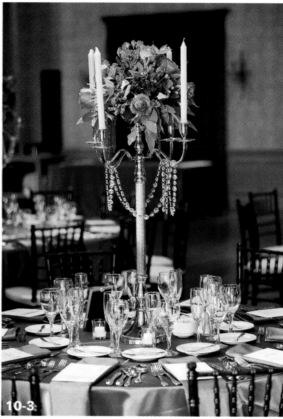

10-3

10-4

ABOUT THESE PHOTOS *A single place setting, the centerpieces, and the cake details are all photographs that can and should be taken before anyone even enters the room. In Figure 10-2 a place setting captured at ISO 400, f/2.8 and 1/80 second and +1.33 exposure compensation. Figure 10-3 shows a full table with the beautiful centerpiece taken at ISO 2000, f/2.8, and 1/160 second. Figure 10-4 shows the details on the cake. It was taken at ISO 1250, f/2.8, and 1/60 second with a flash.*

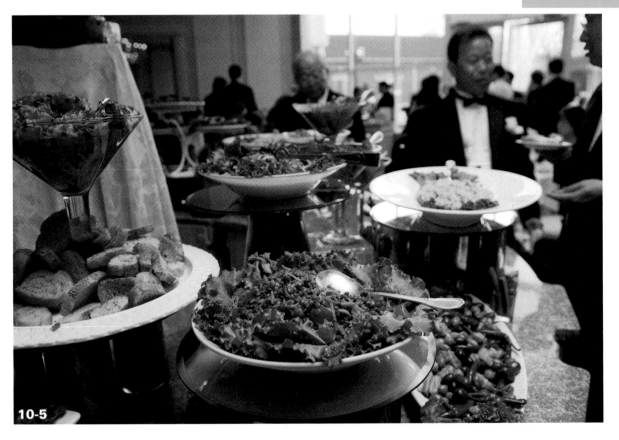

10-5

ABOUT THIS PHOTO *Photographing the food after it has been set out but before it is served up to the guests takes some quick timing and planning. Be ready to take those few food images quickly. This spread was taken at ISO 800, f/4, 1/1200 second.*

corner and have the group stagger around across the table from you. This can also work if you just have the guests turn toward you, but once again, it works best if you orientate yourself toward the table from the corner.

The second method is to have the group stay where they are but turn to the camera. This method is less disruptive but calls for a little more space between tables for you to pull it off successfully. Because the subjects of the photo are around a table, there needs to be a rather deep depth of field, which means you need to be a good distance away from the table to get the

desired depth of field. If you choose this method, be very careful backing up away from the table and make sure you don't bump into another table, or waiter, or guest.

There is a twist to each of these methods, and that is to have the bride and groom visit each table for the photograph, as shown in Figure 10-6. This is helpful three ways: It makes the photo more meaningful because it now isn't just the guests, but the bride and groom with their guests; it gives the guests something to focus on; and it ends any of the "come back later, we will do it then" you might hear from the table. If you are

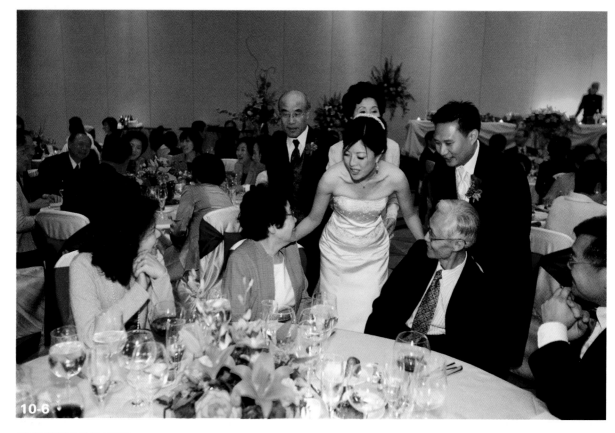

ABOUT THIS PHOTO *The bride and groom captured as they make the rounds visiting each table . Taken at ISO 1600, f/3.5, 1/60 second and .33 of exposure compensation.*

going to do this, you need to plan it with the bride and groom beforehand so that their dinner isn't interrupted.

CAPTURING THE DANCES

Some of the most memorable moments at a wedding are the first dance between the newlyweds and the parents dancing with their newly married children. As the wedding photographer, you need to be able to capture these special moments, and here are some ways to be able to do that:

- **Get into position.** When it comes to the dances, pick a location that gives you a good background. This might be the guests as they surround the dance floor or the band. As with all photos, the background is really important, and it needs to not detract from the main subjects. As you can see in Figure 10-7, using the guests as a backdrop works really well.

- **Use a wide angle.** An overall shot of the couple alone on the dance floor can look great, but remember to keep the couple toward the center of the frame so that the edge distortion

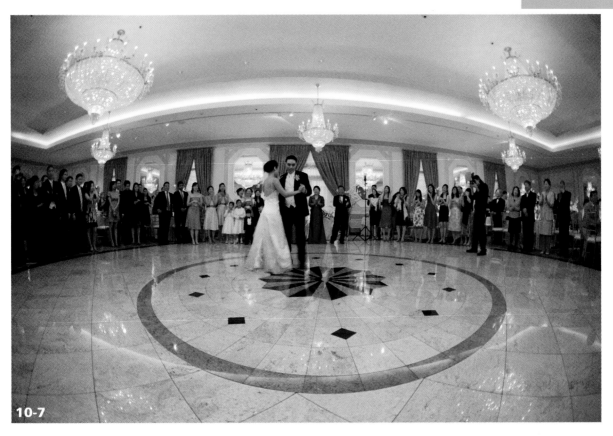

10-7

ABOUT THIS PHOTO *The newlywed couple enjoys their first dance together, surrounded by friends and family. The 15mm fisheye creates a very spacious feeling in the room. Taken at ISO 3200, f/2.8, 1/15 second.*

that can occur with wide-angle lenses doesn't come into play. This is particularly true if you use a fisheye lens, as I did in Figure 10-7. It is also important to remember that objects in the mid- and background will seem really far away, so wait until the couple dances closer, into the foreground, for some of the shots.

■ **Zoom in for expressions.** A close-up or two (see Figures 10-8 and 10-9) as the couples revolve around the dance floor is important; try to zoom in without actually getting physically closer, to focus on the eyes and to capture the looks between the couple.

■ **Look for dip at the end.** Some grooms will have been to dance classes and will try to finish the dance with a flourish. Watch for the dip and be ready to photograph it.

■ **Have the lights in position.** If the room is really dark, and even pushing the ISO on your camera all the way up doesn't result in a good exposure, make sure your flashes are set up, out of sight, and aimed to add light to the dance floor before the dance starts. Because you can control them from your camera, you can add them as needed.

ABOUT THESE PHOTOS *It is important to focus on the eyes, even if they are closed. The focus of Figure 10-8 is the expression on the face of the bride as she dances with her father, taken at ISO 400, f/2.8, 1/60 second. Figure 10-9 shows the love between the newlyweds taken at ISO 2000, f/1.2, 1/125 second.*

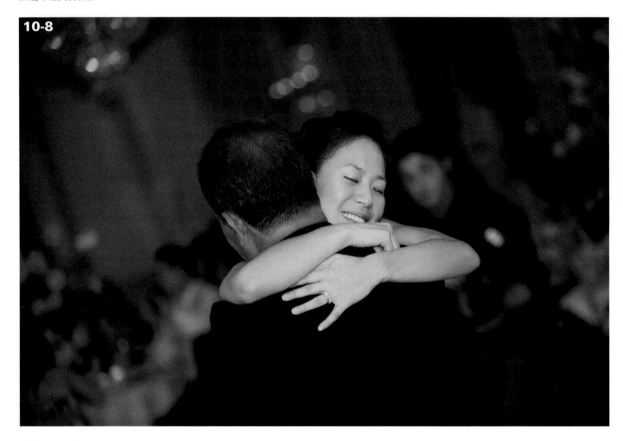

10-8

■ **Use a slow shutter speed.** Using a slow shutter speed combined with Rear-curtain sync shows movement in your images; this can add a nice touch to any dance photos. First make sure you have the shots you need for the album, and then reduce the shutter speed to less than 1/15 second, like the 1/10 second shutter speed used in Figure 10-10, and change the flash mode to Rear-curtain sync. This causes the flash to fire at the end of the exposure, freezing the motion at the end instead of the beginning. It takes some practice to get it just right but when it works, the results are great.

CAKE CUTTING

The bride and groom cutting the cake is one of the reception must-have shots. Given the timing of the cake cutting is planned in advance, there is no reason you cannot capture it in all its glory. If the cake is on display during the whole reception, make sure to get some full views and some close-ups of the cake detail. A macro lens can really help with getting the details. If the cake is being lit by a spotlight or any other room lighting, you will have to adjust the white balance to make sure the cake looks its true color. You can do this one of three ways: You can make sure you are shooting in RAW and plan on adjusting the white balance using software in post-production; you can set the white balance to the type of light predominantly present in the room; or you can set a custom white balance.

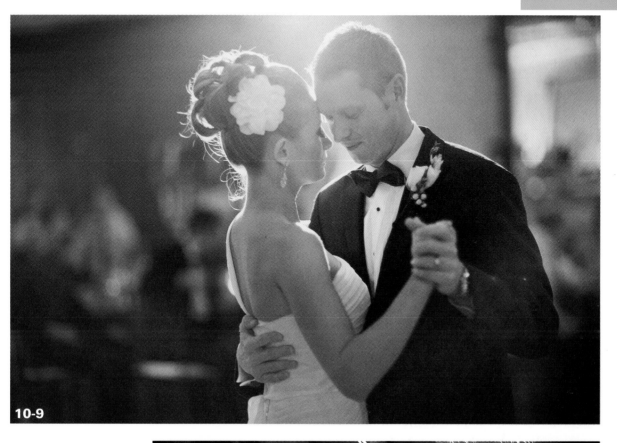

10-9

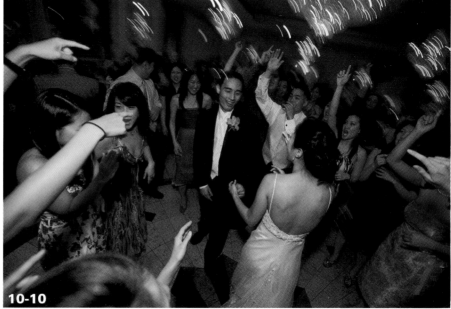

ABOUT THIS PHOTO
There is more movement in this image because the people and the camera were moving while the shutter was open, only to be frozen when the flash fired at the end of the exposure. Taken at ISO 800, f/4, 1/10 second.

10-10

Using a flash helped to reproduce the cake with natural colors in Figure 10-11, and a little adjusting of the white balance later helped create a great shot of the cake.

White balance is covered in detail in Chapter 6.

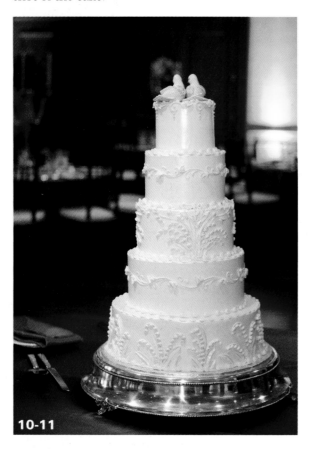

10-11

ABOUT THIS PHOTO *The cake usually stands alone on its own table. This makes it easier to shoot because there is no clutter surrounding it. Taken at ISO 1600, f/2.8, 1/50 second.*

During the actual cake-cutting ceremony, I set up off-camera flash units high on light stands off to the right and left of the cake table to add overall light to the scene. Some things that will really help you capture the scene are as follows:

■ **Keep your distance.** By backing up a little and using a zoom lens, you can cover the whole cake-cutting ceremony. It will always be easier to move in than it is to move backward.

■ **Use a zoom lens.** Because this type of lens allows you to change the composition by changing the focal length without having to actually move, you can use a wide-angle shot to set the scene, then a close-up shot of the bride's and groom's hands on the cake knife, followed by a medium shot of the bride and groom cutting the first slice, and so on. You get the idea. Examples of these types of shots can be seen in Figures 10-12, 10-13, and 10-14.

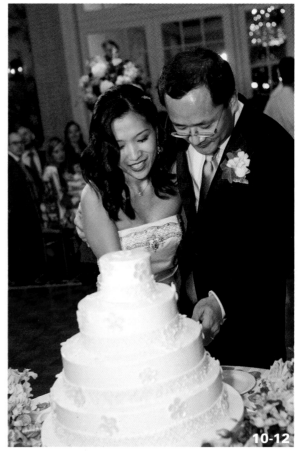

10-12

ABOUT THESE PHOTOS *Other than shots of the cake itself, you want to make sure you get shots of the couple cutting the cake, feeding each other the cake, and hopefully exchanging a kiss after. Figure 10-12 of the bride and groom cutting the cake was taken at ISO 2000, f/3.5 and 1/200 second. Figure 10-13 shows the bride feeding her groom his first bite of cake. Taken at ISO 500, f/4.5 and 1/13 second. The kiss after the first bite of cake in Figure 10-14 was taken at ISO 1600, f/2.8 and 1/60 second.*

10-13

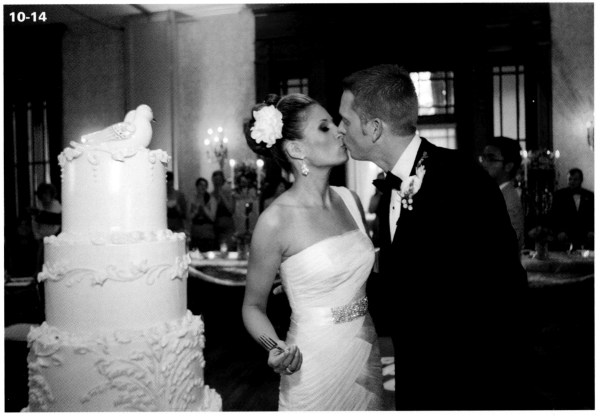

10-14

- **Get a posed shot.** Have the couple stop and pose during the cake cutting. It might look a little fake while they are doing it but will be a shot they want later on. Have them pause on the key moments such as holding the knife, the first cut, and feeding each other the cake.

- **Be polite.** Sometimes guests will step between you and the cake table; many times they are just trying to get a quick photo of the moment. Just politely ask them to move aside but try to keep a smile on your face and be friendly.

- **Feel free to be the director.** Let the couple know what it is they need to do: where to cut the cake, where to look, where to place the knife. They will appreciate it, and you will get better photographs.

- **Watch for reactions.** This is especially true if you are the second photographer at the wedding. Your job is not only to back up the main photographer with some overall shots but also to look for guests' reactions, especially if the bride and groom feeding each other the cake becomes messy.

TOASTS

If there is one part of the reception that is guaranteed to get an emotional reaction from the bride and groom, and the guests, it is the toasts. Toasts can be a little scary for both the person offering the toast and the couple being toasted. Every eye and ear in the house is on the person offering the toast, and chances are he or she will be a bit nervous.

Look for opportunities before the toasts have been said to catch the person who will be offering the toast rehearsing or reading over his notes, as shown in Figure 10-15. It adds a great touch to the wedding album and really helps to tell the whole story of the day. The only way this works is to know who is giving the toasts and when they will happen. This is when a good prime lens that has a maximum aperture of f/1.4 or f/1.8 really pays off. Combine that lens with a high ISO of 3200, or even 6400, and you can capture the moment without a flash, so as not to interrupt the speech preparation.

The actual speeches are pretty easy to photograph, because it is obvious who is the center of the attention and where the speeches will take place. The most important part of shooting the speech or toast is timing: Wait until the speaker looks up and if he is using a microphone, wait until he has lowered it a little so that you can see his face clearly. Focus on the eyes and use a shallow depth of field to really blur the background, which in turn makes the subject pop off the background. In Figure 10-16, I used an aperture of f/2.8 and patiently waited for the speaker to look up.

During the toasts, there is another subject to photograph other than the speaker: the bride and groom. If you are shooting with a second shooter at the wedding, make sure that one of you is photographing the speaker and the other is looking for the reactions to the speech. Keep in mind that you do not need a lot of photos of the speaker — a few good ones will go a long way — but the reactions from the bride and groom can be priceless. Using a shallow depth of field allowed me to capture the bride's reaction to the speech in Figure 10-17, and made sure that she was the subject of the photo by keeping her in focus. So if you have to cover the wedding solo, make sure that you can see both the speaker and the bride and groom from your location to get speaker and reaction shots by yourself.

ABOUT THIS PHOTO *A great moment to capture is a person going over his speech or toast before giving it. Just know who will be speaking, and when, and be ready for this type of candid shot. Taken at ISO 3200, f/1.8, 1/125 second.*

10-15

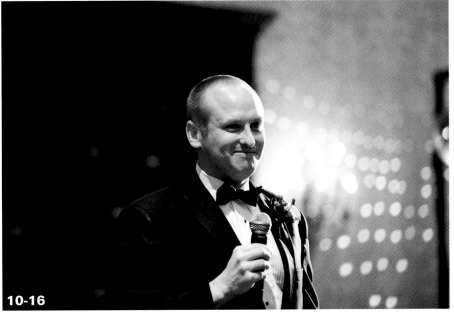

10-16

ABOUT THIS PHOTO
The speaker lowered the micro-phone and looked up, the per-fect moment for a photograph. Taken at ISO 25000, f/2.8, 1/160 second.

10-17

ABOUT THIS PHOTO *The bride reacts to what is being said during the toast from her maid of honor. Taken at ISO 4000, f/2.0, 1/100 second.*

BOUQUET TOSS AND GARTER TOSS

If you plan properly, you can get some really great shots of the bouquet toss and garter toss, including funny and unexpected moments. The main point is to be ready for anything. These two events can involve a large number of the guests, and because they usually take place rather late in the reception, they can be a little chaotic. You photograph the bouquet toss and the garter toss in the same way.

Because the bouquet toss is usually first, I will cover it first. The concept is usually simple and, because the bride throws the bouquet backward over her head, all the participants face the same way, making it easy for you to get all the action from one location. Usually the band or DJ will announce that the bouquet toss is about to happen and request that all the single girls join the bride on the dance floor. The key is to have the participants spread out so that more of them can appear in the photographs, as opposed to them being clumped together in the middle. It pays to do a

little directing here and ask the participants to spread out a little, or make sure you discuss it with the couple if they have a master of ceremonies who will do the announcements. Communication is essential here because there is usually no second chance to get it right, so make sure that they know to wait until everyone is in position and don't rush the whole throw.

Place yourself off to the side, just in front of the bride, so that you can see the bride, the arc of the bouquet toss, and the participants who will

hopefully try to catch the bouquet. If needed, place a flash on a light stand on the other side of the bride, angled to get the whole scene. The rest of the shot is all about the timing of the bride's toss. Have the band or DJ count down to the throw and start taking shots before she actually tosses the bouquet, as shown in Figure 10-18. Adjust the focus as the bouquet travels through the air and hope that you get the lucky bouquet catcher in action.

Don't stop taking photographs at this point; look for the relief in the faces of the women who are happy they didn't catch the bouquet, while the

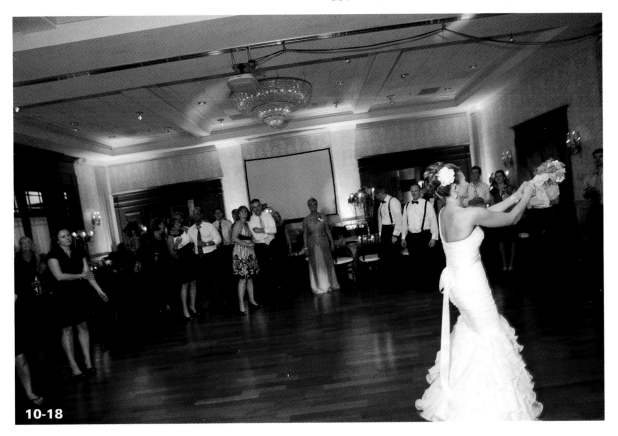

10-18

ABOUT THIS PHOTO *The bride gets ready to launch the bouquet toward the waiting eligible female guests. Taken at ISO 2000, f/4, 1/40 second.*

woman who did catch it is congratulated by the bride. After the bouquet toss is all over, make sure you get a portrait shot of the bride and the guest who caught the bouquet right there on the dance floor because the garter toss is next and the setup is the same, so you don't want to spend a lot of time changing your gear.

The garter toss follows the same general design as the bouquet toss, and you use the same basic lighting and camera positions. The big difference is the start of the toss, where the groom removes the garter from the leg of his bride. Coordinate with the couple and the wedding planner that the band, master of ceremonies, or DJ issues a request for all the eligible young men to join the groom on the dance floor after the bouquet toss. Make sure that you have a chair ready for the bride to sit in. If you are the one to place the chair, you can control where the bride and groom are located and can get the best angle for photos of

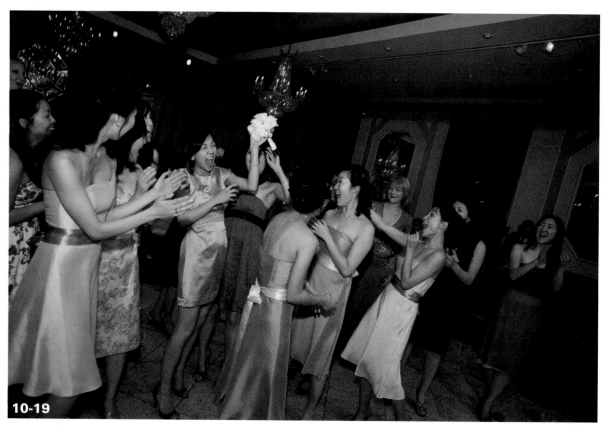

10-19

ABOUT THIS PHOTO *The bouquet has been caught and the reaction of the woman who caught it captured. Taken at ISO 400, f/2.8, 1/60 second.*

the scene. Have the young men gather around the bride and groom, creating a meaningful backdrop to the photos of the groom removing the garter. Have the band or DJ start up the music and capture the groom removing the garter from his bride. Be ready because if you think you have seen everything, the garter removal will most likely prove you wrong. Who knows for sure how the groom got the expression from his bride in Figure 10-20.

With the garter in hand, have the groom wait a moment while the chair is removed and the eligible men get into position to catch. The rest is the same as the bouquet toss only with the men instead of the women. When both tosses are over, try to get a shot of the guests who caught the bouquet and garter together; it will make a nice memory.

tip *Having a second shooter for the bouquet and garter toss means that one of you can focus on the toss, while the other focuses on the catch. Just make sure you plan who is going to do what before the actual toss.*

When you work with a second photographer during the bouquet toss and garter toss, make sure that the photographer is out of the frame. Have her shoot the same scene with a different focal length and available light. For example, if you are shooting wide at 20mm, then have the second shooter use a longer lens to capture facial expressions or a close-up of the bride's or groom's hands holding the bouquet or garter.

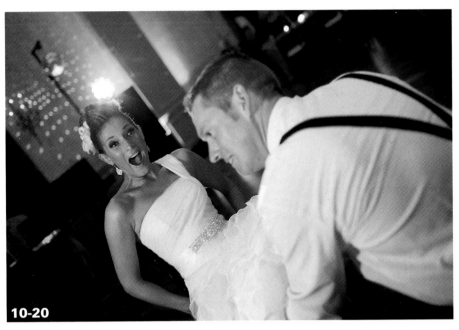

ABOUT THIS PHOTO
Focusing on the bride while the groom removes the garter can result in some great spontaneous expressions. Taken at ISO 200, f/2.0, 1/15 second.

10-20

10-21

ABOUT THIS PHOTO *The dancing was interrupted, and because I was there and paying attention, I was able to grab a shot that otherwise would never have been captured. Taken at ISO 2000, f/4, 1/40 second.*

CANDIDS

There are numerous occasions during the reception for candid photos, from the slow dances to the faster dances, from reactions to the speeches and toasts to interactions during the cocktail hour; and the main goal is to capture a moment that will help tell the story of the wedding.

At times, the candid moments simply present themselves to you. For example, while I was photographing the dancing couple in Figure 10-21,

one of the guests intentionally bumped into them. Because the couple were already the center of attention, it was easy to capture this moment.

Some of the best candid photographs happen while people are sitting around talking to each other or listening to the speeches or toasts. The key to this is to use a longer focal length, allowing you to get in closer but not intrude. Look for the reactions to the toasts from the guests, and the easiest way to get in close is to use a longer lens,

10-22

ABOUT THESE PHOTOS *The guests react to the toasts, and these candids capture those moments perfectly. You don't need to know exactly what was said to know that it was funny, and maybe a little shocking. Figure 10-22 was taken at ISO 1000, f/3.5, 1/40 second, while the reactions in Figure 10-23 were captured at ISO 400, f/4, 1/60 second.*

10-23

as I did in Figures 10-22 and 10-23. This enables you to get in close and not get in the way, and because you have been around all day, the guests will stop noticing you when you raise the camera to your eye and start shooting away.

There is one more type of candid. Well, actually, I like to call it the "posed" candid. As you can see in Figure 10-24, the subjects know that a camera is present and do a quick pose for you.

ABOUT THIS PHOTO *A little bit of clowning around is to be expected and hopefully captured. Taken at ISO 800, f/3.5, 1/150 second.*

NETWORKING TIPS Weddings are a great place for wedding photographers to network and to meet new clients. Just make sure that your networking doesn't impact the job at hand. The most important job is the one you are on, but that doesn't mean you can't think ahead.

Vendors. You will do some of the networking throughout the day, as you interact with the other vendors. This includes the caterers, the flower vendors, the videographer, and anyone else working at the wedding. Exchange business cards with everyone and more important, give them images showing their great work afterward. Just make sure copyright information is on every photo so that if a photo is used by the vendor for any type of advertising, your name gets out there as well.

Guests. If guests are present who are interested in hiring a photographer, they will watch you while you work, and if they are interested in hiring you, they will approach you if given the opportunity. Be professional, and hand them a card and ask them to contact you when the wedding is over. Remember that they would expect this professionalism from the photographer hired to work at their wedding.

Slide shows. Technology is a wonderful thing, and if you can put together a slide show of 25 to 50 choice images from the wedding to be shown at the reception, you not only entertain the clients and their guests but also showcase your work to a room full of potential clients or referrals. Clearly, the time you have between the ceremony and the reception determines whether this is even an option.

Don't rush off. Once your job is done, don't just rush off. Let the bride and groom know you will stay for a bit in case they need anything. Use that time to download images and make yourself available to the guests. By now they all know who you are, and guests who are interested in your services might approach you.

Above all, act professionally all the time. You never know who might be watching.

Assignment

Capture a Real Moment

There are so many posed moments in a wedding, from the portraits to the cutting the cake, that some photographers forget to shoot the candid images, to capture real moments. This assignment is about being able to capture the real moments, those that happen between the posed shots. The most important thing that you can do is pay attention because there is never a moment at a wedding when nothing is happening. Once you capture that real moment, upload your shot to the Web site to share with other readers.

Capturing a real moment is all about being able to read people and watch for the details. The good part is that you can practice this anywhere. For example, go and sit in a coffee shop and just watch the facial expressions, conversations, and the gestures of the people around you. This practice will help to train your eye for real moments when they happen at the wedding. There are a few things that can help:

- **Always have your camera ready to go.** It is no good seeing one of those moments and not having your camera ready with you. These moments usually only last for a split second, so you need to be ready to go.

- **Have your camera set up for your location.** Every location has different lighting conditions, and you need to make sure your camera is set for the conditions first. It is no good seeing a great moment, and then realizing you need a higher ISO or wider aperture.

- **Shoot in burst mode.** Once you see a moment unfolding, shoot more than one shot. This will up your chances of capturing that very moment.

The moment captured here took place after the toasts when the bride's father went over and gave the bride a hug. I would not have been able to capture this moment had I not been paying attention to the bride after the toasts. I saw the hug and immediately brought my camera up to my eye and got the photo. I had already set the camera for the low-light conditions and didn't have to adjust the settings to get a proper exposure here. The hug only lasted a few seconds and then the moment was gone. Taken at ISO 6400, f/4, and 1/20 of a second.

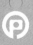
Remember to visit www.pwassignments.com after you complete the assignment and share your favorite photo! It's a community of enthusiastic photographers and a great place to view what other readers have created. You can also post comments and read encouraging suggestions and feedback.

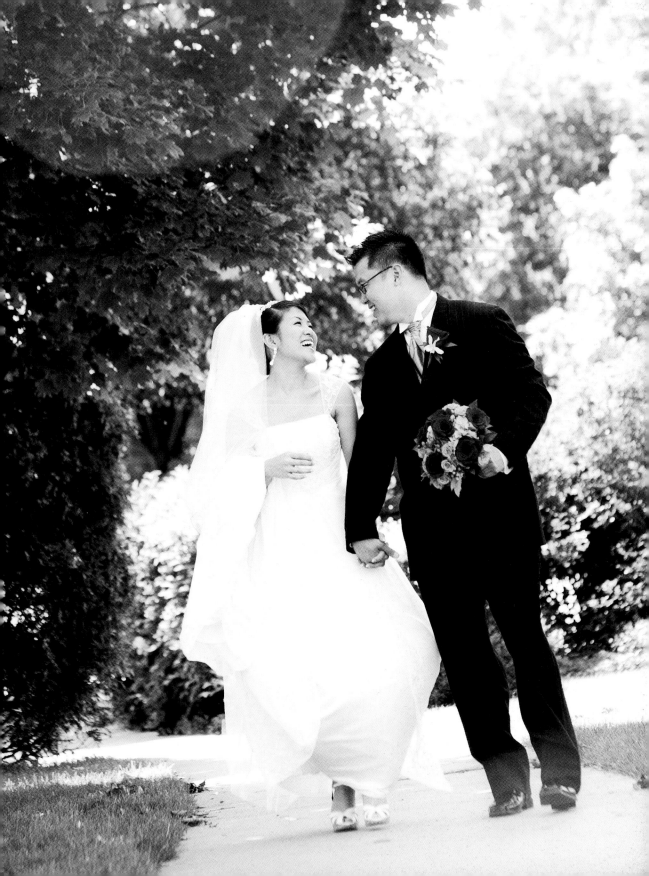

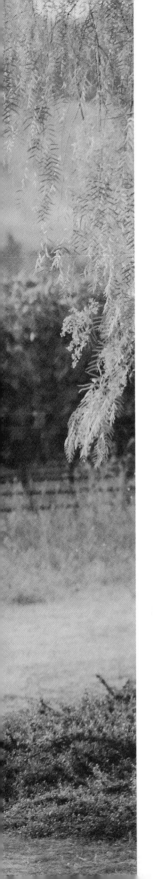

POSTPRODUCTION

The wedding is over and the bride and groom are hopefully on their way to a wonderful honeymoon, but you still have a lot of work to do before you can call it a day. You need to deal with all those wonderful images that were taken during the events of the day. The photos need to be downloaded from the memory cards into the computer, sorted and edited, including applying any software actions, and then output for the newlyweds to view. After the couple have made their selections, the images can be archived. This chapter provides a basic look at the workflow and processes involved in the image postproduction.

IMPORTING, SORTING, AND EDITING IMAGES

The first step when you are preparing the images for the newlyweds is to get the images from the memory cards into the computer, which is the easy part. After that is done, you are faced with one of the hardest parts of the post-processing: deciding which images make the cut. Once you make those decisions, you do the basic editing.

IMPORTING

Every camera has a port that you can connect to a computer to download images via a USB cable. Many cameras come with this cable and for those that don't, you can get the cable at most office supply stores for a few dollars. Just check in the camera manual for the cable specifications. While this is definitely the cheapest solution because most of the time it doesn't cost anything extra, two negative factors make it impractical. The first is that the transfer times are usually really slow, and the second is that it can really suck the life out of the camera battery. A much better solution is to purchase a stand-alone card reader to use for importing your images. There are many different

card readers on the market, such as the one from Lexar and one from Hoodman shown in Figure 11-1; and some things to look for when choosing one include the following:

- **The speed of the transfer.** The faster the transfer rate, the faster the images are imported onto your computer and the quicker you can get work done. The memory card you use also determines the transfer rate speed: Slower speed cards will be slower when transferring the data to the computer. Look for UDMA (Ultra Direct Memory Access) compatible card readers that take advantage of the higher-speed card transfer rates when used with UDMA memory cards.

- **The type of cards it supports.** There are different types of digital media, and it is key to make sure that the card reader you get is compatible with the cards you use. The two main cards used in today's cameras are the CompactFlash card and the Secure Digital card. It is best to get a card reader that can deal with both of these types of cards so you are ready for anything. For example, if a second shooter uses a different type of card than you, you will be able to import the files without having to change card readers. A good example of this is the Lexar Professional Dual Slot card reader, which will read both CompactFlash and Secure Digital cards and costs roughly $50.

- **The connection it uses.** Card readers connect to your computer like any other peripheral, and there are choices regarding what connection type they use. Some readers use the USB 2.0 standard, while others still use FireWire; and with USB 3.0 emerging, the choices are growing. Find the card reader that has the same type of connection that you have on your computer, and if you have doubts, stick with USB.

ABOUT THIS PHOTO
Card readers come in a variety of types. Pick one that can handle the speed of your memory card.

There are many ways to import the images from the memory cards to the computer, and programs such as Adobe Photoshop Lightroom and Apple Aperture have built-in photo importers, as will the software that comes with your camera. For image importing, I use a program called Photo Mechanic (by Camera Bits) that ingests (their word for import) the images and allows me to add a huge amount of information in the IPTC window, shown in Figure 11-2. This data makes it possible to look at an image years from now and know when it was taken, why it was taken, and who took it. Some of the information is written by the camera directly into the digital file, but the rest of it needs to be added. Some of the options you have when importing your images are available in just about every software package. These options enable you to do the following:

■ **Rename the files.** Your camera uses a file-numbering system that doesn't really make much sense, so the good news is that you can change the filenames when you import the images into the computer. A good idea is to use the name of the couple and/or the date of the event. That way you can easily find the images later on.

■ **Add copyright information.** Many times you can add your copyright right into the image during the import. This is a great idea, because it adds a level of protection to your images with very little work on your part.

■ **Add shooting data.** You can add a location and description of the shoot in the image data at import. This enables you to instantly have the data on each shoot available on each image, which means you will never have to guess where the image came from.

■ **Make a backup copy.** Many image import programs allow you to save the files to two different locations at the same time. This gives you an instant backup copy of the photos, which is always a good thing.

11-2

SORTING

Not every image you shoot at a wedding will be great, and you will need to delete some of the bad ones. You may not be surprised to know that photographers tend to become emotionally attached to their images and can have a hard time getting rid of any of them. So, the first thing to do is to toss away the ones that are obvious mistakes, like shots of the floor or ceiling that were inadvertently taken while carrying the camera (which happens to every photographer at some point).

Many programs allow you to sort in a variety of ways; examples include a simple select/unselect checkbox, using a variety of colors, and a star rating that runs from one star to five stars, as shown in the Adobe Lightroom interface in Figure 11-3.

If you are shooting a wedding with a second or third photographer, then make sure that you all get together before the photography starts and sync the clocks on your cameras. This makes the editing process a lot easier, because you can sort the images by time. To do this, open the date/time feature on all the cameras and make sure

ABOUT THIS FIGURE *Sorting by using a five-star system makes it easy to find the images you want later.*

11-3

everything is identically set, down to the second. This means that when all the photos from all the cameras are imported into the computer, you can view them chronologically.

The key thing to remember is that you should only show the best images: those that show the subjects in the best possible way, or those that capture a special moment, look, or gesture.

When I sort a wedding, I do it in the following steps. I find this allows me to pick the best images from the day and supply the clients with a complete set of images.

■ **Quick scan.** The first thing I do when the images are imported is a quick scan of the images. This scan through the images is not to pick the good images but to get rid of those really bad images. I look for the images that are really out of focus or so over- or underexposed that they can't be fixed. Even professional photographers take a few really bad shots, so this is to just get rid of them.

■ **Sorting scan.** After the really bad images are thrown away, the next step is to look at the remaining images and sort them as either

those to keep in the wedding album or those to get rid of. When it comes to this sort, the following items are what I look for:

> **Focus.** Check the focus; is the image really sharp? The viewer's eye will travel to the parts that are in focus first, and if that's not your subject, then the image isn't doing what it should.

> **Exposure.** Is the image too dark or too light? You can adjust this using software, but if the exposure is really far off, then chances are it's not a great shot and definitely not your best.

> **Emotion.** Is there something in the photo that shows how the subjects were feeling about each other — a look, a touch, some gesture that conveys the emotion of the moment?

> **Don't explain.** The image should be able to stand by itself and not need any explanation. If the image needs to be explained, then chances are it's not a great shot.

■ **Check the different events for completeness.** After I have looked at all the images, I make sure that there is coverage of all the different parts of the wedding day. This means that there is coverage of the whole day, from the bride and groom getting ready all the way through the end of the reception. If there are gaps or places where the coverage seems a little thin, I will go back through the images I rejected in the sorting scan of that part of the wedding and look for images that can be fixed in postproduction.

■ **Check the requests.** This is where I make sure that all image requests from the couple have been met. If they asked for extra photos of a part of the wedding or of a person, I make sure that those requests have been met.

tip Many of the software packages available to photographers, including Lightroom and Aperture, allow you to compare different photos side by side. This is a great way to decide which of the two images is better, and it is important to always pick the best shot.

EDITING

Most images need to be edited, at least a little, before they are ready for the customers. This might be as simple as adjusting the exposure slightly or cropping the image. One of the key things to edit is the white balance to make sure that the colors are properly reproduced. Each of the image-editing programs I discuss here can handle the basic edits, but some go much further, allowing you to import, sort, edit, and output the images in different formats, all from the same program.

You also have another option when it comes to editing your wedding images, and that is to outsource the editing to a third party. A company I use on occasion called Photographer's Edit (photographersedit.com) will do the processing for you. They not only correct your images but also provide a Lightroom catalog of the files, so that you can fine-tune the images yourself if needed, but the bulk of the work is done by them. This is a great option if you find yourself extremely busy because it frees you up to book more weddings, and the images from the already shot weddings still get to the customers in a timely manner.

PHOTO-EDITING SOFTWARE

Image-editing software is really big business, and the leader of the pack is Adobe with Photoshop and Photoshop Lightroom. Adobe also has an image-editing package for the hobbyist called Photoshop Elements. Apple has a professional-level image editor as well, Aperture, that only runs

on Apple computers, but has a very loyal customer base and does a lot of things very well. The following sections take a brief look at each of these.

PHOTOSHOP

Adobe Photoshop is the most well-known image-editing software in the world and has been the leader in digital image editing for more than twenty years. It is the gold standard by which all other image editors are judged. Along with the serious image-editing capability comes a serious price tag; you truly get what you pay for.

Adobe Photoshop is actually three separate programs all in one:

- **Bridge.** The Bridge is a free program that ships along with Photoshop and is a basic image-sorting and viewing application. It is also the program you can use to import your images into the computer.

- **Adobe Camera Raw.** Adobe Camera Raw (ACR) reads the RAW files produced by digital cameras and lets you develop these files before opening them up in Photoshop. RAW files cannot be used before they are translated by software like ACR, and because ACR is updated independent of Photoshop, support for newer cameras is added regularly. The layout of ACR is very simple, as you can see in Figure 11-4.

11-4

ABOUT THIS FIGURE *The Adobe Camera Raw window showing the basic editing controls on the right.*

ACR has a big preview window on the left and the main editing controls on the right. There are nine different editing menus built right into ACR, and they all relate to digital photography, unlike the more general image-editing menus in Photoshop. The editing menus in ACR are Basic, Tone Curve, Detail, HSL/Grayscale, Split Toning, Lens Corrections, Camera Calibration, Presets, and Snapshots. The controls are exactly the same as those found in the Lightroom's Develop module.

■ **Photoshop editing workspace.** This is the main editing area of Photoshop, and while the controls move around some each time a new version comes out, the basic layout is the same. In Figure 11-5, the main image is ready

11-5

ABOUT THIS FIGURE *The Adobe Photoshop workspace showing the tools on the left, the main image in the middle, and the information panels on the right.*

to be edited in Photoshop. The tools are on the left with the many different information palettes on the right.

Adobe Photoshop is the top-of-the-line image-editing program, and while you can use Bridge to sort your images, Photoshop's real strength lies in the pixel-level editing it can do.

PHOTOSHOP LIGHTROOM

Adobe released Lightroom specifically for photographers' workflow. Now in version 3, the program allows you to import and sort files and do some minor image editing. It also allows you to create custom print packages and Web galleries if you are the do-it-yourself type.

You start with the Lightroom Import menu, which not only lets you import the images from the memory cards to the computer but also lets you add information to the images as they are transferred. The Lightroom workspace is split into five modules: Library, Develop, Slideshow, Print, and Web. This module-based workflow is organized along the lines of a photographer's workflow, which starts with importing images into the Library mode, where the sorting happens; next using the Develop mode, where any image editing happens; and then outputting the images using the Slideshow, Print, or Web modules.

You use the Library module to do all your sorting, and there are numerous ways to tag the images so they are sorted into different groups. You can use the Pick or Reject tags, rate the image from one to five stars, or use a color-rating system.

The Develop module in Lightroom, as shown in Figure 11-6, has the exact same controls as in ACR. The two different programs are updated at the same time and both can process RAW images.

Lightroom is a great solution for the photographer who wants to do everything himself because it allows Web galleries to be created and published directly from the Web module and prints on your printer directly from the Print module. However, if you are a busy wedding photographer, you might want to consider using a third-party company to handle this. Lightroom allows you to export your images in a variety of formats, allowing you to supply the images to a service provider like Pictage or Zenfolio. The export window allows you to pick the file type and other options. These preferences can be saved as a user preference and used over and over again. Figure 11-7 shows the Export window for Lightroom.

APPLE APERTURE

Apple computer created the Aperture photo-editing software for the Mac-using professional photographer. Aperture offers a complete set of tools for importing, sorting, and editing your images.

Aperture offers tools for sorting and rating your images, lets you create Web galleries and collections, and allows you to create books that can then be professionally printed and shipped directly to you or a client. For the wedding photographer who wants to do it all, this might be a solution worth looking into.

11-6

The exposure adjustments include the Exposure, Recovery, Black Point, and Brightness sliders. These four controls are the main adjustments when it comes to fine-tuning your exposures and are very similar in function to the controls in ACR. The four controls in this section, which are shown in Figure 11-8, are used to correct problems like overexposure and underexposure.

Aperture has many more tools you can use to adjust the color, sharpness, tone, and saturation in your images, and it even allows you to remove small spots and blemishes. If you are already a Mac user, then this is definitely a good option and worth checking out.

PHOTOSHOP ELEMENTS

Photoshop Elements is Adobe's consumer version of its professional image-editing software, Photoshop. The biggest plus to using Photoshop Elements is the price, which is a fraction of the cost of the full version of Photoshop.

ABOUT THIS FIGURE *The Export window in Lightroom showing the File Naming, File Settings, Image Sizing and Output Sharpening choices.*

11-7

If you are just starting out and can't afford the full version of Photoshop, this can be a good place to start, because it provides some basic editing functions. However, it doesn't offer any heavy-duty sorting and organizing features. So, while you can use it for your primary image-editing software, it is certainly not the best option or a good long-term solution if you plan to build your business.

11-8

ACTIONS

Actions are prepackaged instructions that when used with a photo-editing program, create a specific look. They enable you to create a certain look consistently without a lot of work. For example, I use an action that creates a black-and-white version of an image with a single click, as shown in Figure 11-9. The same action can also create a sepia-toned version of the image, or a color-tinted version, or all three. Using actions can really help speed up your editing time.

Actions are useful because they can cut down the editing time after a wedding drastically, but you need to take care that you don't rely on actions alone to make up for poor photography. The actions can be used to enhance and tone an image, but the image needs to be correctly exposed and composed first. A quote that sums up actions for me comes from Denis Reggie, who said "Actions should be the salt and pepper of your image, not the steak."

There are two types of actions: those that you purchase from others and those that you create yourself. There are a great many actions available out there that you can purchase and use, but keep

ABOUT THIS FIGURE *The difference between a color and black-and-white version of the same image. Actions can produce myriad effects with a click of the mouse.*

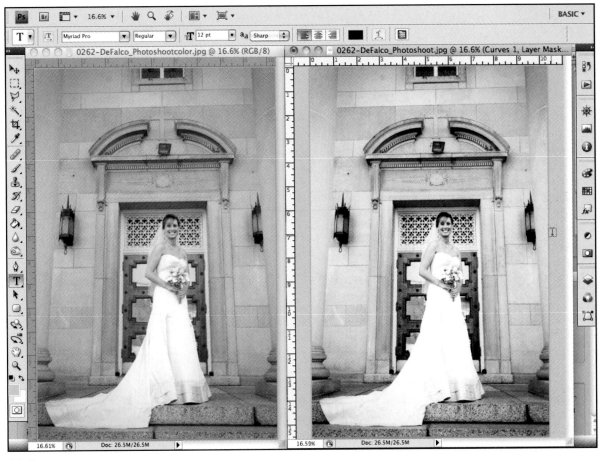

11-9

in mind that if you can buy and use a certain action, so can any other wedding photographer. So while an action might give you a look that you really like, don't rely solely on it to differentiate your work from your competition. One way to keep the actions unique to you is to adjust their opacity so that some of the original image shows through and the action is toned down a little.

> *tip*
>
> It is a good idea to keep a copy of the file without the action so that if the couple ever asks for a color version, or a version that doesn't have the action applied, you have it available.

There are many prepackaged actions available for purchase from companies like Kubota Image Tools and Totally Rad Actions, both of which I highly recommend. One nice feature of the Kubota actions is the dashboard feature, which allows you to access all your actions, not just those from Kubota, from the same place. In Figure 11-10 you can see the image I started with. I applied the Fuji snappit by Kevin Kubota, then adjusted the opacity down to 35%, and then added a warm tone in Photoshop. The result is in Figure 11-11.

231

ABOUT THESE PHOTOS *The before in Figure 11-10 and after in Figure 11-11 show that while actions can help make your image stand out, it needs to be a good image to start with. Taken at ISO 500, f/4.0, 1/320 second.*

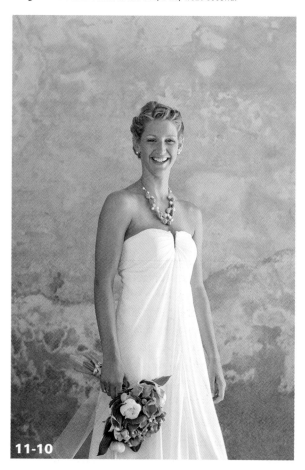

11-10

11-11

OUTPUT

You have sorted and edited your images, and now it is time to output them for use in Web galleries and proof books for your clients. There are a few different things you will need to consider, the first of which is the type of file to use for the images.

■ **JPEG.** The JPEG file type was created by the Joint Photographic Experts Group in 1992 and is the most common image file type. The advantage to the JPEG file format is that it is a universal file format that can be viewed, printed, and shared just about anywhere. You can view the image directly in an e-mail or on a Web site. If you need to e-mail a photo, upload it to a Web site, or even send it off to

be printed, the JPEG file will fit your needs. The downside to the JPEG file is that it is compressed, and information is actually thrown away when you save the image as a JPEG. If you need to open and edit the file again, then that missing information can make it difficult to fully edit the image. It is best to output files in the JPEG format when you know you are not going to edit them again.

■ **TIFF.** The Tagged Image File Format, or TIFF for short, was created for the express purpose of storing images for desktop publishing. These files save all the information in a form that a computer can read, but the downside is that the uncompressed file size makes it very large,

too large for Web use or e-mails. TIFF files are a great way to save the images, especially if you think you might want to edit them again because they don't compress the image or throw away any of the information when saved.

For example, the difference in size in the same image when it is saved in the two different formats is huge. The JPEG version is 1.5MB while the same image saved in the TIFF format is 38.3MB.

FILE MANAGEMENT AND STORAGE

It is really important to be able to keep your images neatly sorted and cataloged so that if needed, you can find the images from a specific wedding easily. Many times a couple will want another copy of certain images months or even years after the wedding, and the first person they are going to ask is the wedding photographer.

You need to come up with a system that works for you, but here are a few things that I have found work for me:

- **Name the files.** Camera file-naming systems are terrible and totally incomprehensible when you need to find an image from a wedding months or years later. I change the name on import so that all the files are actually named for the wedding. I use a sequential number, then the couple's last names and the category of the event — for example, 0371-Smith_Nash_Ceremony.jpg. This allows me to sort the image using the number, but by looking at the filename I know exactly what type of shot it is.

- **Add information into the file.** When I import the files to the computer, I add a lot of information to the IPTC data, including the clients' names, the location of the shoot, any second photographers from the job, the

location, and my copyright information. Other information is already present because it is added by the camera when the image was taken, including the camera type and model, the lens, focal length, ISO, aperture, shutter speed, flash usage, metering mode, white balance, and shooting mode. Software programs can access this data and use this information when and if I need to search for something in particular and for general sorting. For example, I can search for all the images that have taken place at a certain location or all the images from a specific second shooter.

- **Backup.** I back up every wedding onto a DVD and give a copy of that DVD of images to the clients when they have ordered their wedding album and all the print products are delivered. That way they have an archive copy of the wedding, which gives them a peace of mind, and they can ultimately be your last source of backup in the event that you lose everything. It's good to have multiple backups.

- **Backup.** I back up every wedding onto a DVD that I keep just in case the couple ever needs a photo or I need one for a book like this.

- **Backup.** I keep a backup copy of the DVD at a different location from my main computer and hard drive just in case something catastrophic happens to the location. It could be not just a hard-drive crash, but also a fire, flood, or robbery. This way the files are safe in a separate location. I know this sounds extreme, but catastrophes have happened before and will happen again.

As you shoot more and more events, the small amount of time you spend adding the location, copyright, photographer's info, and the client data and renaming files in the import step will have bigger and bigger payoffs. Create a system that works for you and implement it from the start.

Assignment

Choose the Best Shot

This assignment is to sort through your images, find two similar images, and choose the better of the two. If you thought that shooting a wedding was tough, wait until you have to sort and edit the wedding photos. In all seriousness, the sorting and editing stage can be the toughest part of the job, because photographers tend to be emotionally attached to their images and most of the time can't bear to throw any away. As a photographer, it is your job to only show the best images.

When sorting your images, usually the first impression will be the most honest and, as you go through them checking the focus, exposure, and emotions, many times a photo will just seem to be better than the one next to it. Stop and compare the two, all the while working out why the one image stood out over the other. Post both images to the Web site and explain which image you believe to be the best of the two.

These two shots are very similar, and they should be, with the image on the left being taken less than two seconds after the right image, but the one on the left is clearly better in my opinion. The subject is composed slightly better, and because I moved in closer, the subject fills the frame better. These differences are fairly obvious, but some are subtle details, like the cropping out of the edge of the curtain from the bottom left or the more natural looking smile in the right figure that make or break a photo. Which one do you think is better? Both images were taken at ISO 800, f/2.8, 1/100 second.

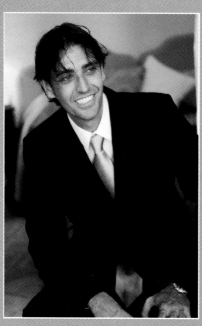

Remember to visit www.pwassignments.com after you complete the assignment and share your favorite photo! It's a community of enthusiastic photographers and a great place to view what other readers have created. You can also post comments and read encouraging suggestions and feedback.

234

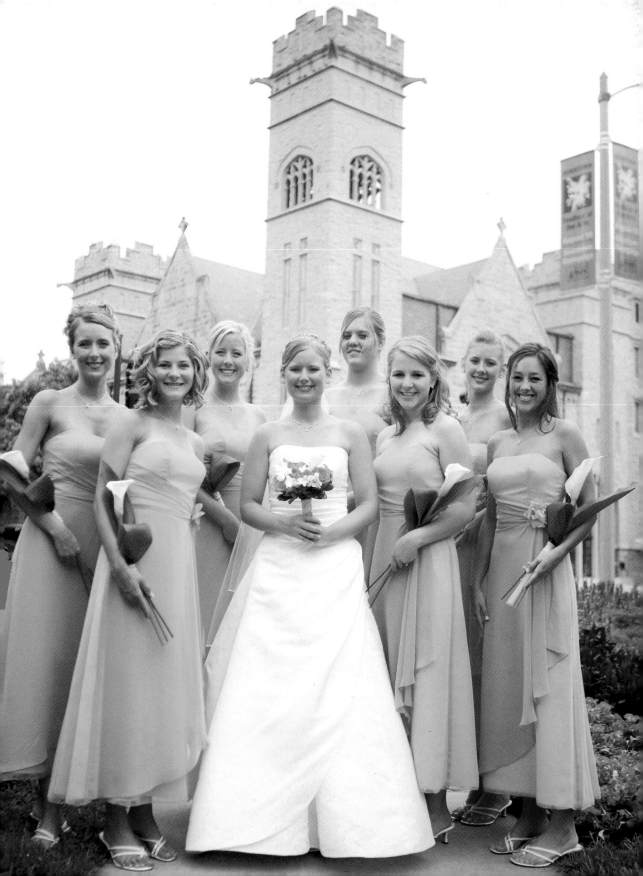

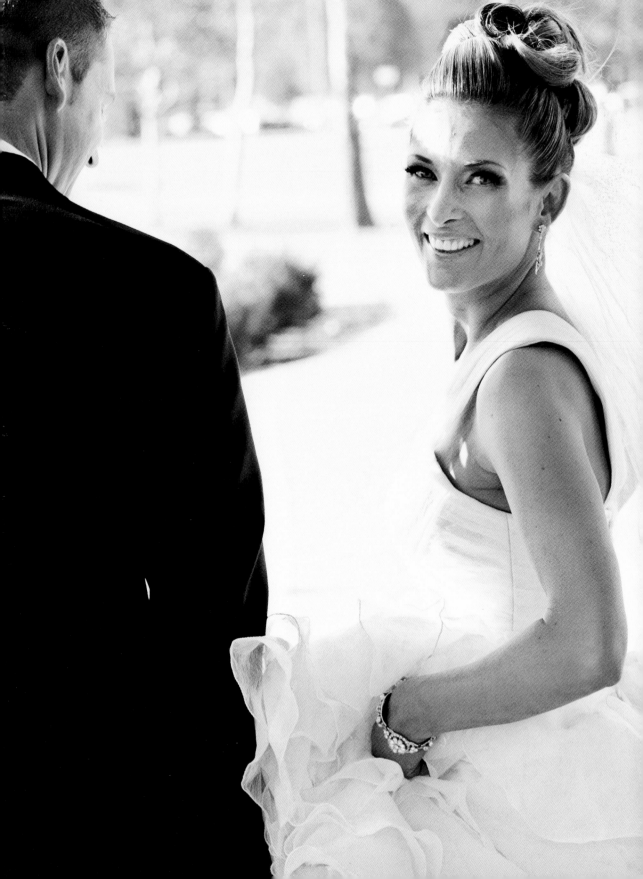

The wedding is over, the images have been sorted and edited, and the couple is back from the honeymoon, so now it is time to show the couple their images. You can do this using a printed proof album, but more likely in this digital era, you will use a Web gallery that is accessible from any computer. This way the client can easily share the photos with friends and family, no matter where they are, and can pick the images they want for prints or put together an album like the one shown in Figure AA-1.

WEB GALLERIES

The Internet has made it really easy to share images with your friends and family, and wedding photographers have been able to use it to streamline the delivery of images to the happy couple. Having a Web gallery is not only a good idea, but is also absolutely necessary in today's digital age. The good news is that you don't need to know a lot about the Web gallery creation process because there are a lot of prepackaged solutions you can use. A few things to keep in mind when picking out a Web gallery solution include:

- **Ease of upload.** Because you don't want to spend a lot of time uploading all the wedding images to the gallery, look for a solution that allows you to automate the process so that a large number of files can be uploaded at once. I use Pictage (www.pictage.com) for all my web galleries, which makes it easy for me to upload my images with the choices shown in Figure AA-2.

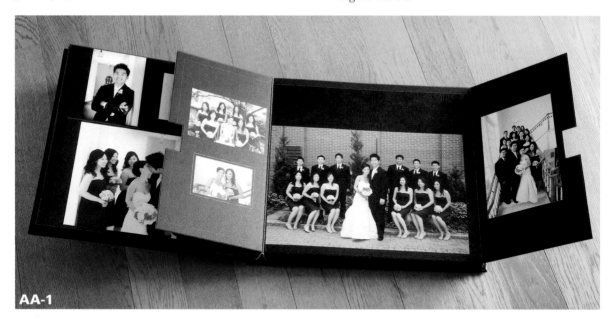

AA-1

ABOUT THIS PHOTO *A professionally designed wedding book is a great way for your clients to showcase, and share, their wedding images.*

AA-2

ABOUT THIS FIGURE *Pictage makes it easy for you to upload images with a stand-alone uploader and plug-ins for applications like Adobe Photoshop Lightroom and Apple Aperture.*

■ **Ease of use.** Use a solution that makes it easy for your clients to view their images, order prints, and share the Web gallery with others who might want to buy prints.

■ **Copyright safeguards.** Because you want to sell prints, it is important that the Web gallery doesn't allow users to take your images and print them elsewhere. The solution needs to have a way to stop unauthorized downloads.

■ **Ordering prints.** Because the goal of the Web gallery is to allow the clients to look at their images, and then order prints, the Web solution needs to have an easy way for them to order prints in various sizes. The Pictage Web gallery enables users to purchase different sizes of prints and packages from a drop-down list, as shown in Figure AA-3.

AA-3

ABOUT THIS PHOTO *This particular Web gallery allows the user to pick from a wide variety of prints for purchase.*

While I use and recommend Pictage, there are other options, including services from Zenfolio (www.zenfolio.com) and SmugMug (www.smugmug.com). You should spend time looking at the options the various services provide and decide which service will best meet your needs.

PROOF BOOKS

Even in this digital world, many people still want to see their wedding images in a printed proof book. This allows the couple to share the proof

books with people who don't have a computer or aren't computer savvy or don't have a high-speed Internet service. There is also something warm and comforting about sitting down together and looking through an album of images that just doesn't happen when people gather in front of the computer screen.

It is not necessary to offer a wide variety of proof books, and keeping it simple works well. Keep in mind that a proof book is not a wedding album, and it only needs to show the images at about

2 inches × 2 inches, as shown in Figure AA-4. To make your proof books the best books possible, keep the following things in mind:

- **Keep the book design simple and update it when necessary.** A simple design is timeless, and it lets the images speak for themselves. That doesn't mean that you shouldn't occasionally update the look and feel of the book to better show your work. Plain backgrounds work really well and don't distract from the images themselves.

- **Tell a story.** The order of the images in the book is important: They should follow the order of the events during the day, telling the story of the wedding beginning with the bride and groom getting ready, followed by the actual ceremony, and then the reception. You can use the portraits as breaks between the storytelling sections.

- **Make sure the quality is excellent.** Because the proof book will be passed around and viewed by many people, it is an extension of you and your business, and the quality affects future potential clients. Make sure that the quality is something you are proud to show your clients.

Many times you can arrange for a full-service company like Pictage to create the proof books along with the Web galleries, so that all print orders can be done online.

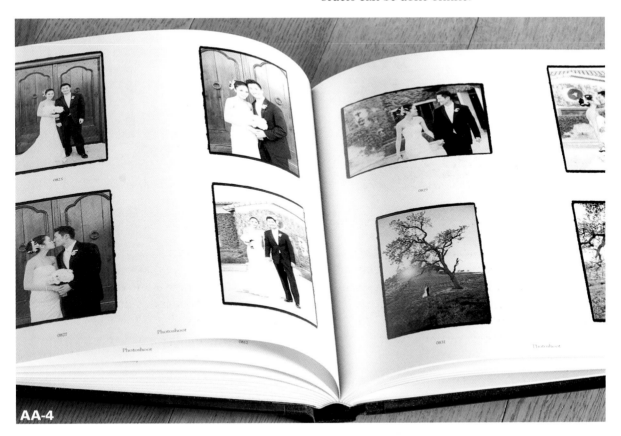

AA-4

ABOUT THIS PHOTO *The proof book with a simple layout looks clean and professional and makes it easy for clients to sit down together and look for images to print or add to the wedding album.*

PRINTS

Digital cameras, the Internet, Web galleries, and electronic photo frames have changed just about everything to do with photography, but there is one thing that still hasn't changed, and that is the photographic print.

Some items to consider when you pick a print supplier are as follows:

■ **Quality is extremely important.** After all the work that went into planning the wedding and all the work that went into photographing the wedding, don't undermine it now by producing inferior prints. The solution here is simple: Use the best quality; it is your reputation that is on the line. Many print companies have custom options for premium service, like the premium prints at Pictage shown in Figure AA-5.

■ **Ease of use is key.** Make it easy for your customers to order prints, and they will more than likely order more. Remember that part of earning a living is to sell products, and the main product is the print.

■ **Sizes matter.** Make sure that the provider you use for the prints offers a wide variety of sizes. Not everyone wants the same size prints, so make it easy for your customers to pick the ones they want.

Options

Custom Prints (Premium prints only)

Pictage image professionals pay special attention to the main subject of the image, usually the Bride and Groom. They reduce facial shine, obvious blemishes, reflections and eyeglass glare. They also remove minor stray hairs and dodge faces to reduce uneven lighting. Custom Prints also include overall sharpening when needed.

Details

- Custom Final Prints will be billed $3.00 additional per image.
- Select the Custom Prints check box in the order interface and specify any comments you may have.

Major Retouching (Premium prints only)

Requests beyond the scope of Custom Final Prints are considered Major Retouching. Skilled Pictage image professionals will work with your images to reduce eye bags and wrinkles, open eyes and whiten teeth, merge and remove objects, reduce grain, dodge and burn and provide overall "digital plastic surgery."

Details

- Provided at $60 per hour, broken into 10-minute increments ($10 minimum)
- Photographers will only be contacted if retouching request exceeds $60.00. Otherwise retouching requests made at time of order will be fulfilled and billed according to time spent up to $60.00.
- Photographer may offer Major Retouching services ("Special Instructions") to consumers at price desired (studio catalog option)

Learn more about Major Retouching

ABOUT THIS PHOTO
Check out the available options when choosing a premium printing service.

AA-5

Many companies offer complete packages, including Web galleries and online print ordering geared toward wedding photographers. Make sure that the company you use to print your images will do so in a professional manner. Remember that your reputation is at stake every time a customer orders and receives a print.

THOSE IMPORTANT EXTRAS

Most wedding photographers now offer Web galleries, proof books, and prints, so what can you do to stand out? One thing is to offer some extra options, those special touches that will allow you to stand out from the crowd. There are two

extra options I'd strongly suggest you consider offering your clients: a wedding book and canvas prints.

WEDDING BOOKS

Most couples want to have a traditional wedding album or wedding book with their memories of the day neatly laid out. There are many options when it comes to wedding books, including those that are part of the Web gallery and print packages through companies like Pictage, but these are usually limited in their designs and options. Because the wedding book should be a special item, and unique to the personality of the couple, I suggest using a company that can create a personalized book, like those shown in Figure AA-6.

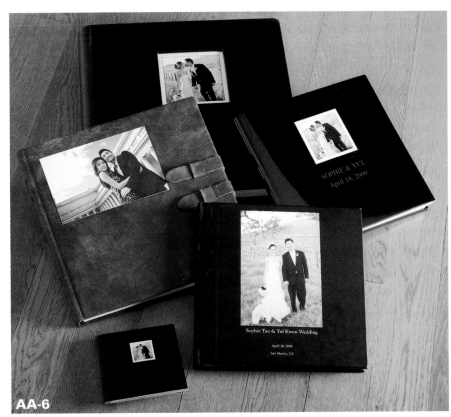

AA-6

ABOUT THIS PHOTO
Wedding books come in a variety of styles and materials.

Just make sure that the company creates a top-quality product, because the book will be passed around and shown off.

A way of making your wedding photography service stand out above the rest is to work with a graphic designer or design service when creating the wedding book so that it really is a piece of art. Two companies that I have worked with, Graphistudio (www.graphistudio.com) and La-vie Album (www.la-viealbum.com), offer extremely high-quality services and products. These companies help the clients design a custom layout and look for their albums, like the one shown in Figure AA-7.

CANVAS PRINTS

Most people have home printers that can do a pretty good job printing a photo, but few are able to print on canvas and have the image gallery wrapped (where the canvas is stretched so that the sides wrap over the wooden frame and the art is secured to the back of the wooden frame.) The high-resolution print quality combined with the old-fashioned look of a gallery wrap turns your regular wedding image into a real piece of art, suitable for hanging proudly in a home. I enjoy using the services provided by Pixel2Canvas (www.pixel2canvas.com) — it provides excellent service and amazing products, as shown in Figure AA-8.

AA-7

ABOUT THIS PHOTO *The custom layout of the book is something that the clients can be proud of and is unique to them.*

AA-8

ABOUT THIS PHOTO *The canvas prints really stand out as something special.*

Again, there are many print providers and, even though I am very happy with the companies I use, it does pay to look at all your options and find the one that best suits your needs. If you take one thing away after reading this appendix, it is that you need to make sure that the products you supply to clients are top-quality products, because the prints and products are a representation of your work.

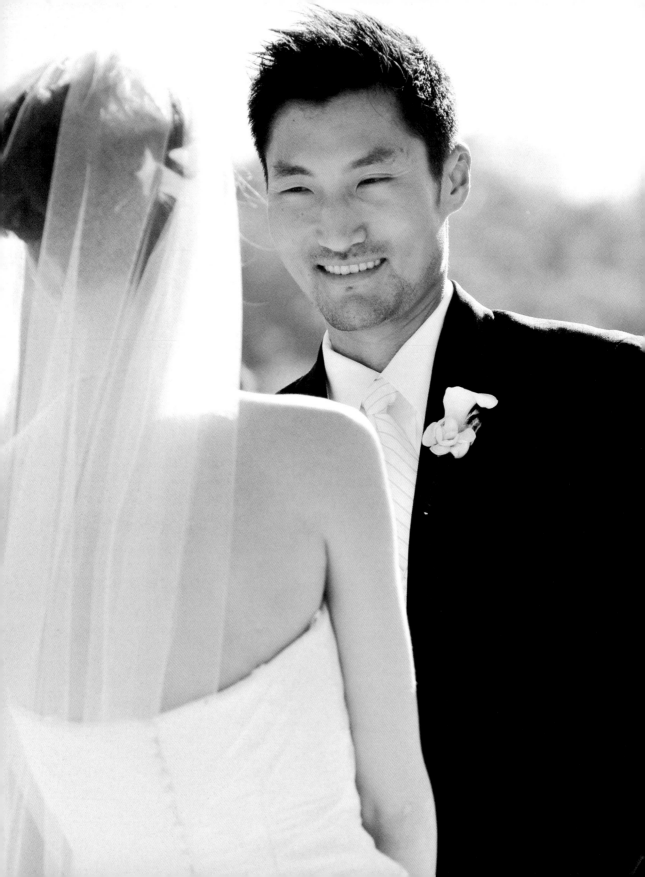

ambient light The natural light in the scene. Also referred to as available light.

angle of view The amount of the scene in front of the camera that a specific lens sees. It is also referred to as field of view.

aperture The lens opening that the light passes through before reaching the sensor in the camera. The aperture can be adjusted by controlling the diaphragm, which is done by changing the f-stop. This is expressed as f/number — for example, f/5.6. The size of the aperture is one of the controls that determine the amount of light that can reach the camera's sensor. The aperture also controls the Depth of Field. *See Depth of Field.*

aperture priority mode A semiautomatic exposure mode in which the photographer sets the aperture and the camera sets the shutter speed.

artificial light Any light that the photographer introduces into a scene.

aspect ratio The proportions of the image captured by the camera, calculated by dividing the width of the image by the image height.

auto mode In this mode the camera sets the shutter speed, aperture, and ISO to achieve the correct exposure.

autofocus The camera automatically adjusts the focus to keep the subjects in focus.

backlighting A method of lighting where the main light is placed behind the subject. Also see *silhouette*.

barrel distortion An effect that causes straight lines to bow outward, especially at the outer edges of the frame. This effect is more pronounced when using wide-angle lenses.

bounce light Light that is bounced off a surface before hitting the subject to create a more flattering light source. This is used mainly with a dedicated flash unit that can be aimed at a wall or ceiling.

buffer The camera's built-in memory that is used as a temporary storage while the image data is being written to the memory card.

camera shake The small movements of the camera that can cause blurring, especially when the camera is being handheld. Slower shutter speeds and long focal lengths can contribute to the problem.

center-weighted metering The entire scene is metered, but a greater emphasis is placed on the center area.

color cast An overall look or predominant color that affects the whole image. Color casts are usually brought about by an incorrectly set white balance. See also *cool* and *warm*.

color temperature A way to describe the color of the light using the Kelvin scale. See also *Kelvin*.

colored gel filters Colored light modifiers that when placed between the light source and the subject, change the color of the light hitting the subject.

compression Reducing image file size by either removing information (lossy compression) or writing the information in a form that can be recreated without any quality loss (lossless compression).

compression distortion A photographic optical illusion that occurs when using a long focal length lens, where objects can appear closer together than they really are.

continuous auto focus mode A mode in which the camera continues to refocus while the shutter release button is held halfway down. This is the best focus mode for moving subjects.

contrast The difference between the highlights and the shadows of a scene.

cool A descriptive term for an image or scene that has a bluish cast.

dedicated flash A flash unit that is designed to work with your camera's autoexposure modes.

depth of field (DOF) The area of acceptably sharp focus in front of and behind the focus point.

diffused lighting Light that has been scattered and spread out by being bounced off a wall or ceiling or shot through a semi-opaque material, creating a softer, more even light. Diffused lighting can also be sunlight shining through the clouds.

digital noise See *noise*.

exposure The amount of light that reaches the sensor.

exposure compensation A method of adjusting the exposure so that it differs from the metered reading.

exposure metering Using the light meter built into the camera to determine the proper exposure. See also *metering modes*.

f-stop A measure of the opening in the diaphragm that controls the amount of light traveling through the lens.

fast lens A description referring to the maximum aperture of a lens. Lenses with apertures of f/2.8 and higher are considered fast lenses. See also *slow lens*.

fill flash A method where the flash is used to fill in shadow areas to reveal details that would usually be lost.

filter A glass or plastic cover that goes in front of the lens. Filters can be used to alter the color and intensity of light, add special effects like soft focus, and protect the front elements of the lens.

flash A device that produces a short, bright burst of artificial light. The word *flash* can be used to describe the unit producing the light or the light itself.

flash sync The method by which the flash is fired at the moment the camera shutter is opened.

flat A description of an image or scene that has very little difference between the light values and the dark values. An image or scene with low contrast.

focal length The distance from the optical center of the lens when it is focused at infinity to its focal plane (sensor), described in millimeters (mm).

focal plane The area in the camera where the light passing through the lens is focused. In dSLRs, this is the digital sensor.

focus Adjusting the lens to create a distinct and clear image.

front lighting A method of lighting where the main light is placed directly in front of the subject.

gigabyte A unit of measurement equaling 1 billion bytes. Used in describing the capacity of the memory cards used in digital photography.

high contrast A description of an image or scene where the highlights and shadows are at the extreme differences in density.

high key A description of a photograph with a light tone overall.

histogram A basic bar graph that shows the distribution of tones in your image.

hot shoe The camera mount on top of the viewfinder that accepts flashes or flash triggers and accessories. Make sure that the flash or accessory is supported by your camera before you try to attach it.

ISO International Organization for Standardization. An international body that sets standards for film speeds. The standard is also known as ISO 5800:1987 and is a mathematical representation for measuring film speeds.

ISO sensitivity The light sensitivity of image sensors in digital cameras are rated using the standards set for film. Each doubling of the ISO makes the sensor twice as sensitive to light, meaning that in practical purposes, an ISO rating of 200 needs twice as much light as an ISO of 400.

JPEG Joint Photographic Experts Group. The most commonly used and universally accepted method for image-file compression. The JPEG is a lossy form of compression, meaning that information is lost during the compression. JPEG files have a .jpg file extension. See also *lossy compression*.

Kelvin Abbreviated with K, it is a unit to measure color temperature. The Kelvin scale used in photography is based on the color changes that occur when a theoretical black body is heated to different temperatures. See also *color temperature*.

LCD (Liquid Crystal Display) The type of display used on most digital cameras to preview your photos and display menus and shooting data.

light meter A device used to measure the amount of light in a scene. The readings from the light meter can be used to determine what settings produce a proper exposure. All recent cameras have a built-in light meter, which helps the camera determine which settings to use when not in manual mode.

lossless compression A form of computer file compression that allows the original data to be reconstructed without losing any of the information. This is useful when it is important that no changes are made to the information. See also *compression* and *TIFF*.

lossy compression A form of computer file compression that reduces the file size by removing data. The file will not match the original file exactly but will be close enough to be of use. This form of compression suffers from generation loss.

Repeatedly compressing the same file results in progressive data loss and in photography, image degradation. See also *compression* and *JPEG*.

low key A term used to describe a photograph with a darker tone overall.

macro lens A specialty lens with the capability to focus at a very close range, allowing for extreme close-up photographs.

manual mode In this mode, the photographer determines the exposure by setting both the shutter speed and the aperture.

megapixel A description referring to the amount of pixels that a digital camera sensor has. Each megapixel is equal to 1 million pixels.

memory card The removable storage device that image files are stored on. It is the digital film in digital cameras.

metering modes The method the camera uses to determine what light to use in the metering process. See *center-weighted metering, scene metering,* and *spot metering*.

middle gray A tone that represents 18% reflectance in visible light. All reflective light meters are calibrated to give an average reading of 18% gray.

noise Pixels of random color introduced by either the amplification process used when shooting at high ISO or heat generated during long exposures in places where there should only be smooth color.

noise reduction Software or hardware used to reduce unwanted random pixels that appear when shooting at high ISO or during long exposures in digital images. See also *noise*.

overexposure Allowing more than the recommended amount of light to reach the sensor, causing the image to appear too light and with less detail in the highlights.

pixel A contraction of the words *picture elements* that describes the smallest unit that makes up a digital image.

prime lens A lens with a single unadjustable focal length.

RAW A file type that stores the image data without any in-camera processing.

rear-curtain sync The ability to fire the flash at the end of the exposure instead of at the beginning. This freezes the action at the end of the exposure.

red eye A condition that occurs when the flash is too close to the lens when photographing people. The light from the flash is reflected from the person's retina, which is covered with tiny blood vessels; thus the red reflects back toward the camera's lens.

red-eye reduction A flash mode that fires a short burst of light right before the photograph is taken, in the hopes of causing the subject's pupils to contract, lessening the amount of light that can be reflected back.

saturation In color, it is the intensity of a specific hue.

scene metering The metering mode that reads the brightness in the entire frame and tries to match the data with a built-in database to get the best exposure. In the Canon system this is referred to as Evaluative metering; in the Nikon system this is called Matrix metering.

sharp A way to describe a well-focused image.

shutter A mechanism that controls the amount of light that is allowed to reach the sensor by opening for a specific length of time designated by the shutter speed.

shutter release button The button that when pressed causes the shutter to open and allow light to reach the sensor for the length of time programmed by the shutter speed.

shutter speed The amount of time that the shutter is open and letting light reach the image sensor.

side lighting A method of lighting where the main light source is to the side of the subject.

silhouette An image or scene where the subject is represented by a solid black object against a lighter background. See also *backlighting*.

slow lens A description referring to the maximum aperture of a lens. Lenses with a maximum aperture of f/5.6 are considered very slow. See also *fast lens*.

spot metering The only area that the camera uses to meter the light is a small area in the center of the scene. Some cameras will set the metering area to what focus point is being used.

stop A term of measurement in photography that refers to any adjustment in the exposure. When stop is used to describe shutter speed, a 1-stop increase doubles the shutter speed, and a 1-stop decrease halves the shutter speed. When stop is used to describe aperture, a 1-stop increase doubles the amount of light reaching the sensor, and a 1-stop decrease halves the light reaching the sensor. A stop can also be used to describe ISO settings, where a full stop either doubles or halves the ISO settings, making the camera either more or less sensitive to light. Most camera settings can be adjusted in 1/3 or 1/2 stops.

TIFF Tagged Image File Format. A lossless file format for images that is universally acceptable by image-editing software. See also *lossless compression*.

tonal range The shades of gray that exist between solid black and solid white.

tungsten light A light source that produces light with a color temperature of approximately 3200K. This is the type of incandescent light usually found in homes and produces a very orange color cast.

underexposure Allowing less than the recommended amount of light to reach the sensor, causing the image to appear too dark and have a loss of detail in the shadows.

warm A descriptive term for an image or scene that has an orange or red cast.

white balance An adjustment to how the camera records the colors to match the lighting of the scene. Setting the white balance correctly for the type of light in the scene will render the colors truer and result in a more natural looking image.

zoom lens A lens that has an adjustable range of focal lengths.

Develop your talent.

Go behind the lens with Wiley's Photo Workshop series, and learn how to shoot great photos from the star. Each full-color book provides clear instructions, sample photos, and end-of-chapter assignments that you can upload to pwsbooks.com for input from others.

978-0-470-11433-9

978-0-470-11876-4

978-0-470-11436-0

978-0-470-14785-6

978-0-470-11435-3

978-0-470-11955-6

978-0-470-421932

978-0-470-11434-6

978-0-470-41299-2

978-0-470-11432-2

978-0-470-40521-5

For a complete list of Photo Workshop books, visit photoworkshop.com — the online resource committed to providing an education in photography, where the quest for knowledge is fueled by inspiration.

Available wherever books are sold.

WILE
Now you kno